John Haberle

AMERICAN MASTER OF ILLUSION

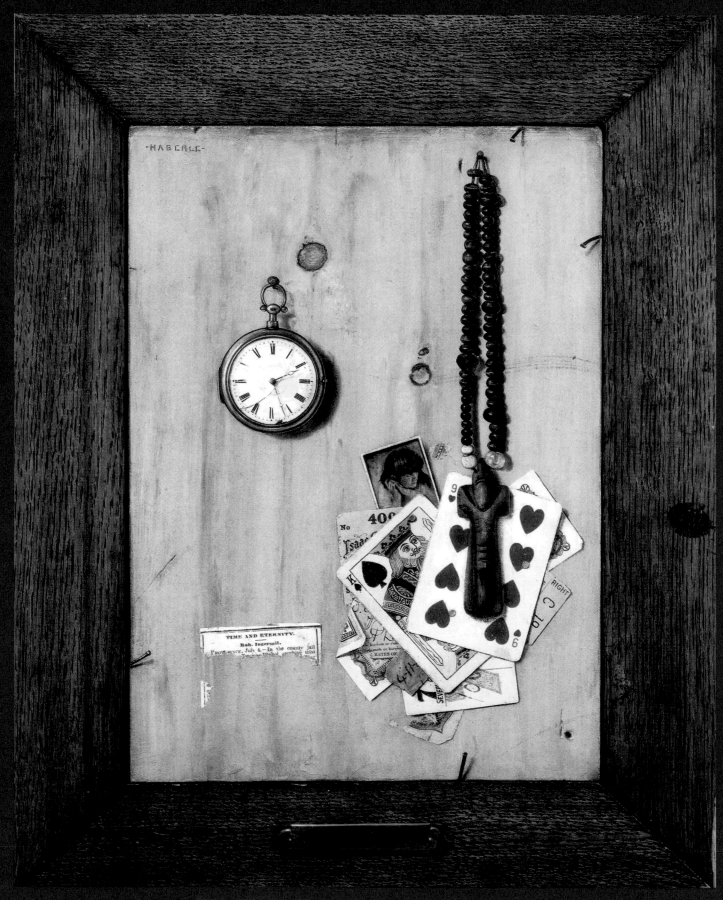

Time and Eternity, ca. 1889–90. Oil on canvas, 14 x 10 in.
New Britain Museum of American Art, Stephen B. Lawrence Fund (1952.01)

John Haberle

AMERICAN MASTER OF ILLUSION

GERTRUDE GRACE SILL

NEW BRITAIN MUSEUM OF AMERICAN ART

NEW BRITAIN, CONNECTICUT

DISTRIBUTED BY UNIVERSITY PRESS OF NEW ENGLAND

HANOVER AND LONDON

This book is published in conjunction with the exhibition
John Haberle: AMERICAN MASTER OF ILLUSION,
organized by the New Britain Museum of American Art.

New Britain Museum of American Art
New Britain, Connecticut.
December 11, 2009 to March 11, 2010

Brandywine River Museum
Chadds Ford, Pennsylvania.
April 17, 2010 to July 11, 2010

Portland Museum of Art
Portland, Maine
September 18, 2010 to December 12, 2010

NEW BRITAIN MUSEUM OF AMERICAN ART
56 Lexington Street, New Britain, Connecticut 06052-1414
Telephone: (860) 229-0257 • Fax: (860) 229-3445
www.nbmaa.org

Distributed by University Press of New England
One Court Street
Lebanon, New Hampshire 03766
www.upne.com

Edited by Pamela Barr, New York
Designed by James F. Brisson, Willliamsville, Vermont

Library of Congress Control Number: 2009939233
ISBN-10: 0-972449-1-X
ISBN-13: 978-0-972449-1-7

Printed in the United States of America

This catalogue is funded in part by
Furthermore: a program of the J. M. Kaplan Fund.

Front cover and frontispiece: *Time and Eternity* (pl. 14)
Back cover: *The Challenge* (pl. 10)

Photograph credits:

Amon Carter Museum: pl. 5
Board of Trustees, National Gallery of Art, Washington: pl. 1
David Stansbury: fig. 20, pls. 16, 20
Katya Kallsen: fig. 17
The Metropolitan Museum of Art: pl. 7
Museum of Fine Arts, Boston: fig. 13
Newark Museum/Art Resource, NY: fig. 1, pl. 15
President and Fellows of Harvard College: fig. 16
Yale University Art Gallery/Art Resource, NY: fig. 7

All reasonable efforts have been made to obtain copyright
permission for the images in this book. The publishers
apologize for any inadvertent errors or omissions.

Contents

List of Illustrations

An asterisk (*) denotes a work included in the exhibition.

Figures

Author's Acknowledgments

I would like to thank the following individuals for their expert help in preparing this manuscript: Pamela Barr for her meticulous editing; Marge Hickey for her organizational and computer skills; Claudia Mize, Haberle's great-granddaughter, for donating the Haberle Papers to the Archives of American Art; Alexander J. Noelle of the New Britain Museum of American Art for his computer expertise and efficiency; Diana Reeve for securing all the rights and reproductions; and Abigail Runyan, formerly of the New Britain Museum, for organizing the early phases of the exhibition. And, finally, my thanks to the late Alfred Frankenstein, who introduced me to Haberle and who planned to write this book before his untimely death.

Gertrude Grace Sill

Foreword

Of the three great nineteenth-century American trompe l'oeil artists William Michael Harnett (1848–1892), John Frederick Peto (1854–1907), and John Haberle (1856–1933), the least well known is Haberle. Born within eight years of one another, the three artists all settled on the East Coast. During Haberle's seventy-seven years—much of it spent in obscurity in New Haven, Connecticut—his output was inconsistent. While he lived considerably longer than the others, his known oeuvre is limited, and he never received the acclaim or patronage that Harnett and Peto were able to garner. His eyesight failing, Haberle was able to produce only a limited number of paintings toward the end of his life.

Haberle's work is astonishing in its intensity and in the startling clarity of his vision. At first glance, his paintings, unlike those of Harnett and Peto, strike the viewer as lacking in three-dimensional depth, yet the immediacy of this effect only serves to heighten the viewer's perception. His approximately forty known trompe l'oeil paintings are so detailed and so precise that they command our attention.

Haberle approached painting with an informed and sophisticated connoisseurship. A highly original artist, he often alluded to complicated, ingenious, witty, and entertaining aspects of contemporary society. The rarity of his work also adds to its allure—much as we prize the limited output of Johannes Vermeer.

The New Britain Museum of American Art is fortunate to have several outstanding works by Haberle, including *Night* (ca. 1909) and *Time and Eternity* (ca. 1889–90). The story of the acquisition of *Time and Eternity* has become part of Museum lore: it was the founding director, Sanford Low, who visited Haberle's daughter and negotiated the purchase of this masterpiece through the Stephen B. Lawrence Fund. Legend has it that Vera Haberle was so pleased at the prospect of her father's painting entering the Museum's collection that she delayed Low's departure a few minutes and went upstairs to her father's bureau to retrieve the pocket watch and beads prominently featured in the picture. She gave both to Low, indicating how gratified her father would have been to know that his work would hang at the New Britain Museum. To this day, both are displayed next to the painting. The late Alfred Frankenstein, who wrote the seminal study *After the Hunt,* came to the Museum and established a warm relationship with successive directors. Over the

years, the Museum has mounted a distinguished series of exhibitions exploring the theme of trompe l'oeil painting—most recently "Seeing Is Believing: American Trompe l'Oeil," which I curated in 2004.

I am indebted to Gertrude Grace Sill, our guest curator for this exhibition, who has spent the last fifty years researching the life and art of John Haberle. Without a doubt, she is the country's expert on the artist. I am pleased that her many years of steadfast devotion to Haberle have resulted in this important publication. The catalogue and the paintings and drawings on view will conclusively establish Haberle, once and for all, as a man of distinguished inventiveness and consummate skill.

I also want to express my gratitude to the Wyeth Foundation for American Art and to Furthermore, a program of the J. M. Kaplan Fund, for providing the funding for this catalogue as well as The David T. Langrock Foundation for supporting the exhibition. Fortunately, the late Howard Bristol established an endowed fund in memory of his mother, Alice Osborne Bristol, to help fund research and publications related to the permanent collection.

As always, I wish to thank the Museum's resourceful staff. Abigail Runyan and subsequently Alexander J. Noelle coordinated the myriad details of the exhibition. Volunteer Diana Reeve provided key assistance securing rights and reproductions and illustrations for the catalogue. Pamela Barr did an excellent job, once again, as editor. The installation of the exhibition took place under the direction of John Urgo. Maura O'Shea and Heather Whitehouse organized the related programs at the Museum. I wish to thank Claudia Thesing, Director of Development, and Dina Silva, Development Manager, who secured funding, an impressive accomplishment in troubled times.

The exhibition will travel to the Portland Museum of Art and the Brandywine River Museum. The catalogue will be distributed by the University Press of New England and it has been a pleasure working with Michael Burton. Most of all I am glad that John Haberle will receive the critical scholarly attention he so much deserves.

Douglas K. S. Hyland
Director
New Britain Museum of American Art

John Haberle

AMERICAN MASTER OF ILLUSION

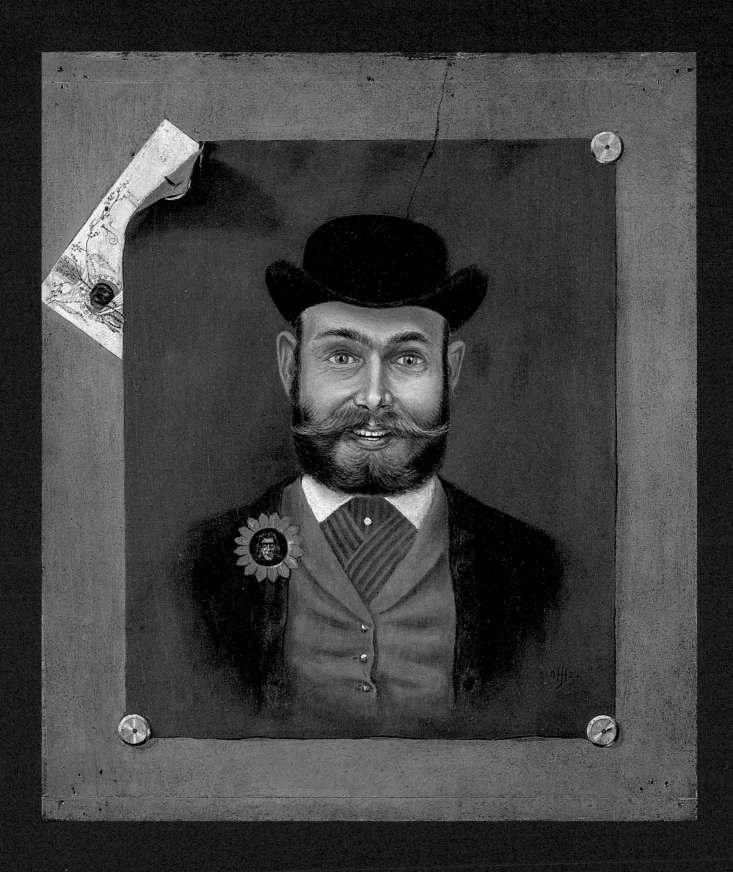

That's Me! (Self-Portrait), 1882. Oil on panel, 11 x 9½ in.
Private collection. Photo courtesy Spanierman Gallery, New York

Haberle's Recollections to His Daughter Vera in 1925

Dear Vera:

As requested and in fear of being subjected to the awful penalty you threaten if I fail—I herewith begin my recollections of things relating to your father whom I think I know as well as he knows himself. Your father, owing to his religious disbeliefs, might be taken for a bad man, but as bad men smoke, drink, gamble, and dissipate generally, he cannot be classed as one. I would trust him with my own daughters, but not with my own wife. To enter wedlock he would have neither priest, minister or rabbi . . . a justice of the peace was good enough for holy matrimony.

If he liked the word of God, he would prefer theocracy to all other forms of government, but there have been too many gods to his liking, including the God of War, that the world is still worshipping; furthermore, he says that religion being a system of worship, he doesn't think the creator expects to be worshipped, and would be quite content if we just obeyed his laws.

He sees and knows there is a creative power. He believes a Jew, a Mohammedan, a Buddhist, or any other ist can live just as upright a life as a Christian. Your father has attended most of the places of worship excepting the Jewish. He thinks the Catholic the most inspiring. The C.S. Church the coldest, the contribution box and congregational singing was about the only thing that reminded him of being in church. He once attended their Wednesday evening "How Do You Do" meetings. Your father will now tell his own story.

I was born and brought up in the usual way. Have had a yearly birthday since May 22, 1856. My father and mother with their daughter Sophia and little (son) Fritz, started from places that sounded (as well as I can remember) like Baum Erlenbach, Jactskreis, Oberamtstadt, Ehrsingen, Undsoweiter, Wertenberg or Schwabenland, Germany, via Bremen for America, taking 28 days to make the trip which was saddened by the death of the baby boy, who was buried at sea. My father and his remaining family landed at Castle Garden, New York, thence migrated to New Haven, Conn. where I arrived some time later.

My father (George Frederik Haberle and his wife Catherina Dorothea Meyer) as was the custom, especially in the old country, learned his father's trade, that of tailoring. Tailors in those days made both women's and men's clothing. My mother's father was a shoemaker. There were no shoe or clothing factories in those days.

I was born, I believe on Ashman St., was christened by Bishop Dr. Brewster in Christ Church at the junction of Broadway and Elm Streets. We lived there for a time in the old house at the corner of Chapel and York Street, which is now occupied by Mallory, the Antique store man. Our next move was to George St., near Temple, where there was a hill and good sledding in winter time, down to a creek which was, at one time, so history tells us, a canal large enough for boats to enter. It is now filled in and is the continuation of Temple St. to Oak. My sister (who is four years my senior) and I went to Webster School. Of this I remember only the stings of the ruler, on the palms of the hands for doing nothing worse than whispering and bringing and giving prunes and dried apples to the girl schoolmates. My sister tells of the time when I left her on the way to school to go back home to finish drinking some coffee (probably made of roasted acorns) that I had left at breakfast time. Consequently, a note was sent to my good parents asking for an excuse for my absence or tardiness, whichever it was. So my very conscientious father sent me back with the note on which must have been written, "No excuses." This took me to Principal Lewis, a stern old disciplinarian who wouldn't spoil any child by sparing the rod, and so it was applied, just where I do not remember, but I do know that I made a mental note of it and that some day I would have sweet revenge, but although I met the cruel master many times after I had grown in size he always looked too formidable to tackle and so he died before I could kill him.

On Sundays I was a good boy and went to school where I was taught what to believe and which belief didn't make it so. Was taught the story of Adam for whom I felt very sorry. The poor fellow was placed in the garden a full-fledged man—not even self-made—hadn't enjoyed childhood in any way; never played hide and seek, Jacks, marbles, hockey or hooky. I doubt if Adam could do the simplest example in addition, yet he was asked to multiply. If apples ever grew in the Garden of Eden, they surely were pippins. It is a pity that the one that caused the fall of Adam did not fall on his old CoCo, as it did on Sr. Isaac Newton's and demonstrate the theory of the central force of gravity of the earth, and then if later on the great master (who is supposed to have possessed a spiritual body which could overcome a certain natural law) had told us something about the shape of the earth, we would now be much further advanced in science. I don't believe that it was necessary for the creator to violate any of Nature's laws to prove anything. The Bible miracles were all possible, but not probable. Leave the modernist-fundamentalist question to the Ku Klux Klan. In God we trust, and his is about the only one we do trust. Eve was no snake charmer. How about a future cat-rest, a parrotdise, and a dogdom?

If it wasn't for war we would have a very short world history. Pantheism put all of the gods on the dump. If every man went on a war strike we would have no more. Eve sure did raise Cain. Sensible man does not want to be worshipped. Despotism and bigotry have ruled too long. Adam probably escaped such discomforts as chicken pox, measles, mumps, etc. Evolution—there is nothing that man does not ape after. Who made disease-producing bacteria? Adam had no bringing up. It takes faith and a sufficient quantity of dynamite to move mountains now-a-days. Could you get down on your knees and praise God from whom all blessing flow if your whole family had met death by a power not controlled by man?

Now I have drifted some and will try to get into the right channel again.

I was made secretary of the Sunday school and took part in religious theatricals and gave poetical declamations. The minister told my father he should let me study for the pulpit. My father knew better, for I was pretty good at drawing at 14, so he apprenticed me in the Lithographic business where I was to serve four years, with no pay the first year, and very little thereafter. When I had served three years I told the boss who was my instructor that I had served my time. The boss, who was one of the firm, was a Baptist. The other member of the firm was a Congregationalist. The best engraver there was a Catholic and I was supposed to be a Methodist. There was many a schism between the Baptist boss and the Catholic journeyman.

My work the first year was mostly feeding at the presses and removing the imperfections around the transfer work on the stones. There were men of many nationalities working there and they mostly all played the Havana or Louisiana lottery. I took piano lessons after my father bought an old instrument of Morris Steinert for $125. My teacher was Miss Kirschner, aunt to Kirschner of the high school. About all I studied were the scales. In after years I took lessons on the violin of Prof. Balk, who taught the Steinert family. He was a good performer in his prime but a little nervous as a teacher. I always liked to hear him talk about the conservatories of Europe but in order to get him started it was necessary to fill him up with beer and by that time I found that I didn't know what he was talking about, so I gave it up. (The beer literally)

My best time before I took up the brush was while I was at the Yale Peabody Museum, drawing the old fossils which Professor Marsh was having made

for publication. I was there when the great biologist, Huxley, was the guest of Yale and Professor Marsh.

When I was about twenty-three years of age I took a position in Montreal as engraver at good wages and while there wrote to the Catholic lithographer who worked there when I was an apprentice, to come up and take a job where I would be the boss. He did so, and we had many a laugh at the outcome of affairs. With him and the nice brown-eyed Scottish Catholic girl we went to church and cathedral where I enjoyed the stained-glass windows, the decorations, the grand organ, the vocal and instrumental music, and ceremony, and I found it all so impressive and inspiring that I would not have been surprised if something miraculous had taken place. I joined a double quartet and sang second tenor. I also came near joining the choir above by having typhoid fever in the hospital—where I raised the beard I am still wearing. With the money I had saved I paid my bills (for I had a horror of being in debt) and came back to the City of Elms and no one was more happy than mother, and I always said that I would never marry as long as she lived. It was she that helped me most in my brush work after studying at the N.A.D. in N.Y. by the encouragement she gave me and the confidence which I needed. I was admitted to the school by a drawing from the cast which some of the boys said would have admitted me into any art school.

The gentleman at the desk when I applied for entrance looked over the list and said that of the names listed, mine was not on it. But as I happened to be looking over his shoulder I spied it and showed him where it was. I learned later that he was a drinking man. It was a narrow escape for me. I was pretty good at composition and before school closed some of the boys wanted

to borrow them to get jobs with, I suppose, and they were never returned.

The second year at school I exhibited a small canvas at the N.A.D. Exposition called "Editorial Board" price $125 and it sold. Also a poker sketch for $10 sold at another E'xn. This was encouraging. I wanted to do figure work but soon found out that I was no colorist and sometimes was color blind. So I decided to do still-life. The following year I painted a new Five Dollar Bill and sent it to the Academy Exhibition and it sold and brought $350. Mr. Clark who bought it invited me to his home in N.Y. city and there told me that he had asked Harnett to paint him a new Five Dollar Bill and was told that it couldn't be done. After that I painted a number of such canvases, bringing from $150 to $350 for about ten days work—a canvas 20 inches by 24 inches, called "The Changes of Time" brought over $1300. I discovered that there was a law forbidding the painting of monies and some owners of my work got special permission to exhibit it. It is counterfeiting and the penalty is 10 years in the Atlanta prison. I sent a painting of an old two-dollar bill to a Chicago Exhibition and it was denounced by the Chicago Inter-Ocean as a fraud, stating just how it was fraudulently done. I saw N.H. lawyer and for two dollars he told me that I would have to go to Chicago to do anything about it. So I went and met the art critic who made the denouncement and some others by appointment and proved that it was done by art's legitimate tools alone. I was asked by the representative of the paper what I expected and I told him a retraction on the first page, first column, where the denouncement appeared. My price on the subject was $250. I sold it for $350 which difference paid my expenses.

Some of the men in industrial art here and of the Yale Art School started a N.H. sketch club of which I was an instructor. (No salary.) We met once a week and had exhibitions. Some of the members were Leo Hammond, George Langzettel, now secretary of the Yale Art School, Jule Rida, the sign painter, Hopkins, engraver and etcher.

About this time I bought a violin for $200 and owned a dog. Loaned money to friends and got acquainted with your mother at a confectionary store on Chapel St., where I used to hang out evenings. I courted your mother, practiced on my violin while my dog howled until he became a nuisance. I got rid of my violin, and thought it about time to settle down. With the little money I had we built the house we are now living in. It would have been better by $1000 if the money I put into a building loan association had matured instead of manured at the time that we built. With the little that I got from the investment, I bought what I call our thousand dollar sewing machine.

My pictures have been shown in most of the exhibitions here and one year at the Paris Salon.

When the Civil War broke out I was but six years old, but I well remember trying to eat the hardtack that was intended for the boys in blue and stored in the old State House on the green. Recall the excitement caused by the assassination of Abe Lincoln. About this time my father worked for Merwin, whose tailoring establishment was in the New Haven House, the best hotel in the city at that time, on the site where now the Hotel Taft is located. In those days of the Yale fence and Yale rushes my father was kept busy repairing clothing ripped by these rushes and I have been told by boss tailors that he could do the mending so well that it cold hardly be found after it was done. My father

got a cataract on one of his eyes when he was about seventy years old and his vision became so impaired that I took him to New York for an operation, but it proved unsuccessful and he lost the sight of one eye. My father and mother both lived to be about 76 years old. I was alone with my mother when she passed on, and I made a sketch of her after she died, but broke down when my sister and brother-in-law arrived at the house.

I forgot to mention that I was sort of a pet with Mrs. Street, the proprietress of the N.H. house and can still taste the wonderful current pie that she used to treat me to once in a while.

Haberle's Ten Commandments

1. Believe that for every problem there is a solution.

2. Keep calm. Tension blocks the flow of thought power. Your brain cannot operate efficiently under stress. Go at your problem easy-like.

3. Don't try to force an answer. Keep your mind relaxed so that the solution will open up and become clear.

4. Assemble all the facts impartially, impersonally and judicially.

5. List these facts on paper. This clarifies your thinking, bringing the various elements into orderly system. You see as well as think. The problem becomes objective, not subjective.

6. Pray about your problem, affirming that God will flash illumination into your mind.

7. Believe in and seek God's guidance on the promise of the 73rd Psalm. "Thou will guide me by thy course."

8. Trust in the faculties of insight and intuition.

9. Go to church and let your subconscious work on the problem as you attune to the mood of worship. Creative spiritual thinking has amazing power to give "right" answers.

10. If you follow these steps faithfully, then the answer that develops in your mind, or comes to pass, is the right answer to your problem.

Believe that spiritual forces as well as medical technique are at work in healing. Pray for the doctor that he may be an open channel of God's healing grace. By our faith you can place your loved one in the flow of divine power. There is healing there. It is also important that spiritual harmony prevail in the family. "If two of you shall agree on earth as touching anything that they shall ask, it shall be done for them of my Father which is in heaven" (Matt. 18–19). Apparently disharmony and disease are akin. All things are possible to them that believeth" (Mark 9). "If ye have faith nothing shall be impossible unto you" (Matt. 17).

1

The Early Years

In 1944 the misfiling of an index card at the Art Institute of Chicago aroused the curiosity of the art historian Alfred Frankenstein, who began his search for the elusive John Haberle of New Haven. In his important book *After the Hunt: William Harnett and Other American Still-Life Painters, 1870–1900,* Frankenstein included an eight-page chapter on Haberle entitled "Entirely with the Brush and with the Naked Eye." He arranged exhibitions of Haberle's work and continued to write on the artist but, sadly, died before he could update the chapter on his favorite artist in the nineteenth-century American "imitative style." Haberle's work first came to the attention of the American art world in 1970, when nine of his pictures, including *The Changes of Time,* were included in the traveling exhibition "The Reality of Appearance: The Trompe l'Oeil Tradition in American Painting," curated by Frankenstein.

The French phrase *trompe l'oeil,* meaning "fool the eye," which describes the precise, illusionistic painting style of Haberle and others, came into use in Europe and America in the late nineteenth century. In America this "fancy" French phrase was applied to precisely rendered European still lifes exhibited by professional art dealers in New York and Boston whose clients were often wealthy, socially ambitious collectors. The term appeared in "elite" publications such as the *New York Times* and *Century Magazine* but not in local newspapers and was not used by collectors or "imitative" painters. Haberle himself referred to his painting style as "artistic mechanics." (The only instance in which trompe l'oeil is used in reference to a Haberle painting is a detail the artist inserted in *Imitation* as a joke: the "printed" newspaper clipping includes the misspelled term "trompe l'oil.") The work of these artists was exhibited and sold in art supply and frame shops, bars, hotel and theater lobbies, and fairs and exhibition halls. The clients were primarily businessmen, who hung the paintings in their offices.

The appearance of objects in trompe l'oeil paintings must be so precise that they fool the eye of the observer and convince him that the painted subject is "the real thing." What is real and what is not real is the puzzle. The painting technique must be impeccable, with no brushstrokes visible to reveal the artist's hand. The scale and color of the painted objects must be the same as the original. The subjects must be arranged in a shallow space, the picture plane must be flat. The most effective subjects are flat objects such as cards, currency, paper

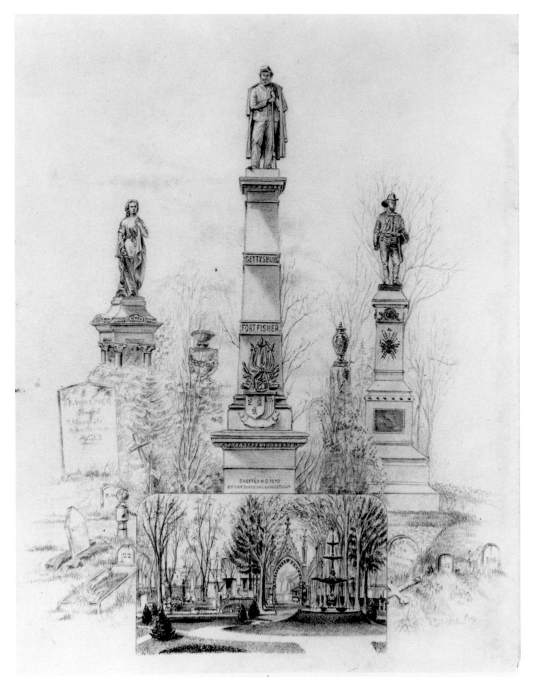

Figure 1. **New Haven Monuments,** 1882. Pencil on paper, 9⅝ x 7⅜ in. Newark Museum, New Jersey, Purchase 1968, Franklin Conklin Jr. Memorial Fund (68.229)

The Staircase Group (1795; Philadelphia Museum of Art), in which his two children appear to be climbing a staircase enclosed by an actual doorframe and projecting steps. (Legend has it that George Washington was so impressed with the illusion that he tipped his hat at the Peale boys.) The vogue for this style began in earnest following the Civil War, when a taste developed for still-life painting compositions both among wealthy collectors and middle-class businessmen. Haberle's career in this demanding technique was brief but brilliant, from 1885 to 1900. William Michael Harnett (1848–1892) is the most famous American artist of this school. His precise still-life compositions of musical instruments, books, smoking materials, and currency probably inspired Haberle to paint his money pictures. While Harnett's compositions demanded the viewer's careful attention, Haberle's were unique in their personal witty details, often carefully hidden and demanding intense scrutiny. According to the journalist Jane Marlin, writing in 1898, Haberle's "imitative work, now that Harnett is dead, is held as the best in the country. . . . Mr. Haberle has certainly created a distinctive place for himself in American art, and his extraordinary work commands large prices."[1]

receipts, clippings, photographs, and so forth. Such paintings are painted illusions, visual artistic jokes.

Trompe l'oeil has its roots in antiquity. After centuries of neglect in Western art, the style reemerged in northern Europe with the invention of oil painting in the fifteenth century. In America the tradition continued in the eighteenth century with works such as Charles Willson Peale's

John Haberle was born in New Haven on May 22, 1856, to German parents who came to America in 1852. His father, George Frederik Haberle, was a tailor, and his mother, Catherine Dorothea Meyer Haberle, a homemaker. In the mid-nineteenth century New Haven was among the most prosperous, rapidly expanding cities in the Northeast. New fortunes were established, old Yankee wealth increased. Factories were being built to manufacture products ranging from firearms to fine furniture. With the establishment of the New York, New Haven, and Hartford railroad, which had a connection to the Midwest, New Haven became a transportation hub. Electricity and telephone exchanges were installed, speeding up communications. The city was home to hundreds of fine craftsmen, including Haberle's father. When George Haberle opened his own tailoring shop near the Yale campus, young John often helped out there after school. Yale faculty and students were clients, and the boy was exposed to the lively intellectual and social life of the university at an early age.

Haberle, whose nickname was Happy, lived with his parents and older sister, Sophia. The Haberles were churchgoing Methodists, and young John dutifully attended Sunday school. The family budget would not permit seminary study, so when Haberle's school days ended in 1870, his father placed him as an apprentice with Punderson and Crisland, one of New Haven's finest printers, producing commercial stationery, bank forms, official documents, and similar products. Haberle learned engraving as well as lithography during his four years at the firm. He may also have worked for Fowler and Hobson, quality engravers and printers known for their fine bookplates.

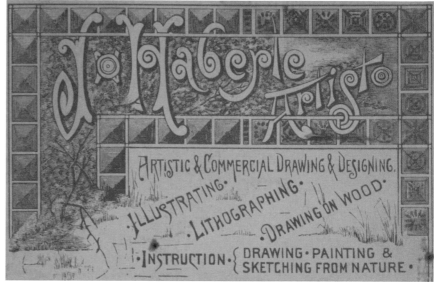

Figure 2. **Haberle's Business Card,** 3 x 5 in. Courtesy Haberle Papers

Haberle produced his first professional work, *New Haven Monuments,* while employed at Punderson and Crisland (fig. 1). The precise pencil drawing of Evergreen Cemetery in New Haven shows three commemorative monuments—to a Civil War soldier, a fireman, and a female figure representing Justice—surrounded by gravestones and shrubbery. A detailed insert of the cemetery entrance shows a flowing fountain, arched gateway, and towering trees.

After three years at Punderson and Crisland, Haberle moved to Montreal, where he took a job as an engraver. While he apparently was involved in the cultural life of Montreal, no work from this period has been located. The only concrete evidence of his Canadian residence aside from his recollections is a worn Canadian postage stamp in *The Changes of Time.*

Haberle designed his distinctive business card about this time (fig. 2). *J. Haberle Artist* is dramatically announced at the top in unique lettering combining curlicues with an Oriental touch. The letters are interwoven within a geometric border enclosing leafy trees. Below, in simpler type, Haberle's various skills are listed: *Artistic & Commercial Drawing & Designing. / Illustrating / Lithographing / Drawing on Wood / Instruction* { *Drawing, Painting & / Sketching from*

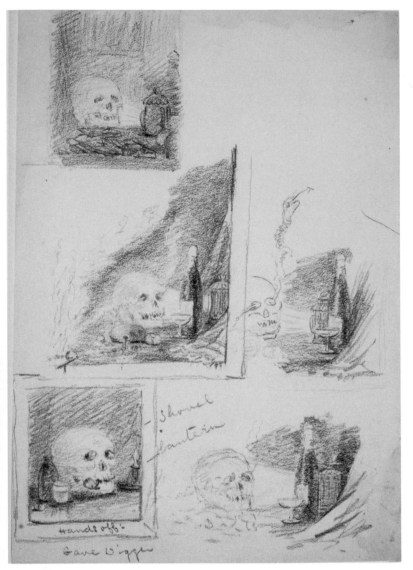

Figure 3. **Skull Sketches.** Graphite on board, 7⅝ x 5⅜ in.
New Britain Museum of American Art, Stephen B. Lawrence Fund
(1969.01.3)

Nature. He most certainly designed the distinctive type. Haberle, the artist, proudly announcing his versatile services, was determined to support himself as an artist.

When Haberle returned to New Haven in 1875, he continued to live with his parents. *Benham's New Haven City Directory and Annual Advertiser* for 1875–76 lists him as a "lithographic engraver" with a studio and home address at 27 Winthrop Avenue.[2] An important professional assignment upon arriving in New Haven was with the famous paleontologist Otheniel Charles Marsh, the founder and curator of Yale's Peabody Museum of Natural History, which

was being organized at the time. Marsh donated his large collection of fossils to the museum. Many of his discoveries and writings had an influence on the teaching of evolution.

Haberle drew illustrations for Marsh's publications such as *Skull Sketches* (fig. 3), an unsigned lithograph printed by Punderson and Crisland. (He was not given credit for the illustration.) Haberle also worked with Marsh on various jobs at the Peabody Museum: as a "preparatory" repairing fossils, arranging specimens in shadow boxes and display cases, painting scenery, and performing other chores. "My best time before I took up the brush was while I was at the Yale Peabody Museum, drawing the old fossils which Professor Marsh was having made for publication," Haberle recalled.[3] A ledger page in the archives at Peabody confirms that Haberle was employed there from September 1876 to April 1877. Before and after those dates, he was probably paid directly by Marsh, a common practice at the time.

According to family tradition, Haberle was a jack-of-all-trades who could fix almost anything. He shared an office at the museum with a member of the paleontology staff in room 9 and continued to work there for several years. His engraved card with his name and office number embellished with a skull and crossbones remains (private collection).

Yellow Canary (fig. 4) was painted about this time. A small, life-size, dead yellow canary dangles upside down against the top of a wood cigar box. A piece of red and white twine supports one leg, while the other dangles loosely, the claw open, a grotesque detail. Although dead, the canary appears fresh; its feathers and down are clean and fluffy. Its beak is closed, but one tiny black eye is still open, as if appraising the viewer.

Haberle organized the watercolor like a small bird-trophy composition, a miniature version of the large hunting pictures produced by Harnett, Alexander Pope, and other contemporary American painters. The body is framed by the oval markings of the cigar manufacturer La Flor de Murias. A semicircular label at the bottom identifies the brand as *La Flor de Murias / Fabrica de Cigarros Puros* (last line incomplete). A semicircular label at the top right—the box has been opened—also identifies the brand and further explains that it was shown at a London exposition in 1873. Two circular details below testify that La Flor de Murias cigars won two gold medals there. Unable to resist a humorous detail, Haberle carefully lettered *Harvard, Princeton and Yale* around the profile of the bearded official on the left medallion.

Yellow Canary is signed along the left edge of the paper *JOHN HABERLE, NEW HAVEN, CONNECTICUT 1883*. While it is his only known watercolor, there must be others, judging by the expert technique. The artist would include similar cigar box details in other paintings such as *A Favorite* and *A Bachelor's Drawer*.

Compositions of the tops of cigar boxes were popular in nineteenth-century European still-life painting. Haberle, a smoker, no doubt saw such boxes at the local tobacco shops. Smoking was very much in vogue at the time, and Haberle included a pipe, cigarette and cigar stubs, and a detail of a man smoking a cigarette in some of his paintings. As Theodore Stebbins observed:

> Another of the trompe l'oeil specialists, John Haberle (1853–1933) of New Haven, appears to have made just one watercolor, but

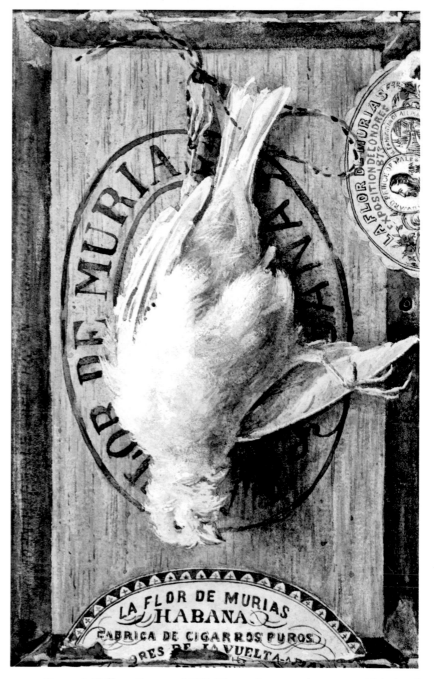

Figure 4. **Yellow Canary,** 1883. Watercolor, gouache, pen and ink, brush and ink, 10³⁄₁₆ x 6⁷⁄₈ in. Yale University Art Gallery, New Haven, Gherardi Davis Fund

it is masterful indeed. Though the transparent medium and the illusionist, hard-edged aim of this painter would seem unlikely partners, Haberle succeeds in rendering a life-size dead canary which hangs on an old cigar-box cover: his handling is minute, essentially invisible—labels, textures of the wood, even the bird, are convincing—and he resorts only rarely to body color.[4]

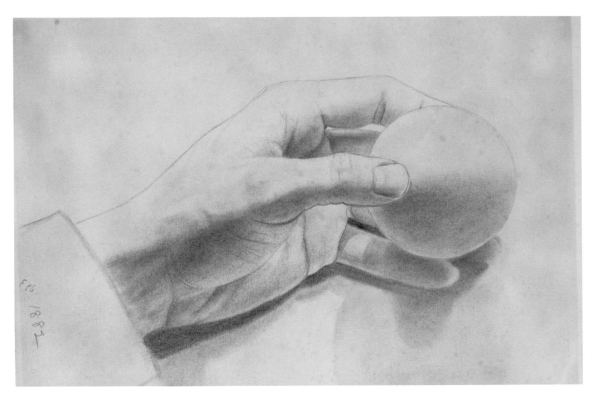

Figure 5. **Left Hand Holding a Ball,** 1882. Graphite on paper, 7 x 9¾ in. New Britain Museum of American Art, Gift of Gertrude Grace Sill (2009.107)

Seventeenth-century Dutch painters excelled at trompe l'oeil still lifes. Their subject matter ranged from tabletop still lifes of food, game, flowers, books, and decorative objects to compositions of paintings themselves. These pictures, prized for their beauty and their amazing deception, were purchased by wealthy collectors throughout Europe. Harnett, who had studied in Munich and Paris, was the main link between this European still-life tradition and nineteenth-century American painting. Haberle appears to have had some knowledge of this European tradition and perhaps of Harnett's work when he painted *Yellow Canary.*

Left Hand Holding a Ball (fig. 5), dated February 1882, is testament to the artist's skill as a draftsman. A light source from top left illuminates the inside of his left hand and clearly defines the palm and thumb, which softly grasps a ball. The light gives solidity to the cuff and other details as do the soft shadows cast beneath the wrist, fingers, and ball. According to Marlin, as the artist was "too poor to buy plaster casts or hire models, he used his own left arm, hand, or foot, braced against the wall, varying the position and making excellent sketches."[5]

Haberle's social and professional sphere expanded when he became a founding member of the New Haven Sketch Club in 1883. Sketch clubs were popular social diversions for men interested in the visual arts. Members were often important collectors as well as amateur artists with a specific interest in drawing and sketching. Haberle's membership in the club confirmed his professional status in local art circles. With this wider exposure and the completion of *That's Me!* (see Prologue) he decided to become a fine artist and applied to the National Academy of Design in New York, America's most prestigious and competitive art school at the time, a bastion of conservative training based on the curriculum of the École des Beaux-Arts in Paris.

Haberle was admitted to the Academy in 1884. He had carefully saved to afford to study at the Academy and while there probably lived in a modest

boardinghouse. He worked hard at his classes and explored the city in his free time. With his curious mind and sharp eye, he certainly visited art galleries and museums, read the newspapers, and absorbed the cosmopolitan lifestyle. A lover of music—he was an amateur tenor and a violinist—Haberle probably attended concerts, vaudeville shows, and theatrical performances when he could afford it.

Life drawing was a basic course at the Academy, and there are numerous signed and dated Haberle drawings from these classes; most, such as *Woman with a Riding Crop* (fig. 6), are competent. They do not, however, reveal any of the unique vitality of *That's Me!* During vacations Haberle returned to New Haven, probably by railroad, worked hard in his studio at whatever commissions came his way, and began perfecting his new "imitative" oil paint technique. In 1885, at the end of the spring term at the Academy, Haberle exhibited two oils, *A Five Dollar Bill* and *Editorial Board* (both whereabouts unknown).

Still-life paintings showing currency originated in Europe, primarily in the Netherlands, during the fifteenth and sixteenth centuries. At the time, Flanders (now northern France and Belgium) was a powerful commercial center, with the rich port city of Bruges as its capital. Painters there and in other small cities in the region created such still-life paintings using the new oil technique, which allowed them greater flexibility and the ability to produce minute detail. While Netherlandish artists often depicted coins, the common currency, in their compositions, the almighty dollar dominated the

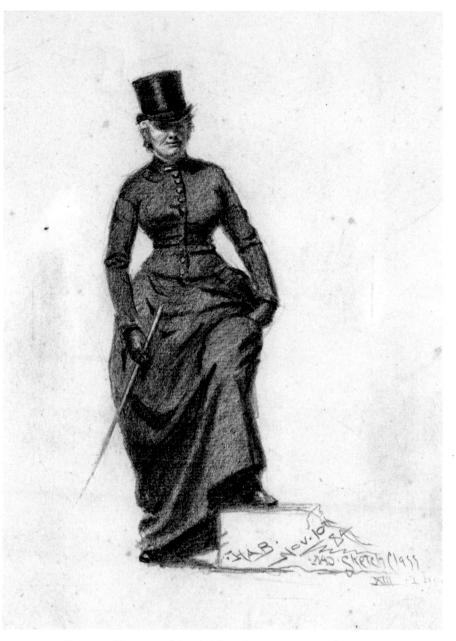

Figure 6. ***Woman with a Riding Crop,*** 1884. Pencil on paper, 9½ x 7½ in. Yale University Art Gallery, New Haven, The Mabel Brady Garvan Fund Collection

"currency school" of American trompe l'oeil paintings in the nineteenth century.

Before the Civil War, the most popular subjects for American still-life paintings were flowers, fruit and other foods, bric-a-brac, musical instruments, and dead game. Haberle belonged to the generation that came to maturity during the post Civil War years of the 1870s, when "in fact and fancy, money seemed to be on everyone's mind. Mark Twain and Charles Dudley Warner's novel *The Gilded*

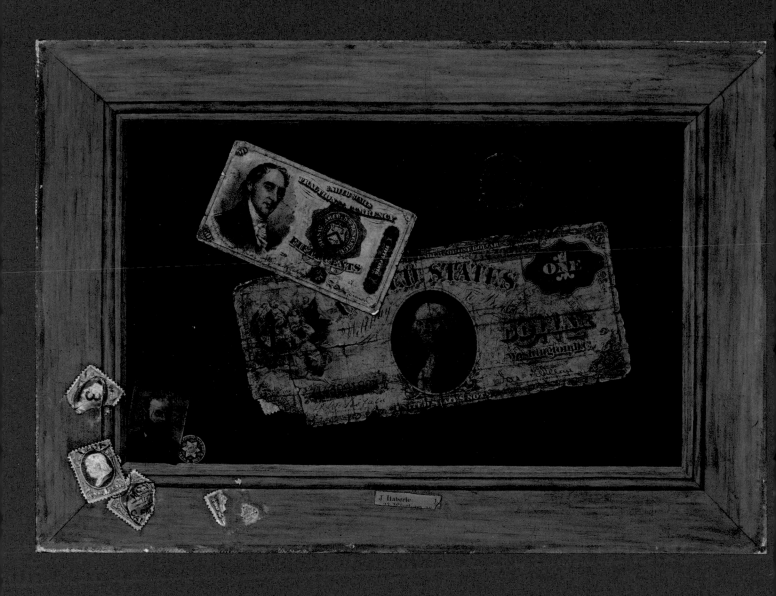

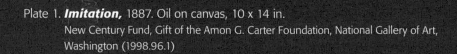

Plate 1. **Imitation,** 1887. Oil on canvas, 10 x 14 in.
New Century Fund, Gift of the Amon G. Carter Foundation, National Gallery of Art,
Washington (1998.96.1)

Age (1873) gave its name to these years of greed, consumption, and money making. Against such a backdrop, it is no wonder that the observant Harnett began in 1877 to fill his foregrounds with single five-dollar bills, gold and silver coins, and rolls of greenbacks."[6]

Harnett's *Five Dollar Bill* (1877; Philadelphia Museum of Art) is the first known nineteenth-century trompe l'oeil representation of American paper currency. The artist explained his definition of still-life painting, "In painting from still life I do not closely imitate nature. Many points I leave out and many I add. Some models are only suggestions."[7]

In 1886 Harnett was approached by the United States Secret Service in New York City and warned about counterfeiting—a charge based on two small oil paintings of currency hanging on the wall of Stewart's, a popular saloon near City Hall, in downtown Manhattan. He was exonerated but told not to paint any further currency compositions, and he did not do so. Harnett showed his work regularly at the National Academy so Haberle was no doubt familiar with it.

Haberle's currency painting *Five Dollar Bill* was exhibited at the National Academy in 1885 and sold to the prominent collector Thomas Clarke, who also owned paintings by Harnett. With fear and trepidation Haberle submitted a more complicated currency painting *Imitation* (pl. 1) to the National Academy fall exhibition in 1887. The catalogue described the work: "*Imitation* by John Haberle is one of these clever pieces of artistic mechanism, showing an old greenback, a tintype and other things which have lately become so popular."[8]

Haberle composed *Imitation* using ordinary objects readily available to him. At the center is a well-worn one-dollar United States Treasury note set on an angle with the image of George Washington clearly identifiable as are the other "printed" details of the bill. None of the bills is new; they are tattered and torn, their edges frayed, their surfaces rough and dirty. Beneath the lower edge of the dollar, which is folded back, is the tiny corner of a postage stamp bordered by its perforated edge. Above the greenback, resting at an opposite angle, is a smaller, fresher fifty-cent fractional note (Harnett had used both of these notes in his currency compositions). Above the one-dollar bill, delicately balanced and defying gravity, is a worn copper 1893 penny. A smaller Colonial shilling is "wedged" into the painted pine frame at lower left, next to the Haberle tintype self-portrait.

All these objects are set against a black background with a subtle simulated wood grain. Three canceled and worn postage stamps with fragments of a fourth are attached to the lower left edge of the painted frame. In the center of the frame is a tiny yellow scrap of paper printed *J. Haberle.* Thus, the artist signed *Imitation* three times: once on the printed scrap of paper, once with the tintype portrait, and once on the upper right corner of the black background. This signature, *J. Haberle New Haven, Ct. / 1887*, is executed in the "carved" manner, as if scraped into the wood board with a knife. (Harnett used this technique in several of his compositions set on "painted" wood backgrounds.) The title itself, *Imitation*, confirms that Haberle had no intention of producing a forgery, of making the painted currency appear to be the "real thing."

When the picture was exhibited at the National Academy, it caught the attention of a *New York Evening Post* reporter, who described it condescendingly: "A small canvas, which without being in any sense a work of art, is a remarkable

piece of imitation of natural objects and a most deceptive trompe l'oil."[9] The writer's misspelling of l'oeil, whether deliberate or not, might have rankled or perhaps amused Haberle.

Thomas Clarke purchased *Imitation* for $350. Haberle must have been elated.

In 1888 Clarke wrote to W. M. R. French, a friend and New York art dealer: "*Imitation* which created so much talk in the National Academy of Design last fall had been studied by William Michael Harnett, who said that he had never seen such reproduction anywhere . . . no artist has yet equaled Haberle in imitation of bills and stamps."[10]

Imitation was framed in the Victorian style, presumably by Clarke, in a deep velvet-lined shadow box set off with an elaborately carved gilt frame. Clarke's seal is attached to the lower center edge. A label on the back of the shadow box identifies the framer as J. H. Lewis & Sons, Fine Gold Picture Frames, 1323 Broadway, New York.

In 1888 *Imitation* was exhibited with other works from Clarke's collection at James D. Gill's Stationery and Fine Art Store in Springfield, the leading gallery for American paintings in prosperous central New England. Gill was an admirer of Haberle's work and would continue to exhibit his paintings until the turn of the century. According to Richard Mühlberger, former director of the Springfield Museum of Fine Arts:

> James D. Gill (1849–1937), a western Massachusetts native, ran a very successful art gallery in Springfield from 1878 to 1921, which featured an annual exhibition in February of "the best work of the best American painters" as he himself described it. The *New York Collector* stated in 1891 that Gill's

gallery had become, "not only a center of New England Art pilgrimage, but an attraction for visitors from this city [New York], but from Brooklyn, and Philadelphia. The Gill exhibitors, indeed, a miniature academy, but a higher standard as regards the work shown."[11]

The Pennsylvania Academy of the Fine Arts in Philadelphia exhibited "The Thomas B. Clarke Collection of American Pictures" from October 15 to November 28, 1891. *Imitation* was included, giving Haberle's work good exposure in Philadelphia.

After Clarke's death, his collection sold in February 1899 at American Art Galleries, New York. *Imitation* was listed as lot 36 in the sale catalogue, which states:

> Mr. Haberle is a native of Connecticut and a pupil of the National Academy of Design. His small still-life panels have created popular interest in the art institutions in this country. The work is an assortment of familiar objects—bank notes, fractional currency, coins, postage stamps, etc. painted with microscopic detail and deceptive imitativeness. The execution is remarkably skillful. Signed as a printed label at the bottom.[12]

Imitation was sold to H. Staples Potter of Boston for $150. It subsequently was acquired by Robert M. Snyder of Kansas City, Missouri, and descended in the Snyder family. *Imitation,* still resting in its elaborate shadow box frame with Clarke's seal attached, resurfaced in 1987 and was sold at Sotheby's, New York, in May 1987; it is now at the National Gallery of Art, Washington, D.C.

Small Change (pl. 2) is another Haberle currency painting, dated 1887, the same year as *Imitation.* It

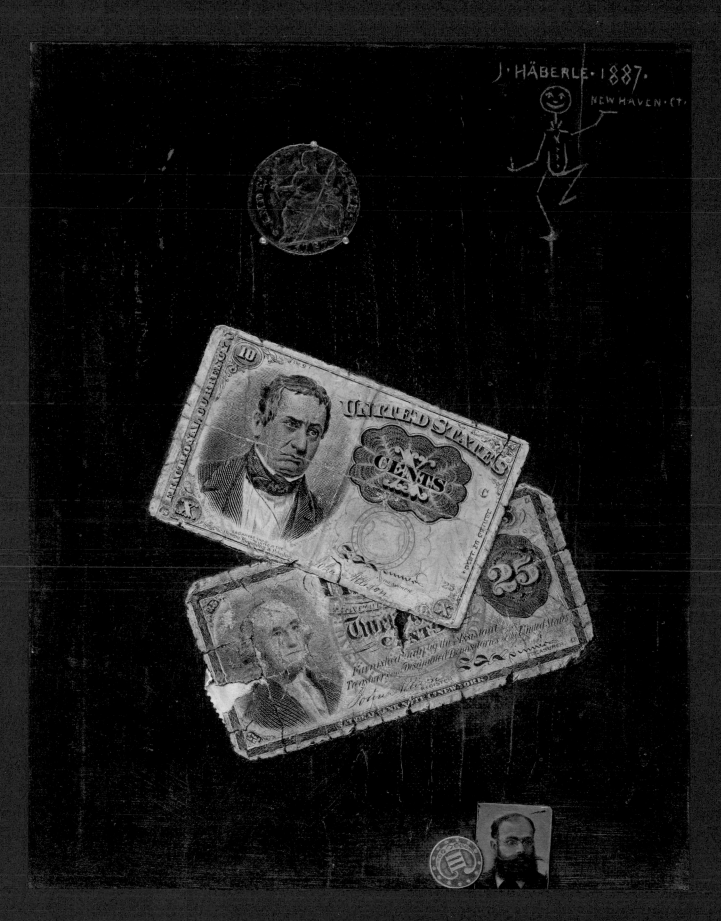

Plate 2. **Small Change,** 1887. Oil on canvas, 9¼ x 7¼ in.
Courtesy Crystal Bridges Museum of American Art, Bentonville, Ark.

Figure 7. ***Fresh Roasted: Peanuts,*** 1887. Oil on canvas, 8¾ x 20 in.
Yale University Art Gallery, New Haven, Gift of H. J. Heinz II Charitable and Family Trust (1979.8)

recently surfaced at an auction in Canada, where it had been in the collection of the same family for many years. There is no record of this painting in any Haberle archives or research materials. The original owner of *Small Change* was an American businessman who lived in Canada.

Both *Imitation* and *Small Change* have the same type of signature—an angular *J. Haberle* "carved" at the upper right corner of the canvas and below, *New Haven, CT.* This type of "carved" signature can be seen in several Haberle paintings dating after 1887. To further confirm his identity, Haberle included a self-portrait in the form of a tintype at the bottom of *Small Change*, a device he used in *Imitation* and would use in future paintings. Haberle had a healthy professional ego and always identified his work, though the form of his signature might change. A grinning red jumping jack, top right, adds a lively note to an otherwise static composition.

The overall effect of *Small Change* is remarkably fresh and contemporary. It is unlike most Haberle paintings, which tend to be cluttered with small objects, dark in tone, and difficult to decipher. (His paintings were sometimes called "puzzle pictures.") *Small Change* is composed of only five objects: a large United States silver coin bearing a symbol of Justice, a ten-cent United States paper certificate resting over a twenty-five-cent paper certificate, and a small metal token wedged next to Haberle's tintype image. (Harnett painted two versions of a ten-cent bill in 1879, *Shinplaster* [Philadelphia Museum of Art] and *Shinplaster with Exhibition Label* [private collection], which may have been an inspiration to Haberle.) Very possibly the original title of *Small Change* is hidden in the relationship between the objects— Haberle usually gave his paintings specific titles relating to the general subject matter.

Haberle carefully built up the edges of the large coin, the token, and the currency with a delicate edge of gesso to emphasize their three-dimensionality. It is hardly visible to the naked eye and can best be seen in a raking light with a magnifying glass. Haberle used this technique in *Imitation* and would use it in future paintings. The artist used a number I sable brush for such fine details.

Small Change is in its original nineteenth-century gold frame composed of four different moldings of stylized floral design in excellent condition, indicating that it may have been enclosed in a shadow box, like *Imitation*. The paper certificates were fractional currency issued by the Federal Government during the Civil War. This paper currency was used as a substitute for metal coins, which could not be manufactured due to a shortage of metal. Contemporary slang for these notes was "shinplasters" since they were of such little value that they were used to bind up scraped shins—like a nineteenth-century Band-Aid.

Fresh Roasted: Peanuts (fig. 7) was Haberle's contribution to the New Haven Sketch Club's December exhibition, held from December 12 to 17, 1887, at the club's headquarters on Crown Street in downtown New Haven. The invitation reads: "All are invited to attend at their room #44 Hoadley Building on Crown Street, 2–9 pm. It consists of Paintings, Studies and Sketches by club members. The object of the exhibition is to call public attention to the efforts now being made by the club to create greater interest in Art in our community."[13] Other exhibitors included the well-known painters J. F. Weir of the Yale Art School and Emmanuel Leutze. In December 1887 the *New York Evening Post* reported, "Mr. Haberle, well-known because of the work he produces, being deceptive in the extreme, has one instructive piece, a representation of still-life, a few ground nuts and an old tin cup. One of the nuts seems to have fallen out of the frame."[14]

Peanuts, brought to the United States by African slaves, became a major crop in the South and were brought back north by soldiers returning home during the Civil War. A novelty, they were sold in bulk in grocery stores and attracted the attention of many still-life painters in the late nineteenth century such as Peto, Jefferson David Chalfant, and S. S. David. With his interest in the commonplace, the lowly peanut was an appealing and appropriate subject for Haberle.

Typically, in *Fresh Roasted: Peanuts* nothing is quite perfect: there is a "homemade" quality about the uneven edges of the bin, the glass is shattered, and a nail is missing from the front molding. The picture is technically uneven, somewhat akin to folk art. Because of their rounded shape, peanuts do not readily lend themselves to trompe l'oeil treatment. In order to make them flatter, Haberle placed the nuts in a grocery bin with a shattered front glass panel. One of the oldest technical tricks in trompe l'oeil painting is to paint flat objects under broken glass. The jumble of nuts is soft and spongy, not truly illusionistic. The tin can, while flattened at the bottom to serve as a scoop, is not convincingly tubular and is also a difficult object for the trompe l'oeil style. As in no other Haberle painting, the texture of the canvas is evident—in the thinly painted area of the back of the bin.

The work is signed *J.H.* embellished with a smiley face at the lower left on the black molding of the bin. *J. Haberle—1887* is clearly painted in his "carved" style in the upper left corner of the inner frame. *New Haven* is painted above the hinge at the left. *Fresh Roasted: Peanuts* is the only known painting by Haberle with food as its main subject. Food was, however, a popular subject with other American still-life painters and their patrons in this period.

In 1887 or 1888 Haberle eloped to New York City with Sarah Emack, a local New Haven girl fourteen years his junior. Haberle commented wryly in his autobiography: "To enter wedlock he would have neither priest, minister or rabbi . . . a justice of the peace was good enough for holy matrimony."[15]

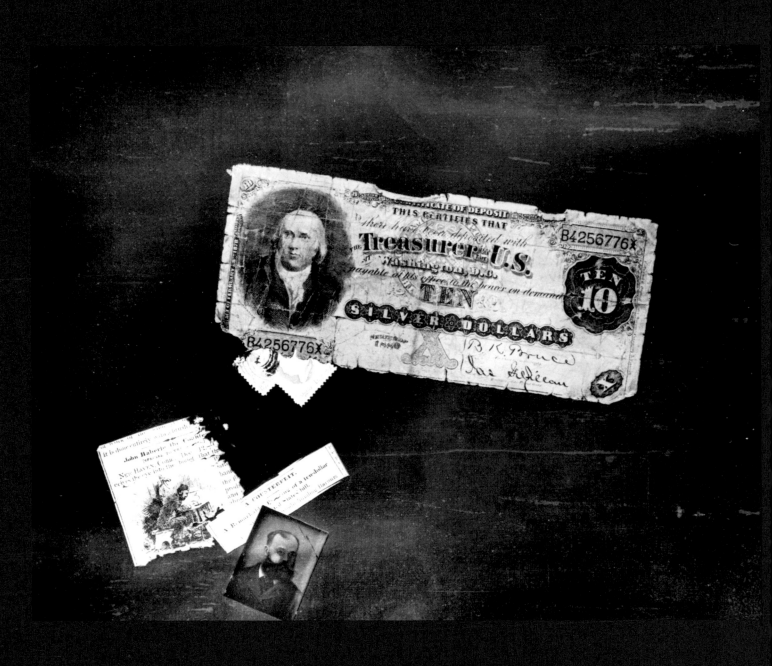

Plate 3. **Reproduction,** 1888. Oil on canvas, 10 x 14 in.
Private collection

2

Fame and National Attention

The years 1887 to 1890 were prolific ones for Haberle. Now a married man and a successful artist with money in the bank, he purchased a small parcel of land at 81 Cove Street in the rural Morris Cove section of New Haven, with a fine view of the New Haven harbor and the Long Island Sound beyond. He and his wife built a simple two-story clapboard cottage with a pitched roof and a front porch. The typical New England house was surrounded by lovely gardens and decorated with cement animal sculptures made by Haberle. At the other end of the lot, on Lighthouse Road, Haberle built a one-room studio. As he told Vera, "With the little money I had we built the house we are now living in. It would have been better by $1000 if the money I put into a building loan association had matured instead of manured at the time that we built."[1]

With the resounding success of *Imitation* in 1887, Haberle continued to produce variations on the currency theme for the next few years. He may also have continued to work with Professor Marsh at the Peabody Museum of Natural History at Yale University.

Reproduction (pl. 3) is another complicated currency painting, probably completed in 1888. It was shown at the Art Institute of Chicago's first annual exhibition of American paintings, held from May through July of that year, and listed in the catalogue as lot 230 for sale for $350. At the center of *Reproduction* is a well-worn ten-silver-dollar paper certificate of deposit of 1880 issued by the Treasurer of the United States. It contains a portrait of Treasury Secretary Robert Morris, the certificate number, and all the other minute details of the real certificate.

Tucked under the lower left corner of the certificate are two one-cent stamps. The top blue stamp appears new, its perforations crisp. In contrast, the stamp beneath is faded, torn, and cancelled. (Perhaps Haberle had seen Jefferson Chalfant's *Which Is Which?* [whereabouts unknown], probably painted about the same time. It also shows a pair of two-cent stamps—one an actual stamp pasted to the canvas, the other painted.)

The two newspaper clippings in *Reproduction* and the tintype self-portrait act as a signature. The text in the clippings, rendered with such precision that it is clearly legible, refers directly to Haberle. The larger clipping bears an illustration of a man seated at a table working by lamplight, a dagger stuck into the wall behind his head—a detail that may refer to Harnett's chastisement arrest for forgery. The first line reads: *of work of the kind that.* The second line claims: *It is done entirely with a brush.* The headline below states: *John Haberle the Counter[feiter].* The next

line reads: *[Special to the World]* and below: *New Haven, Conn. Dec. 12 / [de]ceives the into the belief that.* This right edge of the clipping is frayed, with two tiny scraps resting at right, while the top and left edges of the clipping are neatly cut. The small clipping overlapping at bottom right is on a whiter paper and in a different type. It leads with the small caption: *A Counterfeit.* The next line reads: *A remarkable Painting of a ten-dollar / sil[ver Uni]ted States' bill.* The bottom line, partially obscured by Haberle's portrait, states: *A . . . that would humbug Barnum*—a reference to the great showman and circus impresario P. T. Barnum, who had fooled the American public into believing that the three-headed monkeys, dragons' teeth, and other such impossibilities displayed in his museum were real. Could the missing word be "deception"?

The two clippings refer to counterfeiting and Haberle's possible brush with the law, according to family tradition. The originals of the clippings in every known Haberle painting are preserved in the Cove Street house, carefully pasted to cardboard mounts. This painted clipping datelined December 12 plainly imitates the typographical style that the New York *World* followed between 1883 and 1888, but the *World* did not use half-column cuts at the time and no such story was ever printed by that newspaper. That is, of course, as it should be: a newspaper article about painted counterfeits ought itself to be a counterfeit. One clipping preserved in the house states: "The artist painted bank bills so accurately that the Secret Service men compelled him to desist."[2]

An item about *Reproduction* in the *Chicago Tribune* in July 1888 reflects the reaction of a refined museum visitor, not a tired businessman relaxing in a lively saloon.

> One observer, disgusted that so much work should be wasted for results so insignificant,

said to a trustee standing by: "I should think you would not have consented to putting those things in there. It was bad enough to paint a dollar bill." Even a second examination failed to convince her that they were not apart from the painting. But everything under the glass is brushwork. "It is a pity they spent such time and ability upon such worthlessness."[3]

At first glace, it appears that the paint is actually peeling off the background of *Reproduction*. Upon closer inspection, this illusion proves false: the peeling, chipped areas of the surface, painted to resemble a brownish red board, are painted. Thus, the "disintegrating" background is as a deliberate a deception as the torn currency, cancelled stamps, and newspaper clippings.

Thomas B. Clarke sent a letter of reference concerning Haberle and his work to W. M. R. French, director of the Art Institute of Chicago. The letter, dated July 12, 1888, sent from Clarke's New York office, reads:

> Your line received. The *Reproduction* I can tell you about. Some time ago I bought this picture for a gentleman in this city and he put a handsome frame upon it. I got it directly from Haberle and I have never doubted the work. In my collection I have the *Imitation* which created so much talk in the National Academy of Design last fall, I gave $350 for it. It is a similar subject to *Reproduction*.
>
> I regard the work of Mr. Haberle as remarkable and curious. He told me that he painted my picture [*Imitation*] and the one in your exhibition with a number one sable brush. The artist is a former pupil of our Academy here, and is highly esteemed by those who know him in this city

and in New Haven. No artist has yet equaled Haberle in imitating bills and stamps. W. M. Harnett, the still-life painter, studied the picture named *Reproduction*, and said that he had never seen such reproduction anywhere.

Sincerely,
Thomas B. Clarke[4]

From this letter, it appears that Clarke purchased *Reproduction* from Haberle then sold it to another collector who sent it to the Art Institute of Chicago's 1888 annual.

The following day, July 13, 1888, Haberle replied to French in a letter, datelined New Haven:

Dear Sir:

I have read your letter referring to picture called *Reproduction.* Which must be the $10 note—stamps re—if so I can only say that it was painted as any artist would (or ought to) paint a picture. This picture was painted entirely with the brush in oil colors—with the naked eye—without any photographic aid as many may think. This I will cheerfully sign and take oath to the same before a commissioner of the Superior Court of Cleveland, O. If Mr. J. Wade will take the trouble to examine with strong glass, I think he will be satisfied that it is all right.

Yours faithfully, John Haberle

Would be glad to hear from Mr. W. personally[5]

These references must have satisfied Mr. Wade of Cleveland, since he purchased *Reproduction* and it remained in the Wade family for almost a century. The painting was originally in a deep, heavy gold frame, perhaps a shadow box. It was later reframed in a simpler style.

Haberle's next currency painting, *U.S.A.* (pl. 4), brought his work to the attention of collectors and art lovers in the Chicago area. It was exhibited at the second annual of the Art Institute of Chicago, in June and July 1889. *U.S.A.* generated headlines in Chicago newspapers and created a scandal in art circles.

With its sarcastic title, *U.S.A.* (also known at the time as *The Chicago Bill Picture*) is composed of the reverse of a tattered one-dollar bill placed over a torn ten-dollar bill. *United States of America* is emblazoned in crossbars in the center of the top bill. The upper right corner is mended with a cancelled, worn one-cent Benjamin Franklin stamp. The torn lower left corner is mended with transparent tape through which the engraved letters are clearly legible, providing one of Haberle's most subtle trompe l'oeil effects. Beneath it, on a similar angle as the ten-dollar bill, is a newspaper clipping praising *Imitation* (this clipping also appears in *Can You Break a Five?*).

Haberle's use of the reverse side of the one-dollar bill was not without irony, nor was the title *U.S.A.* His choice of the one-dollar bill as a symbol for America may represent his opinion of the state of the country in 1888. Clearly legible on the right side of the bill is the United States government warning against imitation of federal currency: *Counterfeiting or altering this note, or passing any false or counterfeit plate or impression of it, or any paper made in imitation of the paper on which it is printed, is punishable by $5,000 or fifteen years of hard labor or both.*

Alfred Frankenstein observed, "[The painting] . . . bore the magnificently scornful and sarcastic title, *U.S.A.* . . . The dollar bill is seen face down, so that it flaunts, by way of a public announcement of unrepentance, the full and complete text of the official warning against the imitation of Federal currency which was then printed on the backs of all United States notes."[6]

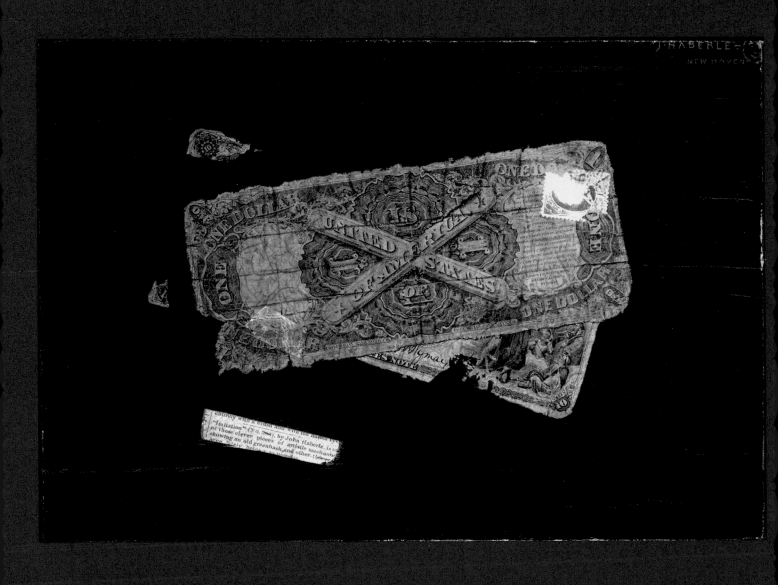

Plate 4. **U.S.A. (The Chicago Bill Picture),** ca. 1889. Oil on canvas, 8½ x 12 in.

Indianapolis Museum of Art, Gift of Paul and Ruth Buchanan (2002.225)

Two letters to Haberle, one from Clarke and the other from French, vividly describe the events surrounding the exhibition of *U.S.A.* at the Art Institute. (Apparently the picture still belonged to Haberle in June 1889, when he submitted it.) On stationery from Clarke & King, 215 Church Street, New York, N.Y., Clarke's letter reads:

Mr. John Haberle,

My dear Sir, the *Chicago Inter-Ocean*, a journal of much repute prints the following: "There is fraud hanging on the Institute walls concerning which it is not pleasant to speak. It is that alleged still life by Haberle, supposed by some to be a painting of money. A $1 bill and the fragment of a $10 note has been pasted on canvas covered by a thick scumble of paint, and further manipulated to give it a painty appearance. A glass has been put over the "painting" since the writer of this picked loose the edge of the bill. That the management of the Art Institute hang this kind of "art" even though it were genuine is to be regretted, but to lend itself to such a fraud, whether unwittingly or not, is shameful."

Can you make an answer to this, or rather do you care to? My friend James W. Wellsworth, a director of the Institute is willing to wage money that the art critic is absolutely in error and that the corner of the [illegible] never has been lifted from the canvas. I suppose you must have sent the picture to the exhibition, as I have never seen it.

Sincerely yours,
Thomas B. Clarke[7]

Three days later, on June 21, 1889, a letter on stationery from the Director's Office, Art Institute of Chicago, was written to Haberle:

Dear Mr. Haberle:

Your letter of June 19 and telegram of last night are received. I have not seen nor heard of the *Inter-Ocean* article, but will have my man try to look it up. I will do nothing about the picture without appraising you. I was absent during the preparation for the exhibition, and do not at the moment know whether the picture is yours or Mr. Clarke's, though of course we have the record. (My gallery man says he has put a glass over the picture.)

Yours,
W. M. R. French[8]

These letters, from prominent men in the field of American art, indicate the significance of the accusations of fraud against Haberle as well as his importance as an American painter. In painting *U.S.A.*, he was deliberately defying the federal authorities, who had arrested Harnett for forgery and admonished Haberle "to cease and desist" producing painted images of American currency. *U.S.A.* was the picture that brought Haberle his greatest public attention.

On July 3, 1889, the *Chicago Daily News* reported:

Critics Called to Decide:
A Newspaper Critic Pronounced a Picture a Fraud, but Retracts

The Art Institute was yesterday afternoon the scene of a delicate and interesting experiment, upon the result of which a personal reputation may be said to have rested and certainly upon

which the merit of a work of presumptive art did depend.

For some days there has hung in the main gallery of the Institute a small picture set down as a still life study under the title *Imitation.* The design was two worn pieces of paper money—a $1 bill, creased and stained but sound and whole, and the ragged remnant of a $10 bill, disposed one across the other, with the $1 bill on top. Glued to one corner of the upper bill was a torn blue I-cent postage stamp with the familiar profile of Ben Franklin, and to the left and below was pasted a small, irregular clipping of a three line newspaper notice of the picture. Few were ready to believe it more than a clever bit of scrap-work, and Mr. Bartlett, the art critic of a blanket-sheet, wrote of it: "There is a fraud hanging on the Institute walls. . . ." Though as far distant as New Haven, Conn., the artist, Mr. John Haberle, was reached, and roused by the critical critique, and he made it the occasion of a hasty journey hither. He asserted that the work in all it details was the simple product of paint and skill by the means of art's legitimate tools alone, and he invited a searching scrutiny of the subject.

Several art experts and newspaper men were there. The small canvas was taken from its frame, and it is little enough to say the picture was "lifelike," and the tests were applied. The lens was used, the paint was rubbed off, and the whole ingenious design proved really a work of imitative art, and a most excellent one. Both bills were painted, the stamp was painted, and the newspaper clipping was painted.

Mr. Bartlett acknowledged his error and said:

That same work is fraudulently done in Chicago, and I was readily disposed to believe this of the same character. Our local fraud begins by pasting a genuine bill with mastic varnish upon a sheet of gelatine, cut away with acids, leaving the imprint perfect. Such work offers merely a clever example of manipulative skill, while Haberle's picture is a true work of imitative art.[9]

The author of this story incorrectly referred to *U.S.A.* as *Imitation*—an error made by referring to the newspaper clipping included in *U.S.A.* that mentions *Imitation.* It is also interesting to note the reporter's explanation of how local Chicago artists created currency paintings by manipulating actual currency and gluing it to a canvas backing. (Examples of such nineteenth-century "currency collages" occasionally appear on the market.)

Nine years later Jane Marlin reported on the Chicago incident in the *Illustrated American.*[10] In the article, she misidentified *U.S.A.* as *Imitation.* Haberle himself, in the interview, also confused *U.S.A.* with *Imitation,* which was never exhibited in Chicago.

Also on July 3, 1889, a later edition of a Chicago newspaper reported:

True Artistic Goal: Genius Seeking the Ideally Beautiful in Preference to Gain a Dispute as to the Genuineness of a Picture at the Art Institute Leads to a Pertinent Inquiry as to What Constitutes True Art

Mr. John Haberle, who painted the dollar bill picture shown at the exhibition of American oil painting which closed a week ago at The Art Institute, came all the way from New Haven last week to prove that his picture was

not a fraud. One art critic had declared that the painting was not a combination of colors and oils, but a genuine dollar bill, bits of a ten-dollar bill, and a one cent postage stamp pasted to the surface of a piece of canvas and dexterously varnished over. The critic even went so far as to state that before the painting was protected by glass he had succeeded in picking a corner of the bill free from the canvas.

Mr. Haberle, feeling that such a charge affected not only his reputation as a painter, but his honor as a man, took the long journey to disprove it. He had no difficulty in doing so. Taking the picture out of the frame, he submitted it to tests which must have convinced even the most prejudiced of its genuineness. But a careful observer needed no such proof. The picture is as accurate an imitation of greenbacks as paint and brushes can make, but even without the aid of a magnifying glass the eye can detect the absence of that elaborate scroll-work of fine lines which is engraved on every piece of paper currency. The effect of these lines is given. At a short distance the reproduction seems perfect; but the lines themselves are not there. If they were, that fact would be strong proof that the picture was fraudulent, for paint could not possibly reproduce them. But that discerns further proof; the presence of paint is everywhere manifest. Having established the genuineness of his work, Mr. Haberle may well regard it as a compliment to the perfection of his imitative skill that a professional critic should have considered the work no imitation, but the real article. How the critic could have loosened from the

canvas a corner of the bill which was not there it may be possible for him to explain.[11]

Four days later, on July 7, 1889, Mr. Bartlett, the critic of the *Chicago Inter-Ocean* who had accused Haberle of forgery and claimed he had picked at the corner of the bill, wrote the following apology:

In an account of The Art Institute exhibition a statement was made concerning the character of one of John Haberle's paintings which did that gentleman a great injustice. It was to the effect that his painting, a still-life representation of bank notes, was made by rubbing a genuine note so that but little remained but the pigment and then pasting it on the canvas and painting over it, a practice that is by no means uncommon in this class of work. As Mr. Haberle's still-life was not a work of this character he very justly felt much aggrieved and in proof of honesty of his execution he voluntarily submitted his painting to the most severe tests which could be devised and came off triumphant. Just how the writer of the notice came to be deceived is not of particular moment for he recognizes the fact that he had no business to be affected by the statements of others, and had nothing to plead in justification. The deception, however, does not appear when one sees the painting. A record of the dispute over the genuineness of Mr. Haberle's painting would prove amusing reading. Better informed and more astute men than the writer of the notice have been taken in, notably Eastman Johnson, dean of American figure and genre painters who had a very serious time proving to himself that Mr. Haberle's paintings were what they purported to be. One gentleman, prominent in Chicago art matters,

although present at the test and being allowed to dig at the painting with his knife, still left with doubts as to its genuineness. The artist not only copies color and appearances with great fidelity, but also reproduces the form and texture of the bill. This is done by the combined use of palette, knife, brush and scraping tool. The bills were in places so built out in the print to imitate an edge that had become detached that people were able to catch a fingernail under what appeared to be the paper. The sharp lines, which would have been impossible with a brush, were made by using the scraper, removing the dark colored surface paint until the light groundwork appeared, it being analogous to engraving. This Mr. Haberle was able to do with great fidelity, having been an engraver during a period of ten years of his life.[12]

The *New Haven Palladium* reported on the Chicago incident on July 2, basing its report primarily on articles the *Chicago Inter-Ocean* report.

Remarkably True to Nature: John Haberle Paints a One Dollar Bill Perfectly

John Haberle, an artist residing at 27 Winthrop Avenue, has recently performed a really wonderful thing with his paint brush. It is a representation of an old one-dollar bill, pasted over a ten-dollar bill, on canvas that is painted brown, representing an old board. The work is phenomenally perfect, with all the characters of Uncle Sam's one-dollar plate, including even the most minute lettering. The edges are worn, thin and torn in some places, while up in one corner is an old Ben Franklin one-cent stamp, stuck to attest a tear. But

the most marvelous thing about the painting is a spot in the lower portion of the bill. This represents an application of court plaster, which is commonly used in mending old bills. The plaster has worn off, and there is a faint spot where it had been, through which the print of the bill is easily discernable. Mr. Haberle framed his production and sent it to the Chicago art exhibition, which was held two weeks ago. Here it received a notice and comment most wonderful. Nobody, of all those who visited the exhibition and made a tour among the pictures, would believe Haberle's production genuine, thinking and saying that the bill was not painted, but was pasted on the canvas. To satisfy themselves scores of people went up to the painting and picked at the bill with their fingers, thinking to get hold of the paper, but they were unsuccessful. It finally became necessary to put glass over the picture to prevent its being destroyed by satisfied curiosity. No greater praise could be found for Mr. Haberle's work than the criticisms that appeared in the Chicago press that morning following the open day of the exhibition. Every paper in the city declared the work to be a fraud, asserting that it was not painted. The papers also stated that Haberle would undoubtedly get himself into trouble by his imposition, and that the exhibition people should at once remove the counterfeited work from their walls. Such notices only served to draw more people to the painting and of those who saw it, not one in 500 believed it a genuine piece of work done by paint and brush. The clamor against the supposed fraud became so strong that the managers of the exhibition finally communicated with Mr. Haberle telling

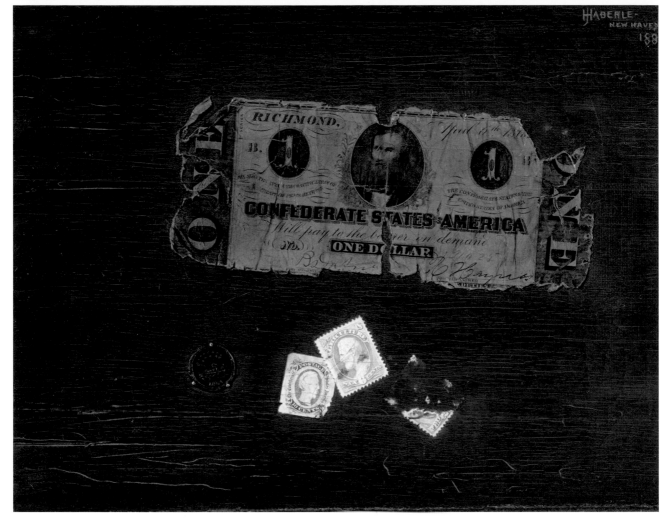

Figure 8. **What's It Worth?** 1886–87. Oil on canvas, 8¾ x 12 in.
Colby College Museum of Art, The Lunder Collection. Photo courtesy Thomas Colville Fine Art

him of the way in which his painting was received. Mr. Haberle at once replied that he was perfectly willing to have anything done to the painting to test its genuineness. Accordingly, the painting was removed from the wall and taken to a chemist. Here an analysis was made of the representation and the bill was found to be of paint and not of paper. Mr. Haberle's triumph was complete. Each paper in the city immediately apologized for the doubt it had thrown over the genuineness of the painting, and highly praised the work. The painting has since been returned to Mr. Haberle.[13]

In the exhibition catalogue *Old Money*, Bruce Chambers adds a contemporary element to the accusation of fraud in *U.S.A.*: "Counterfeiting is, by definition, a fraud, and *U.S.A.* was called a fraud, perhaps a more shameful one than counterfeiting by virtue of being 'passed' as a work of art. Haberle lures us ever deeper into the emotionally-charged thicket of connoisseurship, questioning the standards by which we discern the fake from the genuine, the forged from the authentic, and the 'imitation' from the original."[14]

What's It Worth? (fig. 8) appears to be a comment on the political situation in the Southern states after the Civil War. In the middle of the composition is a frayed Confederate one-dollar bill. All the "engraved" details on the bill are clearly legible, as are the details on the faded blue, orange, and red Confederate stamps below. The third stamp is in tiny fragments. The small coin is attached to the brownish gray wood-textured background with

three small tacks. To emphasize the three-dimensionality of the coin—a Civil War token issued by the Union as a substitute for the copper penny—Haberle built up the tacks and the edges of the dollar bill as well. Another provocative detail is the small "splinter" protruding from a split in the board at lower left.

The Confederate States of America notes were issued by the Southern states that seceded in 1860–61, establishing their capital at Montgomery, Alabama, until May 1861, when it was transferred to Richmond, Virginia. Some notes were issued at Montgomery, but the issues of July 15, 1861, and later are from Richmond. The one-dollar certificate in *What's It Worth?* is from the Richmond series. In *What's It Worth?* the defeated South is represented by its worthless currency and stamps. The dollar bill is as battered as was the Confederate Army. Its currency had no solid backing by the end of the Civil War and was greatly counterfeited in the North.

At the top right is Haberle's "carved"-type signature, with the J incorporated into the H to form a monogram. (He used this monogram in only one other painting, *That's Me!*) Carved below is *New Haven* with a date that appears to be 1880 but is deliberately "smudged"—another sly trick to engage and fool the viewer.

As I observed in *John Haberle: Master of Illusion,* "Haberle's technique was exact to the point of obsession. Perhaps owing to his early career as a lithographer, he painted very fine detail with extreme precision, and his paint surfaces are smooth as glass, with no traces of the brush."[15] A small clipping from the *New Haven Register* reported: "Mr. Haberle is the man who painted bank bills of such accuracy that the Secret Service man compelled him to cease and desist. Haberle did not. Mr. Haberle is generally accorded to be the most successful painter of deceptive subjects in the country."[16]

Can You Break a Five? (pl. 5) is a complex currency composition in the manner of *Reproduction* and *Imitation.* Painted in 1888, it is rendered in Haberle's most impeccable trompe l'oeil style. It shows an especially colorful tattered five-dollar bill issued in 1880. At right is a large pale red medallion woven into the paper, with letters printed over it. The identifying currency numbers—*Z1420719*—at bottom left and top right are also red.

The bill includes a portrait of President Andrew Jackson in a roundel at bottom left; the Roman numeral *V* (top left) and the number *5* (top right) identify the denomination, as do the words *FIVE DOLLARS* in the center of the bill, below *UNITED STATES.* At the center is an illustration of an American pioneer couple—a seated woman and standing man holding an axe, his dog at his side. Their small cabin is in the background, evidence of their success in clearing the wilderness and establishing a homestead. The United States Treasury Department commissioned a number of American artists during this period to paint compositions to decorate American currency. Although the artist of the pioneer couple in *Can You Break a Five?* is unknown, the image recalls the work of William Sydney Mount, a well-known painter of the period.

The five-dollar bill rests on a diagonal above remnants of a one-dollar bill; torn scraps of its corners rest at the upper left and at the left center edge near the frame. At the center Haberle carefully painted the portion of the reverse of a one-dollar bill that contained the warning from the United States Treasury Department regarding counterfeiting. Much of this text can be read with a magnifying

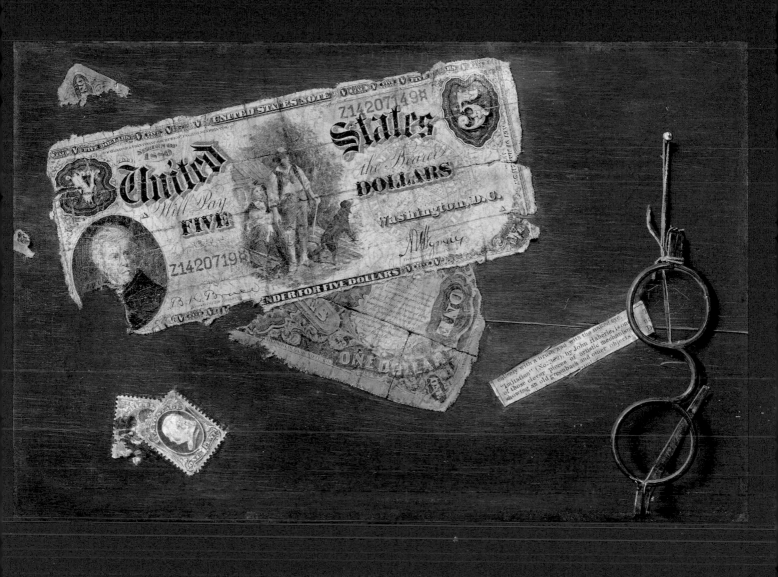

Plate 5. ***Can You Break a Five?*** 1888. Oil on canvas, 7³⁄₈ x 11¼ in.
Amon Carter Museum, Forth Worth, Texas (1985.1)

glass, including *counterfeit* and *imitation of paper money.* This detail also appears in *U.S.A., Imitation,* and *A Deception: Ben Franklin and Five Dollars.*

A battered pair of magnifying spectacles dangling by a string hangs over a small newspaper clipping at the right that reads: *. . . entirely with the brush and with the naked eye. 'Imitation' (No. 3/2) by John Haberle is one of those clever pieces of artistic mechanisms showing an old greenback and other objects*—the same clipping that appears in *U.S.A.* The praiseworthy clipping serves as Haberle's signature. There is no other signature or date. *Can You Break a Five?* is probably the painting that was exhibited at the Pennsylvania Academy in Philadelphia in January 1889.[17]

A Deception: Ben Franklin and Five Dollars (pl. 6) "recycles" its major subject, the five-dollar bill from *U.S.A.* and *Can You Break a Five?* The canvas is an unusual size for a Haberle painting, being almost square. The five-dollar bill is painted face down and set on a diagonal at the center against a deep green background. The frequent folding of the well-circulated bill into eights has resulted in several tears, two of which have been ingeniously repaired. The tear at left is mended with a piece of transparent tape, the other with a worn blue-and-white Ben Franklin stamp. The lettering on the five-dollar bill is clearly visible through the tape—one of the artist's most dexterous trompe l'oeil effects.

The reverse side of the bill includes a great deal of text that can be read clearly with aid of a magnifying glass. The text states the United States Government warning against reproducing Federal currency: *Counterfeiting, or altering this note, or passing any counterfeit or alteration of it, or having in possession any false or counterfeit plate or impression of it, or any paper made in imitation of the paper on which it is printed, is punishable by $5000 fine or 15 years of hard labor or both.*

"Thus Haberle's paintings at first glance seem to be highly objective and detached. However, on close inspection, his work becomes highly subjective, replete with subtle layers of meaning and humorous visual puns."[18] Here, by precisely reproducing the government warning and the entire bill, Haberle was either willfully defying the law or was emphasizing the severe penalties for counterfeiting United States currency.

At the center of the five-dollar bill is a maze-like circular design surrounded by the words *UNITED STATES OF AMERICA.* The number *5* and the numeral *V* decorate the four corners of the bill. Beneath the bill, lower right, is the small fragment of an unidentified postage stamp. The composition is spare and uncluttered. Haberle "signed" *A Deception* with a small newspaper clipping at upper left: *J / HABERLE9 / New Haven.* The figure *9* may indicate that the painting was produced in 1890. A gold mat bearing a metal label marked *HABERLE* in block letters enclosed the painting. The painting and the mat are framed in an elaborate Victorian-style molding and set in a deep velvet-lined shadow box.

The five-dollar United States Treasury note in *Can You Break a Five?* is the one that Harnett painted in 1886 and for which he was questioned regarding counterfeiting. Thus by including the warning on the one-dollar note, Haberle was taunting the authorities even further. As Nicolai Cikovsky, Jr., has observed:

> John Haberle . . . seems to have recognized the implications of Harnett's money pictures more clearly than Harnett himself did, and with more aggressiveness, Haberle made his images of the subject into virtual manifestos of illusionism. Haberle may have hoped to capitalize

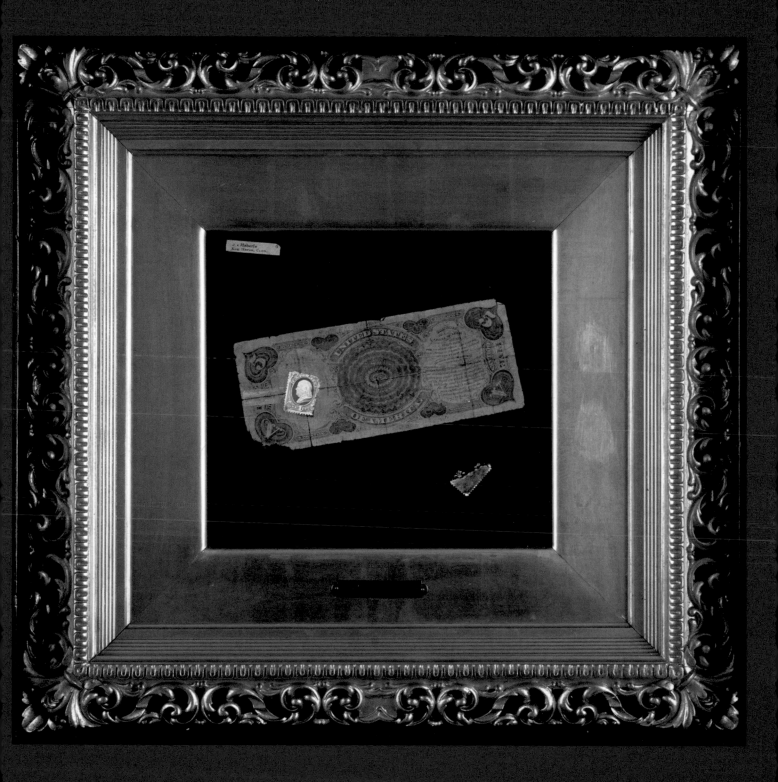

Plate 6. *A Deception: Ben Franklin and Five Dollars,* ca. 1890. Oil on canvas, 9 x 11 in.
Private collection

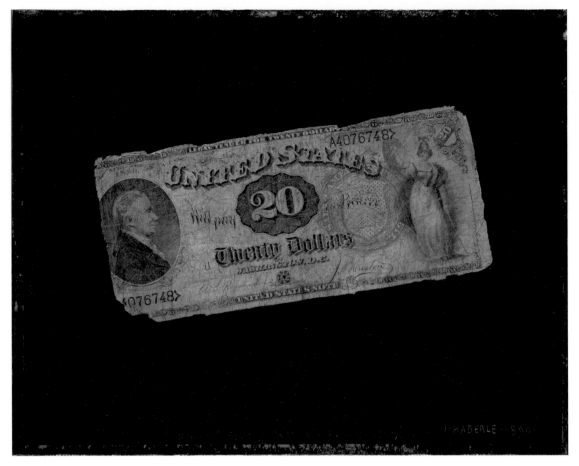

Figure 9. ***Twenty Dollar Bill,*** 1890. Oil on canvas, 7½ x 9½ in. Michele and Donald D'Amour
Museum of Fine Arts, Springfield, Mass., Gift of Charles T. and Emilie Shean

in the roundel at left balances the militant figure of Victory at right. Victory is represented in the classical manner of a standing female figure leaning on her sword, holding her shield aloft and wearing a domed Roman-style helmet. The reddish brown United States seal is at Victory's right. All the lettering, even the smallest detail, is clearly legible. *Twenty Dollar Bill*

upon the notoriety of Harnett's money pictures . . . but he also may have regarded his own as a continuation and perhaps, to some extent, a critique of Harnett's in the sense of carrying them to a higher degree of explicitness than Harnett cared to and flirting with criminality as the condition and the metaphor of illusionism more than Harnett dared.[19]

Twenty Dollar Bill (fig. 9), the work that rescued the artist from obscurity, was located by Alfred Frankenstein during his search for paintings by Harnett.[20] It is one of Haberle's simplest compositions executed in a direct, minimalist manner. A United States twenty-dollar bill series 1880 is set at an angle against a greenish black background. The bill's edges are frayed and tattered, its surface crumpled from frequent use. The dignified profile of Alexander Hamilton, first Secretary of the Treasury,

is signed at the lower right with Haberle's "carved"-type signature, *J. Haberle,* and clearly dated *1890.*

One Dollar Bill (fig. 10) is rendered with the precision of an engraver, even though some of the printing is illegible because of wear and tear. The top edges of the bill bend forward and are delicately built up with gesso. A portrait of Martha Washington enclosed in a roundel at left is balanced by the elaborate numeral 1 at right. The seal of the United States is rendered in reddish-brown paint, the tiny threads woven into the paper; the detailed wrinkled folds and tears are included in exact scale. The handsome lettering *UNITED STATES, ONE SILVER DOLLAR* dominates the center of the certificate.

The subtlest visual trickery is at the right edge, where part of the bill appears to be torn, revealing the canvas underneath, not the greenish black background of the rest of the painting. In this deliberate

deception, Haberle likely was flaunting his painting technique in order to confirm his victory over the critics in Chicago regarding the validity of *U.S.A.* the previous year. The first owner of *One Dollar Bill* was a Boston bank president, apparently one with a sense of humor. Perhaps Haberle intended *Twenty Dollar Bill* and *One Dollar Bill* to be sold as a pair, as they are both almost

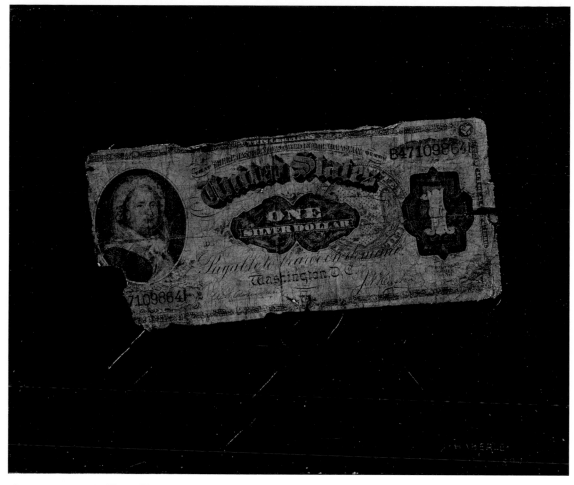

Figure 10. **One Dollar Bill,** 1890. Oil on canvas, 8 x 10 in. Private collection

the same size and were originally in elaborate gold Victorian-style frames and enclosed in shadow boxes.

Ten Dollar Bill was owned by K. R. Hammond of San Francisco, who stated in a letter to Haberle dated April 11, 1915, that it had been displayed at the Paris Salon as entry 38 (or 83).[21] There is, however, no such painting recorded in the Paris Salon listings of that year. "I painted a number of such small canvases, 20" x 24" which took about ten days work," Haberle told Vera.[22]

An undated page from the *Catalogue of Great Paintings* exhibited by the American Art Syndicate at the Boston Theatre about 1896 describes *Ten Dollar Bill:* "An entry #17 *Ten Dollar Bill* by John Haberle is described as one of the most deceptive examples of a realistic painting ever exhibited. Only by the closest scrutiny with a magnifying lens of the highest power

can it be distinguished from a genuine bank note issued by Uncle Sam."[23]

Haberle apparently decided in 1890 that it was time to record his lively bachelor days in the autobiographical *A Bachelor's Drawer* (pl. 7), his most famous work. The format is based on the rack painting. Prototypes for such pictures—featuring a bulletin board to hold letters, cards, receipts, invitations, memos, and other notices—are found in seventeenth-century Europe. The rack board was usually covered with felt or another fabric, with woven tapes stretched across to create a grid—it was essentially a bulletin board without tacks.

With *A Bachelor's Drawer* Haberle's intricate illusionism and his celebration of the commonplace reached a crescendo. It is his most complex painting—thematically, visually, and compositionally. He probably began by painting the wood front panel

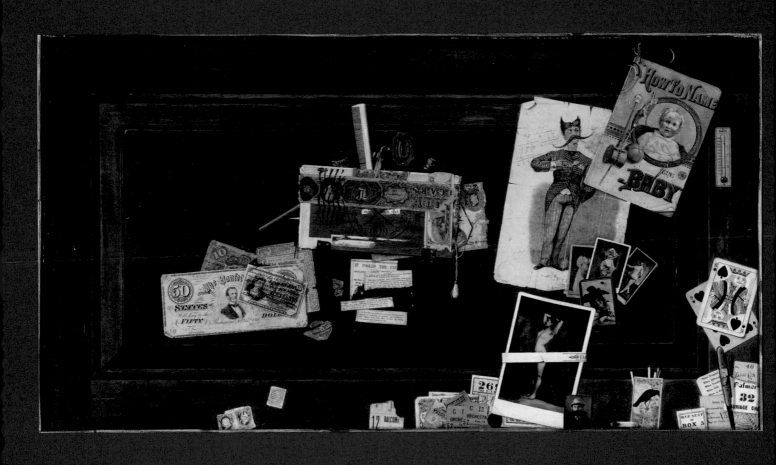

Plate 7. *A Bachelor's Drawer,* 1890–94. Oil on canvas, 20 x 36 in.
The Metropolitan Museum of Art, New York, Purchase, Henry R. Luce Gift, 1970 (1970.173)

of the bureau drawer with a keyhole at top center. The outline of the missing drawer pull at center left indicates the drawer cannot be opened. A wood molding that acts like a painted frame encloses the front of the drawer. At top left Haberle signed and dated the painting with his "carved"-type signature, *HABERLE 1890*. Perhaps the artist planned to finish the work in 1890, but as he did not, he added *−94* in casual, smudged numerals when the painting was finally finished, exhibited, and offered for sale.

The most specifically autobiographical details in *A Bachelor's Drawer* are a tintype self-portrait and fragments of four newspaper clippings: three refer to charges that Haberle pasted actual objects on his canvas, while the fourth and the cluster of paper currency refer to charges of counterfeiting leveled against his paper money. "Haberle's work has often been described as surrealistic, and elements of surrealism are evident here, both in his apparent delight in the absurd and incongruous assortment of objects and in the implausible manner in which they are affixed to the front of the drawer. He also appears to foreshadow Pop Art in his satirical debunking of cultural pretension by singling out trivial and banal things as objects of art."[24]

As a way of summing up his career, Haberle recycled many items in *A Bachelor's Drawer*. The lid of the cigar box appears in *Yellow Canary*, *Conglomeration* (whereabouts unknown), and *A Favorite*. The same currency assortment is found in *The Changes of Time* and *Reproduction*. The artist's pearl-handled penknife is included in *The Palette* and *Conglomeration*. The thermometer still registers a comfortable 68 degrees as it does in *The Thermometer*. Playing cards (the king of spades and nine of hearts) are also included in *Time and Eternity*. The buttonhook and comb reappear from *Conglomeration*. Many of the ticket stubs and receipts were recycled

from earlier paintings. Various versions of his tintype self-portrait appear in *Imitation* and *The Changes of Time;* one can imagine Haberle chuckling as he chose significant souvenirs from his past.

The newspaper clipping headlined *It Fooled the Cat* refers to an incident regarding Haberle's largest painting, *Grandma's Hearthstone*. A *New Haven Register* story of June 10, 1893, reported that a saloon cat was so fooled by the realism of the fire in *Grandma's Hearthstone* that it curled up in front of the picture for a nap!

The newspaper clipping superimposed over *It Fooled the Cat* and two fragments beneath it refer to the 1889 fraud episode at the Art Institute of Chicago. The first clipping reads: *A Newspaper Critic Pronounces a Picture a Fraud but Retreats.* The second clipping states: *'Fake' pictures, in which actual banknotes, etc., were skillfully pasted on canvas and covered first with a wash of bitumen, and then glass, were denounced as pitiful frauds, but . . .* The third: *A New Haven artist has plunged himself into trouble by making too perfect greenbacks in oil. Others have often had trouble by losing too perfect greenbacks in oil,* is probably a reference to careless investors in oil stocks. At the time he was working on *A Bachelor's Drawer*, a Congressional committee was investigating one of the earliest and most ruthless of the "trusts," the Standard Oil Company, which had, through a combination of rate cutting, stock manipulating, and other dubious business practices effectively eliminated competition in industry.

The actual newspaper clippings have not been located, but Frankenstein states that he saw a clipping, probably dated about 1887, in the Haberle house that read: "The artist painted bank bills so accurately that the Secret Service compelled him to desist."[25]

As if to flaunt his facility in painting currency, Haberle included a group of bills at the left, arranged chronologically: the oldest is a Connecticut shilling followed by a fragment of a ten-dollar bill, a

worthless Confederate fifty-dollar bill, and finally a small outdated note marked *International Currency.* Carefully handwritten in neat blue script on this note is the message: *The note with a lot of counterfeit money was taken by detectives from* [illegible] *in New York Jan. 1, 1865. Experts claim this to be genuine.* With this mixture of currency and the message on it, Haberle was deliberately trying to confound the viewer and perhaps to provoke the Secret Service.

Below the currency, three cancelled stamps cling to the wood molding. The top, orange one-cent stamp bears the profile of a woman. The two fragments beneath appear to be cancelled blue Franklin one-cent stamps.

Since the drawer is nailed shut with three small nails—one below the currency lower left, one lower right beyond the photograph of the nude, and the third at the top just left of the cartoon— the bachelor's drawer with its secrets remains firmly closed. Haberle attempts, quite successfully, to confuse the viewer about what is authentic, what is counterfeit, what is real, and what is simulated. "He further tantalizes one by arranging the objects—presumably the contents of the inside of a drawer—on the outside, where they adhere inexplicably to the vertical support. Having aroused the viewer's curiosity about the imagined space behind the drawer front, the artist, in effect denies him access to it by removing the drawer pulls and showing the escutcheon without its key."[26]

The cigar box nailed to the drawer serves as a makeshift container for some of the bachelor's odds and ends: a white comb missing teeth, a buttonhook, a shoelace, a tiny corked bottle—perhaps for cologne or spirits—the end of a corkscrew, a corncob pipe, an opened, stamped, and cancelled envelope with *Conn.* handwritten at bottom. (This may be the same blue envelope used in *The Changes*

of Time.) A tasseled tag attached to the envelope dangles beneath it. The box top itself, with its elaborately decorated labels and jumbled contents, is carefully placed to defy gravity. The top is held closed with a piece of pink ribbon nailed to the front of the drawer next to the escutcheon.

The right side of *A Bachelor's Drawer* is busy and cluttered. Haberle "recycled" the thermometer from his small painting *The Thermometer* and the playing cards from *Time and Eternity.* Below the playing cards is a series of small printed receipts and ticket stubs wedged haphazardly into the lower right corner. They include a pink pawnbroker's receipt marked *Isaac,* a white ticket stub #32 for a Palmer carriage seat, and a pink reservation stub from the Ocean Steamship Company for Stateroom 13. (The number 13 is surely a deliberate choice, as it can signify either good or bad luck.) Beneath is a white inspirational card that reads: *When tempted / When afflicted / When troubled / When sick / When in He . . .* and next to it is a white ticket stub for *One Seat in Box 3.* All these small pieces are held in place by an open penknife with a broken inlaid-pearl handle. Farther left is a match holder marked *CROW* fashioned from a tobacco card that contains five matches and is illustrated by a black crow in profile, nailed to the wood molding. A used match rests at the bottom left. Beneath it, precariously balanced, is a smoldering cigarette, a tantalizing detail. *A Bachelor's Drawer* might soon go up in smoke! Beyond the cigarette, at left, is a tintype portrait of Haberle wearing a pince-nez and a gray fedora.

Haberle's self-portrait is wedged in front of a "cabinet"-type photograph of a female nude in profile, her arms raised above her head. In a nod toward modesty, a white paper band from a stationery pack is stretched diagonally across her private parts. Beneath and beyond her are six theater ticket

receipts, including a pair of orange orchestra seats. Wedged in front of them is a copper penny, a symbol of good luck. Another such symbol, an upside-down horseshoe, is suggested in the partial outline at center top. The symbol may also be a reference to Harnett's paintings that include an inverted horseshoe: *The Golden-Horseshoe* (1886; private collection) and *Still Life: Violin and Music (Music and Good Luck)* of 1888 (The Metropolitan Museum of Art, New York). Perhaps the bachelor's good luck has run out.

A group of four black-and-white photographs—the sort of cards given out in cigarette packs in the 1880s and 1890s—fans out above the nude. The topmost, with a black border, shows a smiling young brunette wearing a large black hat. Behind her are three white-bordered photographs—one of a young lady in a fashionable long white dress holding a straw hat, the next of a screaming baby tied into a highchair, and the fourth of a young female dancer in pantaloons. These photographs partially conceal the lower right corner of a cartoon of a Victorian dandy—perhaps a bachelor—sporting the latest fashion: a tight brown checked tailcoat, striped trousers, a white vest, shirt cuffs, and a handkerchief. His black stock is embellished with a diamond stickpin, and he brandishes a lit cigar. The dandy's swooping brown mustache and exaggerated haircut are the latest in sartorial splendor. The cartoon has been folded, is tattered at the edges, and has been used for jotting down some figures. This amusing caricature is similar to those made by the periodical *Spy* during this period. The numeral *94* is faintly marked by the dandy's lower right leg, possibly a subtle reference to the date *A Bachelor's Drawer* was finished.

A pamphlet *How to Name the Baby* is superimposed over the upper right corner of the cartoon. The pamphlet and a pince-nez hang from a string that dangles from a nail driven into the wood molding. A needle with white thread is stuck into the pamphlet piercing the letter "a" in "Baby." The cover of the pamphlet is illustrated with a portrait of a blonde, rosy-cheeked infant with a red-and-blue ball, a rattle, a jumping-jack toy, and a spool of thread.

Why would a bachelor have such a pamphlet (often distributed with baby food at the time)? Perhaps it is an ironic detail signaling the end of Haberle's lively bachelor days or a reference to his impending fatherhood or both. Haberle's daughter Vera was born in 1894.

Haberle seems to have enjoyed the suggestion of chaos, but within the chaos is incredible order and precision. *A Bachelor's Drawer* contains more than four hundred letters and numbers, all of which are clearly readable, even if the viewer needs a magnifying glass to do so. In spite of his complaints of failing eyesight, Haberle's sharp eye and firm hand were still fully effective when he produced this work, a masterpiece of painted illusion. After completing *A Bachelor's Drawer*, however, Haberle said "he would devote himself entirely to broader work and will make a specialty of figure composition."[27]

The New Haven *Evening Leader* called *A Bachelor's Drawer* "the finest work of its kind ever produced in America."[28] James D. Gill of Gill's Stationery and Fine Art Store in Springfield, Massachusetts, a dealer who often exhibited Haberle's work, wrote him on February 19, 1894 (apparently Gill had seen the painting in progress in the artist's studio in Morris Cove.):

Dear Sir:

I am wondering if your picture of "A Bachelor's Drawer" is finished. If so, why could it not be a good plan to express it to me for the rest of my

exhibition, even though it was here but a week or ten days? It might be a good plan, as we are having a large audience and good sales. I would like very much to receive it.

Very truly yours,
James D. Gill[29]

On May 21, 1894, Gill wrote to Haberle again.

Dear Sir:

Your [illegible] I shall be glad to pay Express both ways on "Bachelor's Drawer" and am ready for it now.

Very truly yours,
James D. Gill[30]

An article in the *Evening Leader* on May 15, 1894, reported that *A Bachelor's Drawer* was on display at Traeger's Hotel on Chapel Street. Traeger's was a popular meeting place in New Haven, and Haberle had exhibited paintings there before. Gus Traeger, one of Haberle's early patrons, had purchased a small currency painting about 1884. The article reads:

Haberle's Masterpiece:
Fine Work of Art on Exhibition at Traeger's
The Artist's Eyes Were Nearly Ruined in Painting It
Last of the Kind that Mr. Haberle Is to Make and It Will Be Greatly Admired

A picture was placed on exhibition in the café of Traeger's Hotel on Chapel Street this afternoon which is undoubtedly destined to become well known throughout the United States, particularly among painters and those interested in the fine arts. It is a painting by the well-known local artist, John Haberle, and it bears the title "A Bachelor's Drawer," and will be pronounced the artist's masterpiece, which means it is the finest work of the kind that has ever been produced in America; for some of Mr. Haberle's efforts have already been adjudged by critics of the leading New York, Boston and Chicago papers to be the finest of their kind ever made.

The picture is painted like all the work ever exhibited by the artist in what is known as the imitative style and so marvelously realistic have the objects been reproduced that the reproduction is almost perfect.

The canvas is 20 x 36 inches, the largest one ever employed by Mr. Haberle, save one, and that was the famous "Grandma's Hearthstone" of which columns have been written in the different cities where it has been shown.

The picture which hangs on the walls of Traeger's café fulfills the title. A large number of such articles as might be found in the bureau drawer of any bachelor, are reproduced in oil. They have been arranged on what represents an old mahogany bureau drawer with much skill and are so grouped as to present each to the best possible advantage.

The grain of the wood as seen through the aged, cracked and time-stained varnish is so clearly done as to completely deceive one. On the drawer is represented a penny comic Valentine which some mischievous niece has probably sent to the "Old Bachelor" who is shown in lithograph likeness. At the other end is—paper currency. So accurately has

Haberle painted the currency—[if] it were done on paper it would easily be passed on a most critical bank teller. An old corn-cob pipe, supported by a leather strap, a number of cigarette pictures, several playing cards, a pawn ticket, lottery tickets, several theatre seat coupons, horse race tickets, are among some of the objects each with its separate history, the sight of which is likely to awake vivid memories in every bachelor who views these which the artist has produced.

Then there is a copy of a book published by some baby food manufacturer entitled "How to Name the Baby" which has a highly colored cover. A cabinet photograph of female model with an envelope band pasted across a part of it to avoid confiscation of some disciple of Anthony [illegible]hstock. Beside these are a number of old postage stamps pasted across the drawer, several newspaper clippings, among others a three part title head of an article published in the Leader the first line of which was "It Fooled The Cat." In one corner is a miniature tintype likeness of the artist himself. On the extreme edge is a cigarette stub, which appears to be lying between the picture and the frame. To adequately describe the wonderful way in which these objects have been published by means of oil color and brushes on canvas would require. . . .

The picture will be exhibited by Mr. Traeger for several weeks. Mr. Traeger was the first to purchase one of Mr. Haberle's pictures, a small bill subject, paying $100 for it.

That was about eight years ago . . . [illegible] weeks after the artist left the National Academy of Design where he had been studying. Mr. Haberle's next purchaser was Thos. Clarke one of the most noted commissioners and art patrons in America who secured his purchase on the walls of the National Academy on "varnishing day." Since then Mr. Haberle has received commissions from the best known collectors in this country.[31]

Apparently *A Bachelor's Drawer* remained on display at Traeger's in New Haven for a month or so but did not find a buyer. The persistent James Gill wrote Haberle again on June 20, 1894:

> Mr. [illegible]
>
> The Bachelor's Drawer both in my front window and in my Gallery has attracted and is attracting considerable attention. I shall be glad to keep it about 10 days longer unless you wish it sooner. Papers here have given it good notices which I will send you.
>
> Very truly yours,
> James D. Gill[32]

In spite of these exhibitions and press attention, *A Bachelor's Drawer* did not sell and was returned to Haberle. A year later, in 1895, Haberle painted a series of three trompe l'oeil versions of small slates. On one, *The Slate,* he wrote the message: *A Bachelor's Drawer is for rent.* A buyer still had not been found.

In July 1898 William Bradish, Assistant Superintendent of the Trans-Mississippi and International Exposition in Omaha, Nebraska, wrote to Haberle about *A Bachelor's Drawer* from the Departments of Exhibits.

Dear Sir:

In lieu of Mr. Griffiths absence from the City, allow me to apologize for apparent neglect in notifying you that your picture was accepted and is hanging in a most prominent positioning the center of one of our galleries. It attracts no little attention and have had one or two nibbles for it. Our catalogue is a little late, but I will mail you one as soon as printed. Trusting this will appease your anxiety, I remain.

Very Truly Yours,
William Bradish, Asst. Supt.[33]

On the same stationery, Haberle received a letter dated October 18, 1898, concerning *A Bachelor's Drawer* from Griffiths himself:

My dear Sir:

I beg to thank you for your favor of the 17th and in reply will say that I shall not let an opportunity to pass where I think I can secure a purchaser for the picture. It has attracted a great deal of attention. I would like to ask if it is not sold here might I take it to Detroit for an exhibition there to take place after this one closes about the end of November. Have several pictures in that city and thus might find a buyer there. I am willing to try if you are.

Kindly advise me and oblige, yours truly,
A. H. Griffiths[34]

In spite of the attention it received in Omaha, *A Bachelor's Drawer* did not sell there either. The painting was shipped to Detroit, where it was shown as Griffiths had promised. It was lot 23 in "A Special Exhibition of Sixty-four Paintings From the Trans Mississippi Exposition." No buyer was found,

however, and the painting was returned to Haberle in New Haven.

In June 1899 *A Bachelor's Drawer* was back in Springfield, hanging in one of the offices of James Abbe, owner and president of the Holyoke Envelope Company, Manufacturer of Envelopes and Papeteries, Holyoke, Massachusetts. A handwritten letter on Abbe's stationery reads:

21 June '99
Mr. John Haberle

My dear Sir:

I set the picture last week. It is in my office here in Springfield. I am in correspondence with an agent to locate it in New York. I am anxious to see it in the café of the Waldorf-Astoria. It would be a great card for you. The agent is to try to be here Saturday and spend Sunday with me. If we don't succeed there, shall try one or two others we have in mind. If you have a New York inquiry will you confer with me? We can locate it and very soon satisfy ourselves as to the motive for asking. I shall get $3,500 for it if I sell it.[35]

In spite of Abbe's efforts, the work did not find a buyer, as it was back in Detroit by January 1900. A typed letter from the Detroit Museum of Art reads:

January 31, 1900
Mr. John Haberle
New Haven, Conn.

My dear Sir:

Thanks for your kind letter of the 19th, very glad to hear from you. The "Bachelor's Drawer" is here with us and I would like to make this

suggestion. There is in this city a very handsome saloon hung with leather and tapestry, elegant in every respect. This owner is an art patron of the best sort. He owns a small piece by you and also "Changes of Time." I believe I could get him interested in the "Bachelor's Drawer" but believe the best way would be to hang it in the place for a time where it would attract great attention but I do not want to do it without your consent.

If agreeable with you, kindly advise me and I will see him at once on receipt of your letter and do with it as I would do with my own.

I hope you are well and wish you a prosperous year.

Very truly yours,
A. H. Griffiths[36]

A handwritten follow-up letter to Haberle from Griffiths on Detroit Museum of Arts stationery dated March 1, 1900, reads:

My dear Mr. Haberle:

Your letter of Feb. 5th rec'd. In due time, not answered for the reason I wanted to see just what I could do before I wrote to you again.

You know without doubt that Mr. Marvin Preston of this city owns three of your pictures. They are elegantly hung in his place of business and attract a great deal of attention. Not the place I had hoped to put it in as I wrote you, an elegant place also; but they feel they would be copying after the first place. . . . I shall be able to yet get them to hang it, but have not given up yet . . . only I thought it best to write you and state the matter as it stood. Of course, I shall

be glad to do anything I can to make a sale and will let no opportunity go by to do it and will let you know as I go on.

With best wishes, I am truly yours
A. H. Griffiths[37]

So after considerable travel and wide exposure to audiences from New Haven to Springfield and from Omaha to Detroit, *A Bachelor's Drawer* was returned to the artist and hung in his home in Morris Cove for the next forty-eight years.

Why did *A Bachelor's Drawer* not find a buyer? Even at its height, in the last quarter of the nineteenth century, the American market for paintings in the "imitative style" was limited. *A Bachelor's Drawer*, like Haberle's currency paintings, was a form of visual entertainment. Exhibited in business offices, art supply and frame shops, bookstores, stationers, hotel lobbies, cafés, and saloons before the advent of television, radio, and recorded music, such pictures were conversation pieces, entertainment for a primarily male auted States Treasury Agents in the 1880s. Haberle was the undisputed master of this demanding "imitative style." But by 1894, when *A Bachelor's Drawer* was offered for sale, the taste for complex trompe l'oeil painting had declined.

Haberle's eccentric, autobiographical subject was probably another reason for the lack of a sale. Deciphering the tiny letters of the clippings, the personal meaning behind them, and other confusing compositional pieces just did not interest collectors. Eventually, in 1970, *A Bachelor's Drawer* was sold to a private collector and donated to The Metropolitan Museum of Art in New York, one of America's finest and most famous art institutions. Haberle would have been pleased.

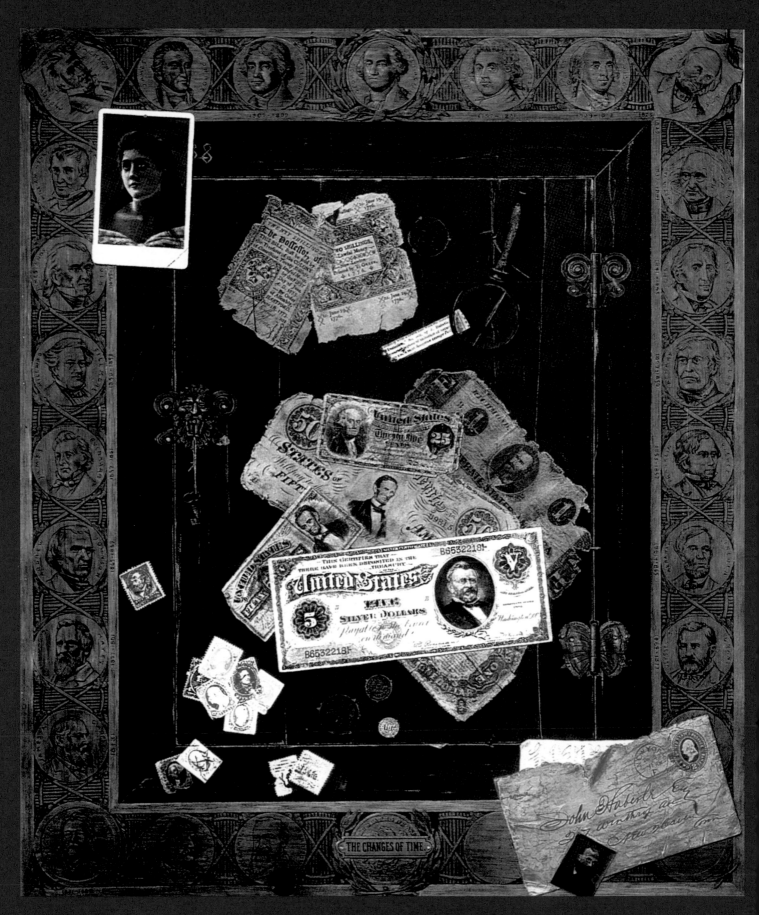

Plate 8. **The Changes of Time,** 1888. Oil on canvas, 23¾ x 15¾ in.
Private collection

3

History Paintings

With *The Changes of Time* (pl. 8) Haberle reached his apogee as the finest American painter in the "imitative style." His impeccable trompe l'oeil skill, original wit, and subtle biographical references were at their best. *The Changes of Time* is his most complex currency painting, referencing American history through its paper currency, coins, stamps, and presidential medallions. It is Haberle's unique contribution to history painting, a popular subject for artists of the nineteenth century. A rare preparatory sketch for *The Changes of Time* exists; some Confederate bills and Colonial notes were also found among the artist's papers.

Victor Demmer, the husband of Vera Haberle, gave Alfred Frankenstein a photograph of a watercolor and ink sketch of *Changes of Time* that he found in Haberle's studio. "Enclosed is a photo of a watercolor and ink sketch found here in the studio as I was looking over the Haberle memorabilia about two months ago," he wrote. "Bills are approx. size as one of the photos. The two bills—the one with the 20 shillings Connecticut Colony has on its side the two shillings bill in *Changes of Time*. You will see a replica of this sketch in the top of *Changes of Time*. The bills are on paper and attached to a painted background of cardboard and the penny is real."[1]

As Linda Ayers observed:

Edwin Nygren and Bruce Chambers recently explored the theme of money in American painting, tracing its social, economic, and political relevance following the Civil War in the materialistic era known as the Gilded Age. They conclude that the Greenback Party, the government policy on bimetallism, financial speculation and corruption, rapid industrialism, the emergence of the American millionaire and the subsequent growing chasm between the rich and the poor, the rise of counterfeiting, and appearance of the economic novel all fueled the nation's interest in money during the late nineteenth century and the artists' fascination with the subject.[2]

In *The Changes of Time*, American paper money, coins, stamps, and newspaper clippings are casually arranged against a weathered gray wood cabinet door, which opens unconventionally from left to right. All the flat paper objects seem to float above the wood surface, as if magically defying gravity. The heavier coins are secured with tiny painted nails.

The variety of paper money, dating from 1773 to 1886, covers the period spanning the Revolutionary and the Civil Wars. The earliest Colonial currency—Connecticut paper shilling notes from 1773 and 1776 issued in New London—is isolated at top center, away from the clutter of other bills of the new Republic scattered below them.

Arranged counterclockwise is a Confederate one-dollar bill with a likeness of Stonewall Jackson. At center overlapping it is a small twenty-five-cent fractional note bearing an oval portrait of George Washington. Beneath is a Confederate fifty-dollar bill with the likeness of Jefferson Davis. The smaller fifty-cent note on top of it, pointing downward to the left, bears a portrait of Lincoln. These smaller notes were issued at the start of the Civil War and served as substitutes for silver and gold coins, which were in short supply due to hoarding.

These bills are frayed and torn, their paper faded with age and use. In contrast, a crisp, fresh five silver-dollar certificate bearing Ulysses S. Grant's oval portrait from an 1886 series printed the following year by the United States Treasury Department sits atop the whole arrangement. Peeking from beneath the lower right-hand corner of the new bill is a fraction of a one-dollar bill that contains the warning about counterfeiting. This is the same fragment that Haberle had already defiantly included in *Can You Break a Five?* and *U.S.A.*

The title of *The Changes of Time* refers not only to the changes that occurred in American history but is also a pun on the word "change," or coins. Indeed, currency itself has the power to make great changes in personal lives as well as history. Haberle used the same kind of double meaning in many of his paintings. Time and use have also changed the condition of the older currency and the cancelled stamps.

As Ayers noted:

> As with other Haberle paintings, the title carries multiple layers of meaning. The formal succession of presidents symbolizes the orderly changes and passage of time, from the beginning of our country to the present. The various types of currency also imply change, though not in such an orderly fashion, and recall our nation's trials and triumphs. Colonial shillings remind us of the Revolutionary War, the bill depicting Washington likewise calls to mind the founding of our nation, the Confederate bills portraying Jefferson Davis and Stonewall Jackson signify the Civil War, and the fifty-dollar bill with Lincoln the assassination of that president. The most recent bill features Grant, whose term was known for its corruption.[3]

A cluster of used postage stamps is set at bottom left. There is a fifteen-cent stamp with an image of Christopher Columbus, a stamp from Canada (a reference to Haberle's 1873–74 stay in Montreal), an isolated blue five-cent stamp delicately wedged into the "painted" wood frame at left, and a cancelled red stamp delicately seals closed the lower left edge of the cabinet door.

At right beyond it, in the crack between the door and its frame, a small piece of paper protrudes provocatively. As William Gerdts explained:

> The iconography is further complicated by the associations that are formed among the different elements in the painting. The post-Colonial money displays heads of presidents from Washington onward, repeating or

approximating images that are incorporated into the frame; the postage stamps echo these again. As the presidents succeeded one another, and most of them had passed on, they were in several senses "canceled," as they are literally on the stamps.[4]

It is also important to recall that stamps were used as currency during the Civil War.

At the upper right a small, very white newspaper clipping separates the Colonial from the United States currency. A magnifying glass above, its lens cracked, dangles by a string from a tack and holds down the right edge of the clipping. The clipping reads: *entirely with the brush and with the naked . . .e. / "Imitation" no. 362 by J. Haberle . . . a / .emarkable piece of imitation of natura.ob / .cts and a most deceptive tromp l'oil.* This clipping, with its misspelled "trompe l'oil" surely delighted Haberle as he used it often in his paintings. According to Frankenstein,

> This [clipping] is a pastiche of at least two different notices. The last line, with its misspelled French word, appeared as follows in the New York *Evening Post:* "Imitation," No. 362, by J. Haberle, a small canvas which, without being in any sense a work of art, is a remarkable piece of imitation of natural objects and a most deceptive *trompe l'oil.*"[5]

The reporter states that the painting is "not in any sense a work of art," an attitude towards the trompe l'oeil painting style widely held in the official American art world during the Victorian period. An assortment of five coins are scattered throughout the painting. Some of the coins are secured with tiny painted tacks; their edges subtly built up to suggest three-dimensionality. "There

is a small coin over the lower part of the Harrison medallion. It has slipped from the place where it was originally tacked, just below and to the right of the cluster of six stamps on the lower part of the door, and there it has left a ghost image of itself."[6] A satyr's-head brass escutcheon at left secures the door, as it is firmly tacked over the opening. The key dangling by a string from the satyr's mouth will be ineffective in opening the sealed cupboard.

A black-and-white photograph of a dreamy brunette seals the upper left corner of the cabinet, obscuring part of the "painted" frame and the "incised" date of *[18]88.* The photograph, its lower right corner cracked, is the type included in cigarette packages of the time. The subjects were often well-known theatrical personalities of the day. In this case it is Madame Lillian Nordica, an American opera star also known as the "Star of the North." Madame Nordica, born in Maine, achieved international renown before dying tragically of exposure in Australia after being shipwrecked off the coast of Java. Haberle may have been an admirer of Madame Nordica and may even have heard her perform in New Haven, where he often attended theatrical events.

At right two elaborate brass hinges—the upper one an abstract scroll design, the lower a butterfly—hold the cabinet door in place. The "frame" around the picture is carefully composed, meticulously painted, and an integral part of the composition. As opposed to the confused arrangement of the center of the composition, the "painted" wood frame is a model of order. The title of the work is "painted" on a brass "label" that is tacked to a United States silver-dollar coin encircled by a laurel wreath at the bottom center. At the top enclosed in a similar wreath is George Washington, flanked by medallions of John

Adams and Thomas Jefferson. All the other presidents, including the incumbent Benjamin Harrison, are arranged around the frame in similar medallions and identified by their names and terms of office.

As Ayers remarked:

> Group portraits of presidents go back at least to the time of James Madison. Usually done at the time of inauguration and featuring the current president in the center, they sometimes also enframed historical scenes or other patriotic images. By late in the nineteenth century, presidential portraits served as borders not only in prints, but also in other political memorabilia such as broadsides, sheet music, and even handkerchiefs. Haberle's "frame," then, might at first glance be dismissed as merely traditional decoration. However, the fact that, in Haberle's painting, the presidents surround money in various forms (even postage stamps were used as money during the Civil War) gives the painting a different connotation. It is money that has the place of honor and veneration, surrounded by our national leaders, past and present. Money is at the center of politics.[7]

Benjamin Harrison is shown at lower left. A Republican elected by a narrow majority the year the painting was executed, he was not inaugurated until 1889. Thus the painting was created in either November or December 1888. A United States Navy button, having slipped from its place above, obscures the end of Harrison's term, which would have been unknown to Haberle at the time.

Separating the medallions are fasces, symbols of the power of the Roman Republic that were carried by its magistrates and later assumed a decorative function.

Four medallions at lower right are empty, reserved for future presidents. Partially covering these empty medallions is a crumpled blue stamped envelope addressed in a flourishing hand to *John Haberle, Esq., 27 Winthrop Ave., New Haven, Conn.* This motif acts as Haberle's official signature. The letter was mailed from New York at 11 A.M. '88. *Return to* is printed on the upper left corner of the envelope. A tintype portrait of the artist is wedged on top of the envelope. As Frankenstein observed:

> The small corner of the letter which protrudes from the envelope is one of Haberle's most delicious feats of virtuosity; one can almost hear him chuckle with delighted self-approval as one studies it. No complete words are legible, but it is none the less apparent that the more boldly stroked letters are in mirror writing, while the interlined, fainter letters are not.[8]

The *Detroit Evening News* reported on Mr. Preston's collection:

> The "Changes of Time" now on display is the one owned by Mr. Preston. The background is an oaken door of a small closet with old-fashioned brass hinges. Scattered about are a number of bills from the 20-shilling bill dated 1775, to the modern five-dollar greenback. In the left-hand upper corner is a photograph of a young girl most exquisitely executed, and lying on an old envelope in the lower right hand corner is a tintype—a perfect likeness of Mr. Haberle. So true to life are these that the edges of the proof seem to curl up before the eyes of the onlooker. Stamps ranging in date from the earliest times to the latest before the Columbian are to be seen, and several old and

modern silver and copper coins are nailed to the background. As though to boast of the close inspection that his unique work of art invites, a magnifying glass is painted and suspended on a nail. The whole is surrounded with a painted oaken frame on which are to be seen likeness of every President from Washington to Harrison.[9]

In its complexity of composition and iconography as well as its technical virtuosity, *The Changes of Time* forecast *Wife, Wine and Song* and *A Bachelor's Drawer*. In a sense, it is also the closest Haberle came to making a history painting.

In 1888, one of his most prolific years, Haberle received a rare commission. James Abbe asked Haberle to paint a copy of his grandmother's fireplace at three-quarter scale. The commission called for a complete departure from Haberle's usual trompe l'oeil currency compositions and required painting a setting filled with three-dimensional objects. Nevertheless, after correspondence the challenge. In an article in the *Springfield Republican*, Haberle stated: "I took the commission solely because it was a subject more difficult and interesting than any ever attempted. I am satisfied that it is my most serious and best work."[10] (Probably the appeal of ready cash, as he was newly married, was also a factor.)

While the exact price paid for *Grandma's Hearthstone* (originally titled *Grandma's Hearth*, pl. 9) is not known, it is safe to assume that it was one of Haberle's most expensive paintings, as it was his largest (8 by 5½ feet) and he was at the height of his fame. In 1891, when Abbe decided to sell the picture, he priced it at $3,500, so it must have cost him several thousand dollars.

Grandma's Hearthstone was an ambitious project, and one in which Abbe was actively involved. It required Haberle to reproduce, at almost full-scale and with great detail, the cluttered Colonial mantelpiece, with a fire burning in its hearth, that Abbe remembered from his rural childhood.

Organizing the project was complicated. It involved locating and transporting an authentic Colonial fireplace and overmantle from its original location, Chesterfield, Massachusetts, to Haberle's studio in Morris Cove. In a letter to Haberle dated October 4, 1888, Abbe asks: "About when will you go up country to sketch?"[11]

Apparently, at first Haberle thought he could work on the project from sketches he would make in Chesterfield. When that turned out to be impractical, Abbe arranged to purchase the fireplace, remove it from the house, and have it shipped to Haberle. Abbe wrote to Haberle in early November 1888: "I am most anxious to get the things together and make a start, then I am content to bide the time. Anything you lack, call on me. For if the suggestion feasible can you first paint mantle and fireplace and then send for me to arrange the articles?"[12]

On November 9 Abbe advised Haberle further, as Haberle was to travel to Williamsburg, Massachusetts, to assemble the fireplace and other articles for shipping.

> When you are there, please get the horns and other paraphernalia packed and ship by freight together with the fireplace. Then I would like you to advise me just what you have that enters into the picture and if you are short anything I will secure it. I know you are short the Farmer's Almanac, and the bottle which I have here

Plate 9. **Grandma's Hearthstone,** 1890. Oil on canvas, 8 x 5½ ft.
Detroit Institute of Arts, Gift of C. W. Churchill in memory of his father (50.31)

which I will bring to New Haven the first time I come there. Also a stocking partially knit, which I have at home. Please get a piece of sheer twine to string your peppers on.

 Yours truly,

 James T. Abbe[13]

Abbe was an exacting patron with very definite ideas about his commissioned work. Apparently, some of his demands did not receive Haberle's approval, because on March 8, 1889, Abbe replied to a recent letter from Haberle:

Of course, anything that does not fully meet your favor, I do not suggest to cause you trouble . . . if I should later on write suggestions not in keeping according to introduced, which is my idea that does not harmonize with your judgment. For I should not want anything in the picture that you are not interested in painting, then no responsibility can be thrown on me. In other words, I want you to sanction in your own mind what ever you do, and I shall agree with you in everything regarding subject matter and arrangement which you say pleases yourself. So go ahead with the layout same as had when I was in New Haven, and if I write anything further you need not take the time to reply. If any suggestion is worth your attention, adopt it: if not, let it drop.

 Yours truly,

 James T. Abbe[14]

Organizing the material, dealing with a demanding client, and working on such a large canvas as *Grandma's Hearthstone* was a difficult task for Haberle, who was accustomed to painting small,

flat objects as he saw fit, without outside opinions or instructions. An article in the *New Haven Register* recounted Haberle's difficulties.

Search for a Fireplace: How Mr. Haberle Secured His Subject for a Picture

Artist Haberle is hard at work on a painting, which in itself will be not only an artistic creation, but has something also of a romance about it. Nearly a year ago he received an order to represent on a canvas a huge, old-fashioned fireplace, which should be nearly as large as the original. To find a fit subject he journeyed into Massachusetts and made many sketches there, but for a long time not finding just what he was searching for. At last, in an out of the way place he discovered his ideal and supposedly purchased it. What portions he wanted were shipped to this city. Shortly after a lawyer sent to Mr. Haberle demanding money for the old fireplace, claiming that he had taken away more than he bargained for. It was the strange surroundings about and below the strange structure that he wanted, but more money was asked for, so to save trouble the artist paid for it. Then the box finally went astray and it was only after a diligent search of two weeks that it was discovered in Peck and Bishop's office.

Mr. Haberle has been working on the picture for some time already, but only has it "laid in." It is full of detail, and when finished will be a complete deceit. At a certain distance set in a proper frame, the kettles and cranes together with the back log and bright embers

will appear absolutely real, as if one had but to reach out and poke them. Mr. Haberle works only on the picture on bright days, and the recent weather has caused much delay, but it will be yet a year before this, his most prominent work of the brush, will be completed and on exhibition.

There the fireplace, each stone being in the position it held when the early settlers constructed it, was furnished as to its own interior and to the mantle and paneling above it, with articles of the early part of this century such as has been seen in similar locations in the fall of the year.[15]

An article from a Springfield area publication of about 1887 describes Abbe's collection in some detail.

Mr. Abbe is, as his many acquaintances in this section and elsewhere know, a patron of art, and a judge of pictures of no mean ability. Very prominent among the decorations of the sample room [of the Holyoke Envelope Co.,] will be some of the triumphs of his skill in selection in this direction, which merit special notice. When the company was burned out last winter [1886–87?] there was rescued from the flames a painting *Ease* by William M. Harnett of New York. This picture Mr. Abbe sent to the Centennial Exposition at Cincinnati, and while it was there he sold it to C. P. Huntington of New York for $5,000. To replace this Mr. Abbe is having painted by Haberle a large picture on canvas seven by nine feet in size, which will embody some of Mr. Abbe's own originating and which will be entitled *Grandma's Hearthstone*.[16]

By November 1890 *Grandma's Hearthstone* was finished and placed on exhibit at James D. Gill's Stationery and Fine Art Store in Springfield. The *Springfield Republican* published a detailed article:

It is certainly a good example of the pitch to which close imitation can be carried by a painter in oils, for it is as literal as one of William Dean Howell's conversations in *The Minister's Charge* for instance. It is not so artistically composed, not so much a picture as *Ease* [commissioned from Harnett by Abbe] but it is quite as skillful in its technique, and in some points this technique amounts to very delicate art, as in the steam arising from the open pot, which hangs on the crane. . . . This steam, such as lightly wavers and floats on the surface of water that barely simmers, and rises in the slightest, thinnest wafts of vapor, is painted exquisitely. The fireplace and the woodwork all is painted that lead-color, or bluish drab, which is much affected in the country even now. A fire burns briskly on a pair of rude andirons, and over it hang from a crane the three-legged pot with a little iron teakettle puffing away at full boil. The gradation of the tones from the sooty chimney-black to the front is another fine point and it seems to us that we have never seen flame, sparks, smoke and steam, all together, so well painted as in this fireplace. The woodwork, where the paint is wearing thin in spots, is capitally done. Under the mantle hangs at the right a bellows with a painted side, and a hickory cane stands beneath. A string of peppers, some red, some green hangs nearby. At the left a tin dinner-horn is on a hook as is a big warming pan.

Shovel and tongs are not wanting. Upon the narrow mantel is seen at the right a book, on which lies a pair of steel-bowed spectacles and the knitting of "grandma" whose hearthstone we are looking at. Her old time lantern, with conical roof and side pricked full of holes, through which the light of the tallow candle within may show, comes next, and then one sees a rotund flask of the "oil of spruce, 1776." A light blue china teapot, without a handle, contains a bouquet of fall flowers, hollyhocks, asters and marigolds; near stands a candle in an iron candlestick, and the snuffers set at its foot. A brown earthenware pitcher, a slide-whistle and an apple complete the furniture of the mantle. Above it the most noticeable things are a flint-lock musket on it whittled crotches and a sword crossed over it, a pistol is in a leather-strap beneath; while from the center at the top under a pair of curly ram's horns, depends a fox's head and brush. High at the right is this invariable string of good hard yellow corn, with one red ear, and off at the left two clay-pipes are tucked in their leather holsters. Perhaps in all the furnishings of the chimney-piece there is nothing better painted than a "Farmer's Almanac" of 1804. The temptation to take hold of the dog's ear on that much-thumbed page, and turn it down, is almost irresistible. Paper and printing are perfectly copied. Other points deserving particular mention are the pipes and string of corn, whose texture is excellently rendered. In fine, we may say that *Grandma's Hearthstone* is a work of uncommon interest, the most ambitious we know of in its class of still-life, and one which will well repay a visit.[17]

Surprisingly, less than a year after the painting was exhibited at Gill's and hung in Abbe's show-room at the Holyoke Envelope Factory, Abbe decided to sell it. He wrote to Haberle:

Dear Sir:

I have written Schaus Art Gallery, desiring that they sell your painting for me. I have named them $3,500.00 as the minimum price. This will help you if it is sold, as well as myself, as I have another idea I wanted carried out if I do sell it, which I propose that you shall undertake. Now, if Schaus' people should write you anything . . . asking what you would duplicate a similar work for, the inquiry will simply be as a result of my correspondence with them, and I would recommend, if you have no objection, that you say to them that you duplicated such a picture for $5,000. If the picture is sold, it will give you reputation which will be valuable to you, and the price carries character with it, and I can handle it with their co-operation very much better than you personally could. While between you and I, of course, I would sell it for very much less, still, the point is to get the customer, and when we get a customer he will be impressed with the value of the picture in a measure by the price, and I should hold firm to the price.

Kindly own receipt of this, and if anything comes of it, it certainly will be a mutual matter. I have agreed to pay expenses of their man if they will send one here to see the picture, for I want them to know what it is.

Respectfully,
James T. Abbe[18]

This letter clearly implies that Abbe—above all a businessman and a "dealmaker"—seemingly treated his paintings, even one as personal as *Grandma's Hearthstone,* as commodities like his paper products. In 1891 Marvin Preston, the manager of Churchill's—described by W. H. Griffith, the director of the Detroit Institute of Art, as "a very handsome saloon hung with leather and tapestry, elegant in every respect"[19]—bought *Grandma's Hearthstone.* The painting was a highlight of the saloon's collection of trompe l'oeil pictures, which also included Haberle's *The Changes of Time* (which Preston purchased in 1891 for about $2,000), *U.S.A.,* and *The Palette.*

Frankenstein described the setting and his reaction to *Grandma's Hearthstone:*

> Preston managed a famous, handsomely furnished saloon known as Churchill's, which was the Detroit version of Theodore Stewart's. All his pictures hung there, but they were dwarfed by the Churchillian equivalent of *After the Hunt*—an immense work of Haberle's that belonged to the proprietor of the establishment, Mr. Churchill himself. . . . This painting, eight feet high and five and a half feet wide, is the largest example of *trompe l'oeil* it has ever been my pleasure to see. . . . Unlike most of the known Haberles, *Grandma's Hearthstone* uses much tone and modeling. . . . As in *The Changes of Time, The Palette,* and a lost picture of a little Japanese doll . . . Haberle here makes much of a painted frame. . . . A bed warmer and a coal shovel protrude from the fireplace and partly cover it, while the string of corn hangs from its upper horizontal bar.[20]

The *Detroit Evening News* ran an article headlined "The Picture Fooled the Cat: Remarkable Example of the Realistic in Painting—One of John Haberlee's Works—Owned by Marvin Preston Represents a Very Old-Fashioned Hearth" (the reporter misspelled Haberle's name throughout):

> There is an interesting picture on exhibit at Churchill's saloon on Woodward Avenue from the brush of John Haberlee, the famous artist in still-life. The picture is owned by Marvin Preston, who was the first man in the West to purchase Haberlee's works. He is the owner of the famous picture "Changes of Time," which created so much interest when it was on exhibition at the first exposition here. It was then that Mr. Preston bought it. It was among the first of Haberlee's remarkable work to be exhibited in the West.
>
> The picture now on exhibition at Churchill's is called "Grandma's Hearth" and was painted by Mr. Haberlee for Colonel James T. Abbe a representative manufacturer of Holyoke, Mass. Most of the objects represented in the picture belonged to Colonel Abbe's parents and are heirlooms in the family. The picture is a perfect representation of an old-fashioned hearthstone of 1804. The date is fixed by the picture itself. There is an almanac—Thomas' Farmers Almanac, a book still famous among the Massachusetts farmers—hanging upon a nail in the fireplace. This was the first issue of the book and is painted from a copy loaned to the artist by the publishers.

One notices among the objects on the mantle the old flintlock gun, the horn, spectacles, the candlestick, the pot, kettle and warming pan, all familiar objects of that period. They are painted with that wonderful realism for which Haberlee is famous—a fame which has so injured his eyesight in that he will be able to do no more close work, although he is not debarred from doing what is known as broad work. One of the most remarkable things about the piece is the representation of the flies which are crawling on the mantle. It is impossible to tell whether they are painted or genuine until the visitor attempts to shoo them away.

The location of the picture adds considerably to the realistic effect. It is arranged at the dark end of the room. With electric lights turned upon it in such a manner that upon entering the place it seems as if there really were an old-fashioned fireplace at the end of the room and the light was the reflection of the fire.

The best critic upon it was the house cat. When the picture was first placed in position, the cat came up from the cellar and started across the room. Cats are very curious animals and want to see everything that is going on. The cat noticed the light and the blazing fire and went over to examine it. After looking the situation over critically for a few minutes she made up her mind it was all right and settled herself down before the fire to snooze. She became part of the picture.

The picture is 5½ feet x 8 feet, and the objects are painted three-fourths size. Mr. Abbe used to have the picture hung up in his office in Holyoke, but owning to some changes in the arrangements of the rooms he found it necessary to remove it. He was uncertain whether he would part with it or build another room for it. And that is how it came to be in Detroit.

There is now no great artist in still-life in America. It isn't a high form of art, and an artist will not do it when he can get better work to do. It is said that Haberlee never painted a still-life until he was compelled to do so. He had the skill to do the work, however, and the public demanded that form of art, so he did it. It is an easy thing for him to paint a picture like that in a few weeks.

His most famous work *The Changes of Time* was so perfect in its realism, that the Chicago artist, knowing that there is a process for transferring real bills to canvas, would not believe they were painted there until the paintings were tested with chemicals [the reporter is confusing *Changes of Time* with *U.S.A.*, also known as *The Chicago Bill Picture*]. *The Changes of Time* represents a number of bills and coins dating as far back as the colonial times, painted upon a board background.

Haberlee lives in New Haven, Connecticut. His works are famous all through the East, and now that Harnett is dead and Haberlee is no longer able to do close work on account of his eyes, these pictures command a rather high price. There are other painters of still-life but they have not the skill of these two men who have painted their last pictures in that kind. There is another picture of Haberlees in Churchill's place. It is a painting known as *The Chicago Bill Picture*.[21]

In one of the few existing letters in Haberle's own hand, written about 1892 from Boston to "Friend Sadie," probably his wife Sarah, he comments on *Grandma's Hearthstone:*

> When I get back to store I will enclose you clipping from "Detroit News" referring to picture "Grandma's Hearthstone" which is now owned by Mr. Marvin Preston the purchaser of a number of paintings. This is a better notice I think than the one that was copied by "the Leader." It is a warm day and I am writing this to you at the Public Garden seated on a bench under a tree. Before me is a lake on which sail Swan Boats. The trip on one of these is 5 cts. If you were with me now, I would take a ride.
>
> Happy[22]

A more detailed article on *Grandma's Hearthstone* appeared two years later in the *Detroit Evening News:*

A Work of Art Is Marvin Preston's Latest Acquisition: John Haberle's Greatest— Grandma's Hearth-stone the Best Still-Life Painting in Existence

Detroit is not possessed of many works of art that perhaps the greatest of them all should come unheralded into the city. There is a painting now being exhibited at Charles Churchill's, 58 Woodard Avenue which no lover of art can afford to miss seeing. It is entitled "Grandma's Hearthstone" and is from the brush of that celebrated still-life artist John Haberle. The picture is without a doubt the very best work of its kind ever exhibited in this country.

The subject of "Grandma's Hearthstone" is an old-fashioned New England fireplace of the style in vogue at the beginning of the century. A bright wood fire is burning over it as are an old-fashioned gipsy kettle and pot. Above the mantle are a number of articles nailed to the wood-paneled walls. In the left hand upper corner are two clay pipes in a rack, which look as if they had not time to cool since leaving the owner's mouth. The center of the background is occupied by a pair of ram's horn and immediately beneath is a fox's head and brush and a coon's head which are marvelous examples of the painter's skill. The perils of our ancestors' life are vividly recalled in the old-time flint-lock musket and horse pistol which hang above the shelf and crossed with the former is a saber which probably grandpa wore when grandma welcomed him home from fighting for his land and liberty in the Revolution. Beneath the mantle-piece are a warming pan, farmer's almanac and ash shovel, while against the right hand side rests the stick which granny no doubt smartly rapped the knuckles of her refractory grandchildren when they transgressed some of her, what seem to modern generations, puritanical rules.

The mantle shelf is, as was customary with our ancestors, the resting place of any articles in daily use. Prominent among these is the old family bible, which well-worn leaves and binding speaking more than words could do how often it was used for family prayers nightly before retiring. A tin candlestick stands on the right-hand side, with a half-burned

candle in it, down the sides of which the tallow has been dripping. The picture is placed at the end of a long room in which the strong light is not allowed to enter. By an ingenious device of electric lamps, the light is shown directly upon the painting without throwing rays on any other of the surrounding objects. The effect that has is very good, and gives to anyone entering the idea that the view seen in front is in reality a fireplace around which are set the articles names, and not merely an exhibition of what a clever artist can do with paints and brushes.

Every object is painted with a degree of realism which is little short of marvelous, and when standing in front of the picture, and seen in the excellent light in which it is placed the surroundings are forgotten and the observer seems to be carried away to a past generation and imagines himself really beneath the roof of a New England farm-house, waiting for the return of the laborers from the fields for their evening meal.

The picture was painted for Mr. James Abbe of Holyoke, Mass., who will be remembered in the artistic world as the man who first bought Harnett to notice by purchasing his now celebrated "Old Violin." This picture was brought at the first Cincinnati exposition and Mr. Abbe resold it to C. P. Huntington of New York before removing it from its hanging place at an advance in price of $4,000.

The "Grandma's Hearthstone" is now owned by Marvin Preston of this city who

has always been a great admirer of Haberle's work and in fact was the first western man to purchase any of his pictures. Every object portrayed is an exact reproduction of an article belonging to Mr. Abbe's parents and are heirlooms in his family.

Special interest is attached to this work of art from the fact that it is the last of its kind ever coming from the brush of Mr. Haberle. The minute painting required for this class of work has so injured the artists' eyes that it will be utterly impossible for him to paint any more of them, although he will still be allowed to exercise his skill in a broader field.

Besides "Grandma's Hearthstone" Mr. Preston is the owner of four more of Haberle's masterpieces. One of them is known as "The Chicago Bill Picture." It is also on exhibition at Churchill's and gained its nickname from the furor it created when on exhibition at the Institute of Art in Chicago. A frayed one dollar bill lying over a $10 dollar one, and the art critics of Windy City jumped to the conclusion that it was utterly impossible for an artist to make so perfect, exact and minute a reproduction with only the aid of palette and brush. A chemical test, however, dispelled their skepticism.

The "Changes of Time," now in exhibition in Grand Rapids is another one owned by Mr. Preston. The background is an oaken door of a small closet with old fashioned brass hinges. Scattered about are a number of bills from the 20 shilling bill dated 1776 to the modern five dollar greenback. In the left hand

upper corner is a photograph of a young girl most exquisitely executed and laying on an old envelope in the lower right hand corner is a tintype—a perfect likeness of Mr. Haberle. So true to life are these that the edges of the proof seem to curl up before the eyes of the onlooker. Stamps ranging in date from the earliest issues to the latest prior to the Columbian are to be seen, and several old and modern silver and copper coins are nailed to the background. As though to boast of the close inspection which this unique work of art invites, a magnifying glass is painted suspended to a nail. The whole is surrounded with a painted oaken frame, on which are to be seen likenesses of every president from Washington to Harrison. Still-life is popularly supposed to be the only kind of artistic work in which Mr. Haberle excels. That such is not the case is proven by another of his works in Mr. Preston's possession. This one is known as "The Palette" and is a painting of an artist's palette with little daubs of color round the edge, which seems to have just left the tubes. The border is a study of about 20 children's hands, forms and figures. Still-life is not a favorite branch of artistic work, both on account of excelling in it and minuteness of work required, but figure painting calls for every bit and an all together different kind of skill. Infant figures are by far the hardest to faithfully portray, but Haberle has clearly demonstrated that were he to make a specialty of this class of work, he would gain even greater fame, if possible, than he has as a still-life artist. Each and every figure on this border is a gem in itself, and, for the sake of

America's artist reputation, it will be hoped that Haberle's eyesight will allow him to branch out into this fresh line.[23]

"The best still-life painting in existence" is indeed hyperbole but surely would have pleased Haberle. *Grandma's Hearthstone* reveals none of the sly, subtle personal and historical touches that make his smaller uncommissioned trompe l'oeil paintings so interesting. It is more stage set than trompe l'oeil. Undoubtedly, the location in Churchill's, at the end of a dark room, made the painting more realistically convincing than it would be on a well-lit museum wall, surrounded by other pictures.

The upper half of the painting is the most successful in terms of deception. A soft light comes from the left, casting delicate shadows overall. The size and variety of objects in the painting gave Haberle an opportunity to display his fine talents as a colorist. The flies on the mantle are set to fly off, the dust on the almanac may blow away.

Haberle used pure color accurately, not dimming its brilliance with umbers or blacks. The grayish blue Colonial overmantel and projecting shelf holding objects from Abbe's childhood are painted in Haberle's impeccable trompe l'oeil technique even though most of them are three-dimensional. The shelf itself projects, impossibly, beyond the painted "carved" frame.

As I noted in an earlier study:

> In the middle section of the painting, however, he was less successful at achieving these effects. A country bouquet of hollyhocks, bachelor buttons, and marigolds is loosely painted with a soft impasto, quite unlike the hard-edged illusionistic style Haberle used

for the rest of the objects. With their delicate translucent petals, the flowers do not lend themselves to trompe l'oeil treatment and introduce a jarring note to the painting. In the lower half of *Grandma's Hearthstone,* the trompe l'oeil illusion fails because the spatial recession of the fireplace and the movement of the flames destroy the flatness necessary to successful illusion. It appears as though Haberle knew he was "stuck" with this problem; he made no effort to paint the cut stone of the fireplace with linear precision, but instead resorted to broad work.

In the central motif decorating the overmantel, Haberle made a bow to the hunting trophy, a characteristic trompe l'oeil subject beloved of Richard L. Goodwin, George Cope, William Harnett, and others. Mountain goat horns curl dramatically in front of the ornate, painted frame. A hunting horn casually dangles from them. A dead raccoon and a possum, their coats soft and fluffy, complete the trophy group. Beneath them, on a rack made of twigs, rest three weapons, a military sword, a flintlock, and a hand pistol. On the shelf below, whose ends also project beyond the painted frame, are a number of homey objects, most of them three dimensional. The worn family Bible projects from the shelf, topped by a pair of spectacles and some knitting in progress.[24]

The lower half of the painting becomes stage scenery. "It is the largest, most colorful, most three-dimensional, most active and most unsuccessful work of Haberle. It is supposed to have once fooled a cat that curled up in front of the painted frame, but it would not have fooled anyone else."[25]

The painting is signed and dated *J. Haberle, 1890* in his "carved" style, at the upper right corner beneath the "carved" wood frame. *Grandma's Hearthstone* hung in Churchill's Saloon for many years, "warming" generations of clients and house cats. C. W. Churchill donated this tribute to the American Dream to the Detroit Institute of Arts in memory of his father in 1950.

On February 24, 1952, an article about *Grandma's Hearthstone* in the *Detroit Evening News* related the memories of Maurice Fox as he studied *Grandma's Hearthstone* in the galleries of the Detroit Art Institute that year.

> Forty-five years ago [1897] Charles L. and Emma Fox, one of the more popular couples in this community . . . screwed up their courage, and buried their pride, took son Maurice A. by the hand and timidly entered Churchill's famed Woodward Avenue café. At first glance that declaration does not seem one whit unusual. But when you learn that the Foxes were staunch WCTU supporters who openly abhorred such places, warned their son about the evils which lurked in such places, you wonder at their visit. It happened, however, that Mrs. Fox was a lover of fine paintings . . . and, well, nearly everyone in town was talking about the "magnificent canvas" that hung in Churchill's. . . . This particular painting was a hearthside. On the hearth was a cheery log fire, and at the sides were strings of colorful peppers, frying in the heat. For some strange reason the artist painted two houseflies atop the mantle . . .

which were so life-like, they tell me, many people tried to shoo them away. Well, as time went by, and Mrs. Emma Fox heard more and more about the painting, she finally made up her mind she was definitely going to see it, even if she had to enter a saloon to view it. So you can well understand how thunder-struck was Papa Fox when his loving spouse announced they were going into Churchill's and have a look. At the time Charlie Fox was a highly respected head of the tailoring department at Mahley's store. He was certain that this daring venture would cause terrific tongue clacking around town, and he shud-dered at the thought. He told his wife he didn't think they should go. But she insisted. Not only that she firmly announced that they were going to take little Maurice along! That was the real shocker to the elder Fox . . . taking a youngster . . . HIS youngster, in the bargain . . . into a saloon. And so it came to pass that the three Foxes apprehensively entered the highly reputable café . . . looking to neither the left or the right. A couple of surprised wags lustily greeted them, offered to set up drinks in honor of the occasion. But Mrs. Fox rather sternly asked the location of the great painting and examined the picture for a full five minutes—then hurriedly left. All that was 55 years ago . . . and Maurice Fox has given little thought to the incident . . . in all that time . . . until he stopped suddenly in his tracks during his recent visit to the Detroit Art Institute.

There as he strolled through the corridors, between walls hung with fine paintings, he stopped suddenly in his tracks . . . looked hard at the picture in front of him. He blinked his eyes several times . . . and looked again, entranced by what he saw. Sure enough, there on the institute wall was that famed painting from Churchill's, he hadn't seen since before the turn of the century . . . when his mother and father had marched him into a saloon.[26]

Haberle would have been delighted by this story and its lively humorous writing style. Many of his paintings decorated saloons even though such high-minded art lovers as Mrs. Fox did not consider them "fine art."

The Challenge (pl. 10), a recently discovered Haberle painting, was described by the *Boston Transcript* in 1896 as "a dueling pistol of the old style and a belligerent note demanding satisfaction which has been tacked up on the wall and used as a target." The article continues:

The public is invited to visit a free exhibition of Haberle's famous Realistic paintings on Monday, June 29 at Conway and Company's 48 School Street, Boston. Policemen and Firemen will be interested. . . . This exhibi-tion is the private collection of Mr. Frederick McGrath and cost $10,000. The exhibition will continue for several days. The most striking work is a picture of an old and worn one dollar bill. In this imitative line of still-life work Mr. Haberle is very skillful. Although this painting is executed in the usual way, it is difficult to believe that there is not some trick about it, so perfect is the illusion of reality.[27]

Plate 10. **The Challenge,** ca. 1890. Oil on canvas, 27⅞ x 15½ in.
Thomas Colville Fine Art

The article also mentions three other Haberle paintings in the exhibition: *The Clay Pipe, Jumping Jack,* and *Key to Libby Prison* (whereabouts unknown).

The *Boston Daily Globe* published a similar though less specific story: "Exclamations of surprise are heard at the exhibition of realistic paintings by Mr. John Haberle this week at 48 School Street. The collection is the private one of Mr. Frederick McGrath, and is open to the public for a brief period free of charge. So graphic are the reproductions of still-life that the spectator is tempted to refuse to believe that such results could be accomplished with paints and brush."[28]

The Challenge was probably commissioned, as its subject is so specific and masculine. The patron was probably from the New Haven area or from Springfield or its vicinity. It is signed (lower right) *J. Haberle* in the artist's "carved"-type signature.

The background of *The Challenge* is a gray wood surface—perhaps a door. It appears to be in excellent condition except for the joint at upper left, where the panel appears to be pulling apart—a sly, typical Haberle detail. The picture shows a target composed of five black circles, some of which are fading. Hanging from a nail left of the target is a brown flintlock dueling pistol made by the English manufacturer Ketland & Co. Such weapons were cheaply manufactured and exported to the United States.

Nailed above the target, at left, is a note on white paper. The lower right portion of the note is partially obscured by five black bullet holes. The note reads:

—son, Esq. Sir, nothing but a meeting on a field of honor will satisfy me after our recent episode. Accept this challenge or be forever branded a coward.

Yr. obed. Serv—
L.G.

The handwriting, in black, is in an eighteenth-century cursive style, written with a metal pen point. The Mount Vernon reference is unclear. William Reese has identified the script as a replica of the hand of George Washington.[29] The text may refer to the duel between Button Gwinnett and Lachlan McIntosh on May 16, 1777, in which Gwinnett was killed. The bullet holes on the note presumably obscure where Gwinnett's signature would have been an ironic Haberle touch.

How did Haberle get access to an original note in George Washington's hand in order to copy it? The note probably belonged to the patron who commissioned the work. Could that patron have been Frederick McGrath whose collection of Haberle paintings was on exhibition at Conway's at School Street in Boston in June 1896? Further research may someday reveal the full meaning of one of Haberle's most perplexing paintings.

4

A Remarkable Variety

·

Between 1895 and 1900 Haberle produced a number of works in two styles: a less precise trompe l'oeil manner and a loose Impressionist mode. These paintings also include a number of compositions based on variations on a theme.

After finishing *A Bachelor's Drawer* in 1894, Haberle declared that his eyes were ruined and he was giving up reproductive work. Painting in his "loose" style lessened eyestrain. By producing series and making only small changes each time, as in the *Slate* and *Torn-In-Transit* series, he could paint each canvas without designing a completely new composition—a clever compromise.

Frederick McGrath of Boston was the largest collector of Haberle's work, and an exhibit of his collection was held on School Street in 1895. It was well attended and covered in the Boston press. A slate (whereabouts unknown) owned by McGrath was described in the *Boston Gazette:*

> One subject that appeals to the sense of the ridiculous is a slate which looks as if it had upon its surface the attempt of an urchin to draw. A closer inspection, however, makes it apparent that slate, caricatures and all, are but the creation

of the artist, yet a very real creation they appear to be. In one corner a copy of a choice bas-relief seems to have been sculptured, rather than painted, and another picture of a woman is so daintily done in respect to the attire that the figure is seen as through a veil of gauze.[1]

There are three known paintings in the *Slate* series; at least two others are missing. All are approximately nine-by-twelve inches—close to the size of the actual object. As usual, Haberle chose an ordinary object for his subject. Slates, small pieces of slate framed in wood, were used for schoolwork and as memo pads for office, home, or shop notes in the late nineteenth century. The writing on the slate surface with a piece of chalk could easily be erased and the slate surface used again and again. It was more durable and less expensive than paper and proved to be a handy object before modern conveniences such as telephones, faxes, and e-mails.

The Slate Memoranda (fig. 11) is just such a humble object, embellished at the top with the word *Memoranda* handsomely rendered in red Gothic script. A small chalk pencil hangs between the letters *o* and *r* from a string nailed into the "wood" frame. It casts a soft, subtle shadow at right. A crack in

Figure 11. ***The Slate Memoranda,*** 1895. Oil on canvas, 12⅛ x 9⅛ in. Fine Arts Museum of San Francisco, Museum Purchase by exchange, gift of Miss F. M. Knowles, Mrs. William K. Gutskow, Miss Keith Wakeman, and the M. H. de Young Endowment Fund (72.29)

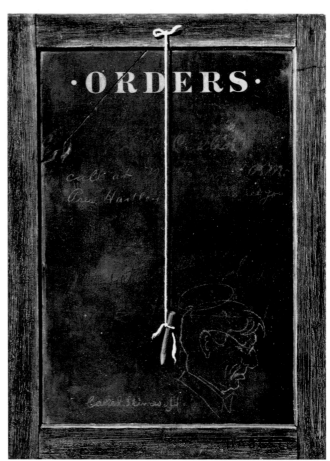

Figure 12. ***The Slate Orders,*** ca. 1890–95. Oil on canvas, 11 x 8 in. Private collection

the slate runs vertically from top to bottom at left. The surface of the slate is a realistic flat gray color embellished with chalk jottings in white. The left side is empty except for a few faint erasures and a jaunty, smiling stick figure at the bottom, which sports a wide grin and a white head feather.

Frankenstein thought that the stick figure represented the artist "as a dancing brave with a feather in his hair and with his name beneath broken into syllables in a feeble effort to make it look 'Indian.'"[2] Beneath it, Haberle signed the work *HAB-ER-LE* in clumsy capital letters.

A Boston paper reviewing the McGrath collection described a Haberle painting, probably *Memoranda:* "There is a very funny slate, which

appears to be covered with a small boy's handiwork. Looking closer, it is evident that the slate pencil, and even the frame, are only the work of the artist upon the canvas. There is not a real slate, but the imitation is very deceptive."[3]

Written in neat script on the slate at right is the message: *My Last slate at / Watertown* [a section of New Haven] and the signature *FRED.—* perhaps a reference to Haberle's neighbor and friend Fred Jones. A few random, vertical chalk strokes run through the message.

Another work in the *Slate* series has *ORDERS* neatly painted at the top in block letters (fig. 12), probably inspired by the type used in an office or a grocery store. A string nailed into the painted wood frame with a loop at the top holds a chalk pencil. The string divides the letters *D* and *E*. A dark shadow, the only one in the painting, is cast

to the right of the string. The slate is flaked and cracked at the upper left. Like Haberle's other slate subjects, its main surface is covered with partially rubbed out jottings, forcing the viewer to squint in order to decipher the smudged ghostly script. The note in the top right corner slate reads *F.L.H. called* and continues below at left *call at . . . PM.* Beneath it is the note *Pres. Hadley* [of Yale University] *wishes to see you* and beneath it *will soon / Gustave R. Sattig* and *called 3 times.* In contrast to the casual jottings, a precisely drawn profile of a man wearing spectacles, his mouth turned down, a delicate halo hovering above his head, appears at lower right. Below him at left, Haberle signed the work with his monogram. He signed the work again in crude capital letters at lower right *HABERLE,* as if carved into the wood frame.

The Slate is the third painting in the *Slate* series (fig. 13). Again, the precisely painted directions in neat capital letters suggest a note used in a grocery store or similar establishment. In this version, the string is broken, leaving a soft tassel of frayed cotton "nailed" into the top of the wood frame. The string, which holds a dangling chalk, is looped over the top of the "frame" at right. The gray surface of the slate is full of chalky scribbles; the top half contains a grinning whiskered cat with the caption in a neat script *but the cat can.* This phrase probably refers to the article "It Fooled the Cat" that Haberle inserted in *A Bachelor's Drawer.* At left is a dancing stick figure and a tick-tack-toe scribble. Written below is *Painting* in neat script, and beneath it, partially erased and scribbled over, is *A Bachelor's Drawer.* The next line reads *For Rent / inquire of / John Haberle / New Haven, Ct.* At bottom left is the word *Studio.* At the top left *HABERLE* is again "carved" into the frame. The artist extended the painted surface around the sides

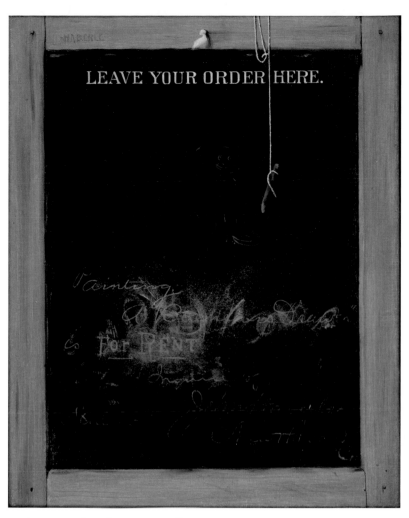

Figure 13. **The Slate,** 1895. Oil on canvas, 12 x 9⅜ in. Museum of Fine Arts, Boston, Henry H. and Zoe Oliver Sherman Fund (1984.163)

of the canvas, even including careful dovetailing at the joints of the frame, so apparently he intended the work to be hung with these edges visible and without a separate frame. The humor is in the contrast between the carelessness of the messy images on the blackboard and the precision of its actual printed form and that of the accompanying chalk that hangs on a string.

The *Slate* series confirms Haberle's training as a lithographer and engraver as well as his facility and passion for lettering. Despite the scribbled and erased notations, the *Slate* compositions are spare and monochromatic compared to the colorful clutter of ticket stubs, currency, stamps, coins, and other items in many of his earlier works. The series is particularly appealing to contemporary tastes

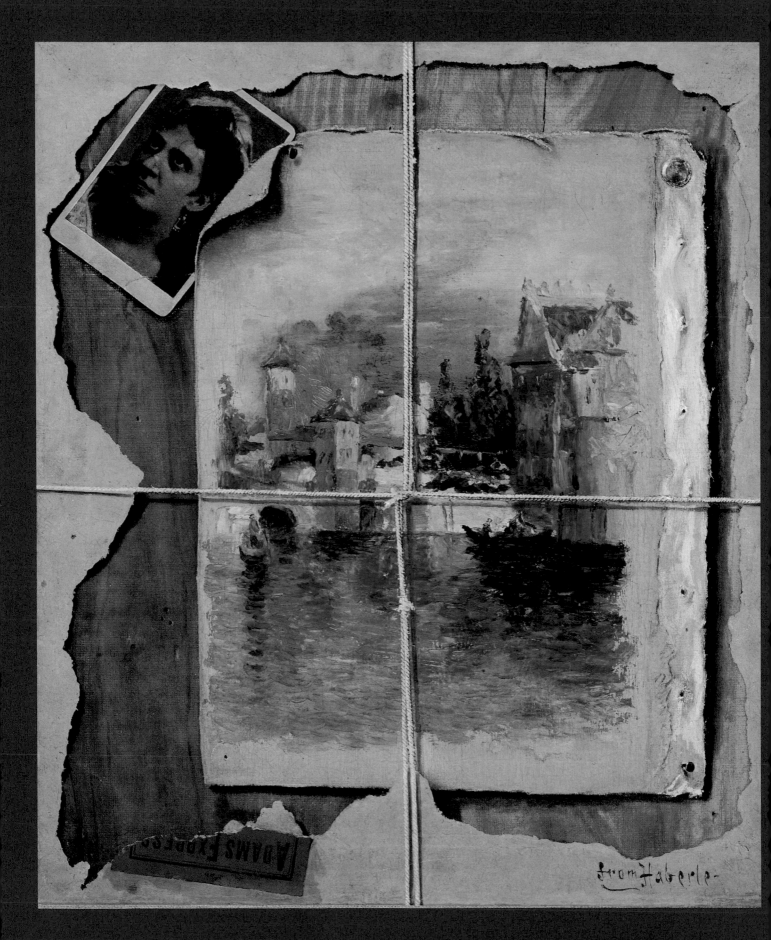

Plate 11. *Torn-In-Transit with Woman's Photograph,* 1888–89. Oil on canvas, 14 x 12⅛ in.
Memorial Art Gallery, University of Rochester, New York, Marion Stratton Gould Fund

because of its sparse simplicity, subdued coloring, and sense of nostalgia.

While Haberle painted the *Slate* compositions to resemble the actual object, the *Torn-In-Transit* works are only partially in the "imitative" style. The paintings themselves, worked in the broad style, become objects—paintings of paintings. This new concept was a clever compositional idea for Haberle. He continued to suffer from extreme eyestrain due to the demands of his trompe l'oeil style; the *Torn-In-Transit* compositions, all approximately fourteen-by-seventeen inches, were less demanding.

This series of canvases of partly unwrapped pictures demonstrates the artist's typical delight in his pictorial deceptions. While Haberle never attempted the classic letter-rack format, he came close in *Torn-In-Transit,* with its play of layered pictures in a teasingly shallow plane. "Both its puns on art about art and its sense of two-dimensional abstraction bring it close in spirit to Peto's work."[4]

A *Torn-In-Transit* picture owned by McGrath was included in his 1895 exhibition. The review in the *Boston Sunday Post* noted, "Another picture is a representation of a painting spoiled by the express company. This is so true to nature that more than one has advised the owner to get damages from the express company."[5]

The three variations in the *Torn-In-Transit* series include torn fragments of labels from Adams Express, a shipping firm with an office in New Haven. The first version, *Torn-in-Transit with Woman's Photograph* (pl. 11), includes a photograph, top left, of the popular opera singer Madame Nordica, "Star of the North," whose picture also appears in *The Changes of Time.* An unfinished landscape is carelessly tacked to the wood background. The landscape—rendered in a broad Impressionist style

in soft colors— resembles Lucerne, Switzerland, and is a view Haberle might have copied from a postcard. The rest of the painting—the torn wrapping, knotted twine, photograph, label, and wood support—is in Haberle's precise illusionistic manner. The knotted string casts a delicate shadow over the landscape. Haberle carried the illusion even further by continuing the painted wrapping paper and twine onto the edge of the stretcher.

The upper left edge of the canvas, nailed loosely to the wood, curls forward holding the photograph wedged between the canvas and the rough edges of the torn paper wrapping. The lettering in the red Adams Express label fragment, bottom left, is glued upside down and rendered in Haberle's most precise style. His own signature, *from Haberle,* appears in small letters at lower right.

The picture was shown in New Haven and reviewed in the *Register:*

> J. Haberle has a number of examples of his skill noticeable among which is a clever piece representing a photograph of an actress and a landscape painted upon a bit of razed canvas. This is represented as tacked into an old board. It is very deceptive and misleads the eye into the belief that the two separate pictures are actually fastened upon the board. It would humbug Barnum. Mr. H. has some good crayon drawings as well as some "poker work."[6]

Torn-In-Transit (fig. 14) is another variation, but this time the subject is pure landscape. In general, "Trompe l'oeil insists upon subjects that stay put in nature as they do in art . . . it should cause very little surprise that still lifes are very likely to be still."[7]

Yet, provocatively, almost the entire surface of *Torn-In-Transit* is a mountain landscape with

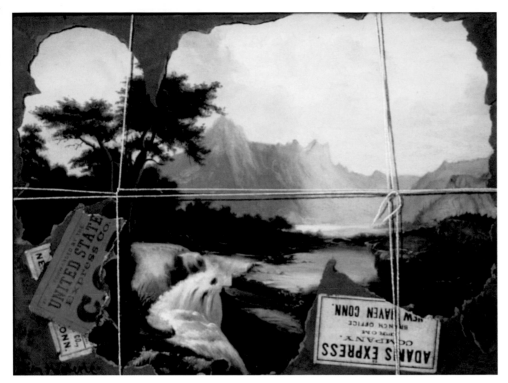

Figure 14: **Torn-In-Transit,** 1890–95. Oil on canvas, 13½ x 17 in.
Brandywine River Museum, Chadds Ford, Pa. , Gift of Amanda K. Berls, 1980

a lake and rushing waterfall spilling out at the foreground. The landscape, painted in a broad, rather clumsy style, is of the sort that was produced by the hundreds and sold inexpensively to decorate American homes of the period.

Haberle "wrapped" the painting in brown paper that is almost entirely torn off the package. The contrast between the ideal world of the landscape and the commonplace reality of the torn paper, string, and shipping labels makes it the most dramatic work in the series. The thin twine, clearly inadequate for shipping, divides the composition into six sections and casts delicate, illusionistic shadows on the landscape. The torn brown paper acts almost like a frame. The red label at left reads: *22 Forwarded by the United States Express Co., C.O.D* [partially missing]. A fragment of a green label beneath reads *New . . . Conn.* An upside-down yellow label at lower right, its corner torn, reads: *Adams Express / Company / from / Branch Office / New Haven Conn.* The painting is signed lower left *From Haberle* in his script style.

Torn-In-Transit, Express Company, C.O.D (pl. 12) uses the same formula but "wraps" a different landscape. The three shipping labels in Haberle's most precise lettering can be easily read. Most obvious is the torn yellow label *Adams Express / Company from / Branch Office / New Haven Conn.* at right. A fragment of a green label below reads *NN.* At left is a red label *22 Forwarded by the United States Express Co., C.O.D.* [partially missing]. The painting is signed in his script style, *From John Haberle.*

Writing about the *Torn-In-Transit* series, Wendy Bellion noted:

Haberle relegated almost all trompe l'oeil details to the pictures' margins, thereby minimizing potential harm to his eyes while maximizing illusionistic possibilities. . . . This was not a novel trompe l'oeil concept: around 1480, a Ferrarese painter first represented the scene of a canvas concealed by, then stripped of, a wrapper. Haberle modernized this illusionistic conceit by cunningly simulating pictures partially shorn of their mail packaging.[8]

Frankenstein commented further:

In both of these works the effect is that a painted landscape—in one a view of a town seen from the water and in the other a cottage on a neck of woodland between a lake and a stream—has been shipped in a paper wrapping which has been torn open in transit. In each, most of the canvas is taken up with the

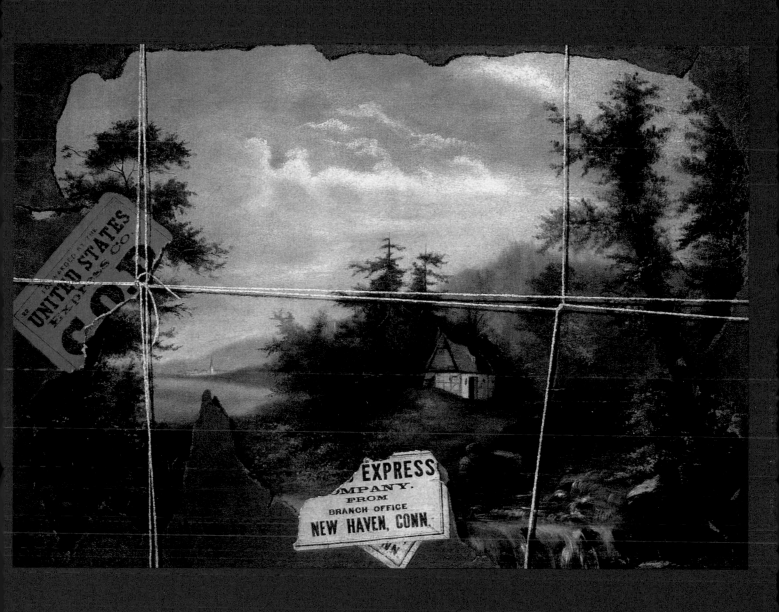

Plate 12. ***Torn-In-Transit, Express Company, C.O.D.,*** ca. 1889. Oil on canvas, 14 x 17 in.
Private collection. Photo courtesy Berry-Hill Galleries, Inc.

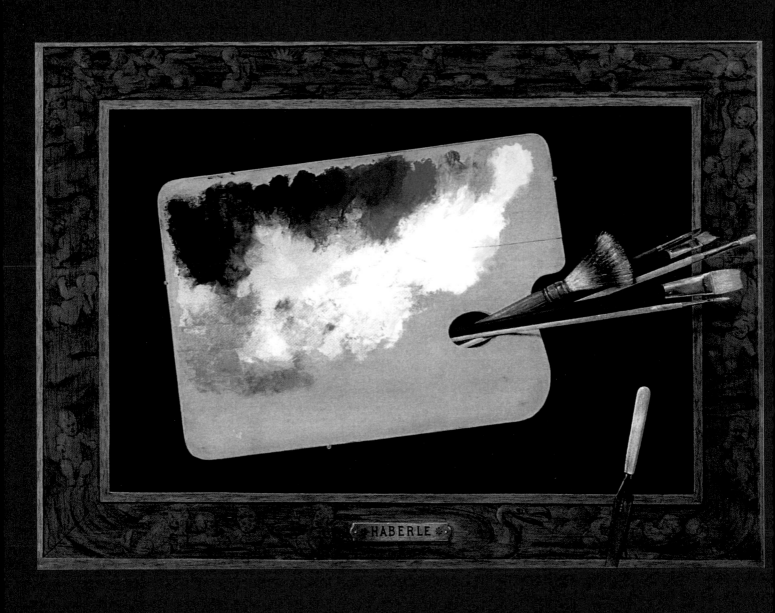

Plate 13. **The Palette,** ca. 1882. Oil on canvas, 17½ x 24 in.
Private collection

landscape, which, in the nature of the game, had to be done in a broad, free, splashy style. The wrapping paper, the string, and the shipping labels are, of course, illusionistic, but they occupy a minimum of space. And when one arrives at the point where the nonillusionistic elements in a work of *trompe l'oeil* occupy nearly all the space, one can go no further; this is the end of the line.[9]

Haberle's palette series is probably his most unusual. It includes two paintings and a drawing. While neither painting is dated, one was offered for sale at Gill's Thirteenth Annual Exhibition of American Paintings, in 1890.[10]

A reviewer for the *Detroit Evening News* wrote:

Still-life is supposed to be the only kind of artistic work in which Mr. Haberle excels. That is not the case proven by another one of his works in Mr. Preston's possession. Known as *The Palette,* it is a painting of an artist's palette with little daubs of color around the edge which seems to have just left the tubes. The border is a study of about 20 children's heads, forms, and figures. Still-life is not a favored branch of artistic work, both on account of the difficulty of excelling in it, and the minuteness of the work required. Figure painting calls for every bit as much practice and an altogether different kind of skill. Infant figures are by far the hardest to faithfully portray, but Haberle here clearly demonstrated that were he to make a specialty of this class of work he would gain even greater fame, if possible, than he has as a still-life artist. Each and every figure on this border is a gem, and, for the sake of American art's reputation, it is to be hoped that Haberle's

eyesight will allow him to branch out into this fresh line.[11]

The Palette (pl. 13) is a two-dimensional trompe l'oeil of a palette, paintbrushes, and palette knife painted to scale. The palette, of pale yellowish beige wood, is set at a slight angle against a flat black background. An assortment of six brushes has been thrust haphazardly into the thumbhole. They project beyond the painted "frame" and throw soft shadows on it. The colors are neatly arranged along the top of the palette in a loose, colorful abstraction, from black to white. Below them, the colors are mixed from gray to blue to pink to white, as if the artist were in the process of creation and had casually thrust the brushes in the thumbhole for a momentary pause. The artist's ivory handled palette knife, *New Haven* marked on its blade, is wedged below into the lower molding of the painted frame.

The composition is set within a painted trompe l'oeil frame "carved" with a border of twenty-two nude babies frolicking among the waves—an incongruous juxtaposition of subjects. "Screwed" to the border is a painted metal label, slightly bent, marked *HABERLE.* A lively pelican, its large beak open, swims from underneath the right side of the label, alarming the chubby infants cavorting nearby. The static quality of the central still-life composition juxtaposed against the lively and unusual border is typical of Haberle. The combination of freely mixed paints on the palette knife makes this one of Haberle's most "modern" compositions.

The Artist's Palette (fig. 15) is a remarkable work, unique in Haberle's oeuvre and indeed in nineteenth-century American art. It is an assemblage of five actual paintbrushes and a palette knife attached to

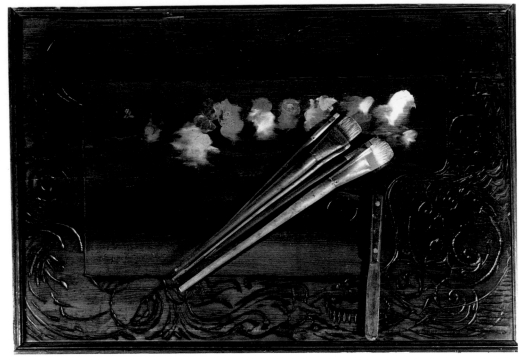

Figure 15. **The Artist's Palette,** ca. 1890–95. Oil on panel with brushes and palette knife, 18 x 27 in. Private collection

a wood panel. The shape of an artist's palette was burned into the wood with a hot stylus, a novel technique known as pyrography (on his business card, Haberle offers lessons in this technique, calling it Drawing on Wood).

Blobs of paint are arranged along the top of the palette, ranging from creamy white to umber. Some of the colors have been smudged, suggesting use, even though the brushes and palette knife are pristine. Haberle outlined a knot in the wood to suggest the hole for the artist's thumb. The brushes are set at a dramatic diagonal through the center of the composition and seem to defy gravity, as there is no obvious method of attachment. A real palette knife, with a brown wooden handle, balances below the thumbhole. No trace of paint adheres to the blade.

Surrounding the palette is an elaborately incised border that Haberle burned into the richly grained wood surface and then enhanced with dark brown paint. The largest and most ornate embellishment is at right within the curve of the palette: a scroll enclosing a voluptuous mermaid with waves curling around her tail. Above, another sea creature emerges

from a stand of grass. The top border encloses in its waves a pair of cupids riding back to back on the rays of a radiating star above. In the upper left corner, an elongated cloud passes over a crescent moon. Beneath the moon, a rabbit stands erect, ears alert atop a circular scroll. A cresting wave appears at lower left and joins with the sea border at the bottom. A beaked sea monster, a frolicking infant, and a scaly fish complete the unusual border design.

The Artist's Palette was originally enclosed in a velvet-lined shadowbox and bordered with an elaborately carved gilt frame in the Victorian manner. Haberle used this framing style for a number of his trompe l'oeil compositions. With this technique, Haberle, in the obscurity of Morris Cove, seems to have anticipated the twentieth-century innovations of Duchamp's Readymades and Picasso's assemblages such as *The Bull* (1943; Galerie Louise Leiris, Paris), a sculpture consisting of the rearranged seat and handlebars of a bicycle. Haberle's assemblage, however, is more formal, requiring careful craftsmanship and less spontaneity. The innovative *The Artist's Palette* apparently did not appeal to Haberle's public since it descended in the family until 1984, when it was sold.

In the meticulous, palette-shaped ink drawing *The Palette* (private collection), Haberle superimposed a drawing of a palette over a railroad bridge, a rural landscape incorporating long railroad tracks, and a curving country road with small cottages and telephone poles. The subject within the palette is a

girl knitting, seated cross-legged on a folding stool in a lush tropical landscape. The thin strip she knits incorporates the name *HABERLE*. The drawing may have been intended for a lithographed trade card, as these often incorporated illusionistic devices.

Time and Eternity (pl. 14) is Haberle's version of a vanitas picture, a theme popular in northern Europe after the Reformation. Vanitas pictures typically present a collection of objects that reflects the transience and uncertainty of life. An hourglass denotes the passage of time; coins and jewelry, the folly of wealth. Food reflects the evanescence of the senses; playing cards, the foolish risk of gambling; a musical instrument, the sense of hearing, which will also soon be gone. European vanitas paintings, however, were detached and objective, rarely incorporating personal objects or opinions, as did Haberle's paintings.

Haberle took objects from his life—a watch, rosary, ticket stubs, playing cards, a photograph, a newspaper clipping—and arranged them to make his own subtle, ironic version of an American vanitas picture. The title, *Time and Eternity,* has multiple meanings, as Haberle's titles so often do. It comes literally from within the painting itself—from the headline on the torn newspaper clipping at the lower left, *Time and Eternity*—as well as from the objects that form the composition. It may also refer to a popular poem of the period by Rollin John Wells entitled "Growing Old." The last line of the first stanza reads, "And so we are nearing the journey's end, / When time and eternity meet and blend."

Below the headline, in smaller type is *Bob Ingersoll / Providence, July 4.* The text then reads provocatively: *In the county jail awaiting trial.* The word "Providence" may be a pun on the religious reference. Also, ironically, July 4 is the day when freedom, not

incarceration, is celebrated. The clipping refers to Robert Ingersoll (1833–1899), known as the Great Agnostic. Nicknamed "Injursoul," he was a prominent American lawyer and orator who gained popularity as a fiery, wise, and witty speaker. He charged as much as $3,500—a princely sum—for his lectures, which ranged in subject from Shakespeare to the abolition of slavery to universal suffrage. Ingersoll felt the South was responsible for Lincoln's assassination and did not believe in established religion. His unconventional views were widely published. Ingersoll was a target for fundamentalists, who may have been responsible for putting him in the county jail. In 1880 and 1895 he was tried for blasphemy and acquitted.[12]

A pocket watch—symbol of time—hangs from a nail above the newspaper clipping. Its lens is cracked and its Roman numerals fading, and the hands are stopped at 2:26. Ingersoll was also a brand of popular, inexpensive watches, and Haberle may well have intended this visual pun. The watch casts a shadow to the right. Beyond the watch, eternity and religion are represented by an unusual string of brown wooden rosary beads terminating in a primitive, carved crucifix.[13]

The three-dimensional beads act as an anchor, holding down the scrambled assortment of flat objects—themselves symbols of worldly life. They contrast the spiritual with the temporal, the sacred with the profane. The colorful playing cards—a nine of hearts and a king of spades—suggest gambling. Beneath them rests paper currency (perhaps a five-dollar bill), a lavender theater stub marked *Right C 10,* a pink pawnbroker's receipt, a coy woman's photograph from a cigarette package, part of an insurance policy, a bookmaker's receipt,

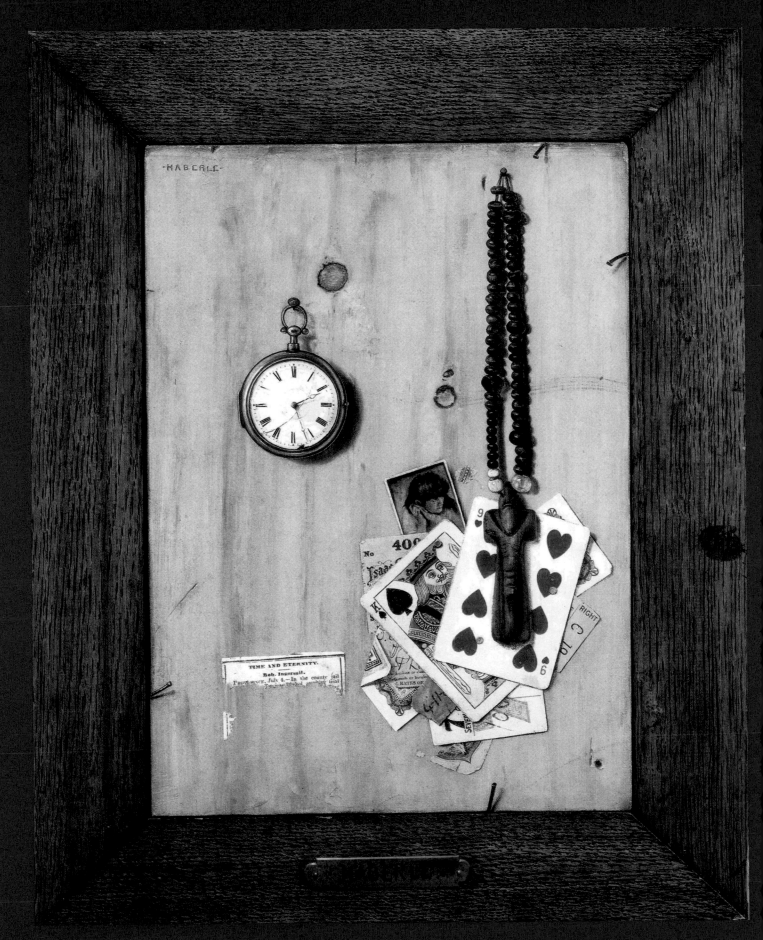

Plate 14. *Time and Eternity,* ca. 1889–90. Oil on canvas, 14 x 10 in.
New Britain Museum of American Art, Stephen B. Lawrence Fund (1952.01)

and a card with a lucky 7. A tiny scrap of printed gray paper rests at right of the photograph. The few tiny letters read *Grave*—perhaps part of the word "engraved" or a reference to death. The scrap appears to have come from an engraved document.

Haberle drove two small nails into the nine of hearts to prevent the whole conglomeration from collapsing—the only time he resorted to such a practical device. Usually, his trompe l'oeil arrangements, no matter how complicated, seem to be magically secured to their backgrounds. The composition is arranged against a pale yellow pine "board" whose grains and knots are carefully rendered. Five thin nails are randomly placed on all four sides of the "board" and "hold" the painting within the real simple brown wood frame. A brass label below on the frame identifies the painting. Haberle signed the painting at the upper left with his last name in his "carved" manner, as if the letters had been scratched into the board with a penknife.

Time and Eternity is one of Haberle's most philosophical paintings, contrasting in both obvious and subtle ways the juxtaposition of the material life with the religious, contemplative one. While not a conventionally religious man, Haberle stated his religious attitude to Vera in 1925. "If he liked the word of God, he would prefer theocracy to all other forms of government. . . . He doesn't think the creator expects to be worshipped, and would be quite content if we just obeyed his laws. He sees and knows there is a creative power."[14]

In a letter dated November 7, 1891, Elizabeth Champney asked Haberle to offer *Time and Eternity* to a charity art sale at Sherry's, a fashionable restaurant in New York, on December 3 and 4. The art sale would benefit the Messiah Home for Children.

We expect to have a very choice exhibition of paintings, and hope to make sales. Our plan is not to beg paintings, but to put ourselves in business relations with the artists, asking them to name to me their lowest prices and making as large an amount as possible above that for our charity, thus keeping the artists' regular prices before the public, while sharing the profits of the sale. We intend to have the exhibition extensively written up in the daily press and expect that it will be largely attended.[15]

It is not known whether Haberle ever donated *Time and Eternity* to the benefit or if it sold. It came to light in an antique store outside Boston in summer 1951.

Clock (pl. 15) is a painting that becomes an object, a departure for Haberle. He actually created a three-dimensional clock by stretching the canvas over a wood frame. Which came first: a painted flat canvas that was later stretched over the frame or the stretched box on which the clock was painted? Haberle probably copied the work from a clock of his own. Such shelf clocks were made by the thousands in Bristol and Thompsonville, Connecticut, and sold for reasonable prices all over America.

The constructed case looks like deep brown veneer with narrow wood moldings. On its door Haberle painted a composition that resembles the reverse-painted pictures on the glass panels of the Connecticut clocks. It shows a freely rendered lake view with mountains in the background and a tiny sailboat on a pale blue sea. A patch of green grass in the foreground completes the scene.

Frankenstein recalled:

One is a picture of a clock which stands about four feet high and is not nailed to an ordinary stretcher but to a boxlike affair some four inches deep, so that the canvas turns back to that

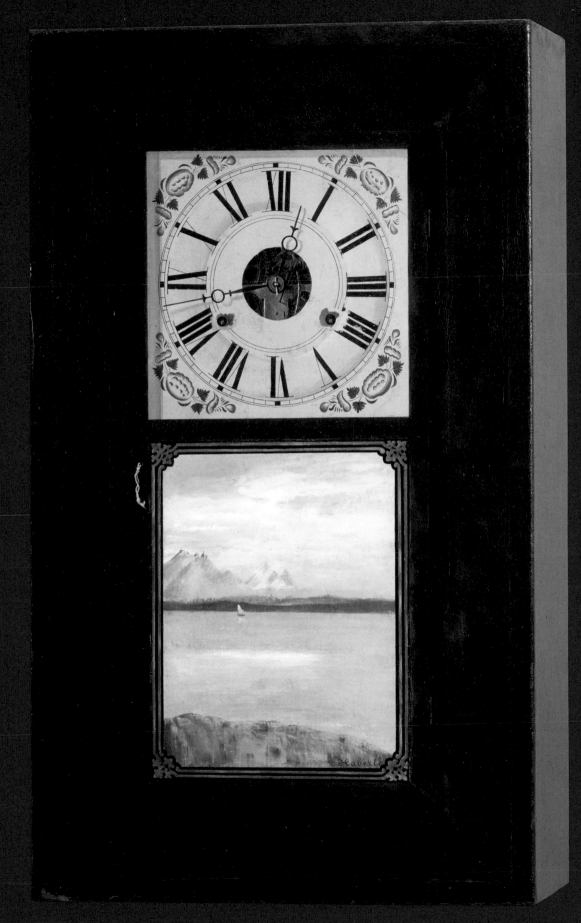

Plate 15. **Clock,** 1895. Oil on canvas and wood construction, 26¼ x 15½ x 3¾ in.
Newark Museum, New Jersey, Purchase 1971 Charles W. Engelhard Foundation (71.166)

depth on all four sides and creates the effect of a palpable, three-dimensional object. This picture stands, or did stand, on a dark shelf above the stairway in Haberle's house and I passed it three or four times before I even faintly suspected that it was not an actual clock.

The face of this timepiece is executed in a meticulously realistic manner, but beneath the face is a landscape in the very cheap and commonplace style one associates with paintings on glass made to be inserted in the doors which give access to the mechanism of old-fashioned clocks. In other words, much of the illusionistic effect produced by this painting arises from the fact that a good part of it is *not* illusionistically painted.[16]

Haberle signed *Clock* in script at the lower right on the grass. A painted gold linear border, embellished with fleurs-de-lis in the four corners, sets off the view. Above it the white face of the clock itself is decorated with floral motifs that appear to be stenciled, while the Roman numerals are precisely painted. The hands of the clock, which cast subtle shadows, point to 12:43. Roman numeral IIII is peeling, as is the surface around the adjacent screw and its counterpart on the other side. The complicated clock mechanism with interlocking wheels is partially visible through the central opening. Apparently, the key to the clock door has been lost, and a limp twisted string replaces it.

As Franklin Kelly observed:

> Three-dimensional illusionistic constructions such as *The Clock* . . . are rare in American Art and, indeed, in the history of trompe l'oeil painting. It is easy to understand why this is

the case, for creating a convincing illusion of a flat surface, or of a space that projects a few inches *behind* the planes of a canvas, requires minimal suspension of disbelief on the part of the viewer. An actual painted three-dimensional object, on the other hand, must occupy space so accurately and so seamlessly as to be accepted as a real thing with mass and volume. It must project into the space occupied by the viewer and cannot rely on perspective or other purely visual means to work its magic.[17]

Clock is actually a shaped canvas, a nineteenth-century precursor of the twentieth-century sculptural shaped canvases of Jim Dine, Frank Stella, Lee Bontecue, and others. "Haberle here uses the same device, but for the purpose of *heightening* illusion by means of thingness or objecthood. Parallels between Harnett, Peto, and modern artists are often drawn, but it takes John Haberle to parallel the moderns by turning them inside out."[18]

A Favorite (pl. 16) is the painting that brought Haberle to public attention in 1948 after half a century of obscurity. It is one of his contributions to the popular genre of smoking paraphernalia. Frankenstein wrote:

> Until the present writer's work began, Haberle was known to the art world solely through two small *trompe l'oeil* paintings in the Springfield Museum of Fine Arts, where they were catalogued as works of "J. Haberle, XIX Century, American". . . . No one knew where Haberle had lived, and if it were not for the fact that the Art Institute of Chicago keeps its exhibition records in the form of a card-index file, Haberle would have remained as mysterious as Dubreuil or F. Danton, Jr., but in searching

Plate 16. **A Favorite,** ca. 1890. Oil on canvas, 14½ x 11½ in.
Michele and Donald D'Amour Museum of Fine Arts, Springfield, Mass., Gift of Charles T. and Emilie Shean

the Chicago records for the name of Harnett (which was not to be found there), I accidentally turned up a nearby card on which was written "John Haberle, 27 Winthrop Avenue, New Haven, Connecticut" and the titles of three pictures by this artist which Chicago had seen in 1888, 1889, and 1890.[19]

Still-life paintings of smoking materials were popular in Europe, especially with male patrons, and migrated to the United States in the nineteenth century. Harnett painted several smoking still lifes that included pipes, tobacco, cigars, and matchboxes; Peto and others followed the trend.

Haberle, ever the individual, presented his own unusual composition of smoking materials. In *A Favorite*, a cigar-box lid, slightly askew, is seemingly set into a rectangular hole cut into a yellow pine board. The board is tacked down, presumably to a wall, by three screws at the corners. The screw at the top right has fallen out. The cigar-box lid is carelessly secured with a toothpick wedged into the right-hand edge and a nail protrudes into the wood above it. The cigar-box top has come loose, revealing black space at bottom left and top right. A mysterious small door has been cut in the center of the cover and is attached at the top with a makeshift leather hinge. A loop of string dangles provocatively from the bottom edge of the door, coaxing the viewer to pull it open and see what surprise awaits inside. Wolfgang Born remarked on the mysterious door, "In the top of the cigar box is a hinged flap that can be opened by means of a cord forming a sling. This contrivance suggests the playful tinkering of a boy—children saw holes in cigar box lids and would drop marbles through."[20] The brand name *FLOR* is incised into the wooden top of the cigar box. A

similar top is used as the background in *Yellow Canary*. Sturdy cigar boxes were often recycled as handy catchalls for everything from household odds and ends to currency containers in banks.

To the left is a well-used Meerschaum pipe suspended on a tasseled cord from a brass tack. At right, serving as an improvised match holder for four matches, is a crumpled photograph of the kind that was included in cigarette packages in Haberle's day. The bonneted young woman smiles coyly as she holds a kitten, unaware of her undignified fate. Scratches on the board above the match holder indicate a bit of sandpaper that had once been attached there to serve as a striking surface. Haberle's incised signature appears at lower right under the carved profile of a man smoking, perhaps Haberle himself. A thin wisp of smoke drifts from the cigarette and disappears into the pattern of the wood grain.

A Favorite was offered for sale for $450 in 1891 at the Fourteenth Annual Art Exhibition at James D. Gill's Stationery and Fine Arts Store of Springfield and is illustrated in Marlin's article 1898 article on Haberle in the *Illustrated American*, where it is identified as the property of Walter D. Jones of New York City.[21] Apparently, Charles T. Shean, proprietor of the Hotel Charles in Springfield, purchased the painting sometime after 1898. *A Favorite* was part of Shean's collection of American trompe l'oeil paintings that hung in the hotel bar and poolroom before being moved into a gallery on the ground floor of the hotel designed specifically for art. The Sheans donated Haberle's *A Favorite* and *Twenty Dollar Bill* to the Museum of Fine Arts in Springfield in 1939.

Pan of Fresh Flowers is a rare floral by Haberle, rendered in his "loose" Impressionist style. The bouquet was probably picked by the artist

Plate 17. **Pan of Fresh Flowers,** ca. 1895. Oil on canvas, 20 x 36 in.
Private collection. Photo courtesy Kennedy Galleries, Inc.

Figure 16. ***Grapes on a Ledge,*** ca. 1895. Oil on canvas, 6 x 15¾ in. Harvard Art Museum, Fogg Art Museum, Anonymous gift (2004.193)

himself, as neighbors recalled his Cove Street cottage being surrounded by a lovely garden. The selection includes geraniums, nasturtiums, pansies, daisies, phlox, petunias, and dusty miller rendered in clear natural colors.

Flower paintings, usually formally arranged in fancy vases, were a popular subject during the Victorian period. Ever the contrarian, Haberle casually set his bouquet in a tin dishpan placed off-center on a white cloth and painted the summer flowers as they arranged themselves. The canvas is signed at lower right *J Haberle* in his script style. As William Gerdts and Russell Burke so aptly observed:

> Haberle's eyes began to trouble him in the mid-1890's, and trompe l'oeil became an impractical approach for him. But he did not abandon still-life painting; he merely changed his style. Haberle's later pictures are flower and fruit paintings, often set out of doors. They are colorful and full of light, broadly painted, with soft forms and juicy brushwork. Quiet pictures, with nothing fantastic or magical about them, they are not readily identifiable as Haberle's. But they are pictures of beauty and

real quality, and it may well be that, after the excitement of the rediscovery of the trompe l'oeil school subsides, more attention will be paid not only to later nineteenth-century artists who chose not to use this mode of expression but also to non-trompe l'oeil pictures by artists of this school.[22]

In *Grapes on a Ledge* (fig. 16), the complexity and precision of the artist's tightly illusionistic style have given way to a simple, freely rendered still life. A modest Impressionist composition in the artist's "loose" style, it appears to have been painted outdoors, with the grapes bathed in dappled sunlight. Two bunches of grapes, still attached to the vine, rest on a white canvas, the texture of which shows through in several places. Haberle appears to have painted this work spontaneously, perhaps even drawing the grapes directly on the canvas with his brush. The lush purple Concords, a common New England variety, were probably picked from Haberle's grape arbor at his home. The subtle tonality of the grapes, ranging from deepest bluish purple through pale green to umber with red highlights, confirms his skill as a colorist.

The painting is signed in a free manner, incorporating the *J* into the first stroke of the *H* of Haberle—the signature used on Haberle's "loose"

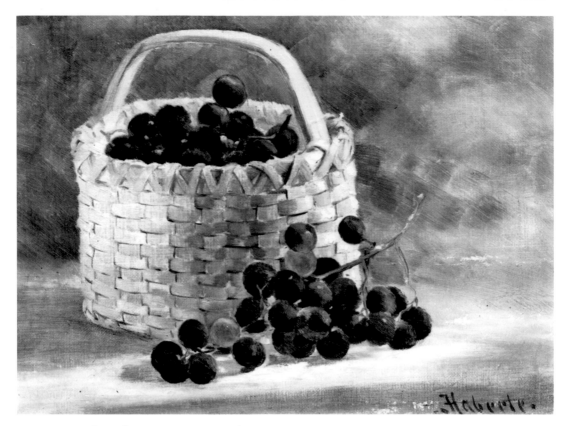

Figure 17. **Basket of Grapes,** ca. 1890. Oil on canvas, 8⅞ x 11¾ in. Private collection

style compositions. According to Vera, Haberle exhibited *Grapes* at the Fifty-fifth Annual Exhibition at the Pennsylvania Academy of the Fine Arts, in the late 1880s or early 1890s. It did not sell and remained in the Haberle family.[23]

In *Basket of Grapes* (fig. 17) the fruit fills a tan basket with a handle. A triangular bunch of grapes rests at the lower right edge, casting a shadow on the center of the basket. Although the basket and grapes rest firmly on the horizontal surface, the surface and background are indeterminate, neither indoors nor out. The woven texture of the canvas is evident given the thin application of paint; a swath of white paint highlights the lush, varied purple of the grapes. The signature, *JHaberle,* is in the same style as that in *Grapes on a Ledge.*

The small still life *Basket of Orange Cherries* (private collection) is atypical of Haberle's style and subject matter of 1887, when it was painted. That year, Haberle exhibited *Reproduction* and *Imitation,* currency compositions in his most precise

trompe l'oeil style that received much attention and sold quickly. The paint application in *Basket of Orange Cherries* indicates that Haberle was already experimenting with a free Impressionist style. The paint is applied thinly and smoothly with no impasto or evidence of brushstrokes. The color is clear, realistic, and carefully modulated. The open wicker basket with a handle is set on grass before a vague darkened background at left. At right a blue sky glows through the clouds and blades of grass sway in the breeze. This loose, open background contrasts pleasingly with the more precise rendering of the cherries. The painting is signed *Haberle '87* at lower right.

This kind of modestly priced still life was popular with Victorian collectors, especially women, who found them decorative additions to parlors and dining rooms. They were worlds apart from Haberle's illusionistic paintings of currency and masculine subjects that sold for high prices and decorated men's offices, saloons, and hotel lobbies.

5

Boston Triumph:
New Directions

Haberle had his first and only one-man show, in Boston in June and early July 1896. It was a highlight of his professional career. The paintings, from the collection of Frederick McGrath, were exhibited free of charge to the public at Conway's, a retail liquor store that he owned. McGrath had recently purchased the Haberle paintings from the Boston art dealer and collector C. E. A. Merrow. While there is no record of which pictures were included in the exhibition – probably about a dozen—they were valued at ten thousand dollars, a considerable sum at the time.

Two identical reviews ran in the *Boston Times* and the *Boston Gazette* on June 28, 1896:

> Tradition tells us that there have been painters, both in ancient and modern times whose art was so realistic that when they put flowers upon canvas, bees would hum about their easels in quest of honey. The counterpart of such genius is seen in a group of masterpieces of similar character from the brush of Mr. John Haberle, to be placed on exhibition beginning next Monday in the establishment of Messrs. Conway & Co., 48 School Street, Boston. So realistic are reproductions of such subjects

as bank bills, newspaper clippings, and even photographs, lithographs and engravings that the spectator is amazed and almost ready to assert that what he sees is a clever arrangement of actual objects, instead of representations on canvas done with the brush and paints alone.

> These wonderful paintings have recently become the property of Mr. Frederick McGrath, having been acquired through Mr. C. E. A. Merrow, the well-known collector at the cost of $10,000 with the explicit understanding that before they are withdrawn from public view the purchaser shall give at least one free exhibition within a year after they came into his possession, and in some convenient location.

> They have therefore been placed with Messrs. Conway & Co., 48 School Street for this purpose and the public will be permitted to view them for a brief period, free of charge.[1]

The *Boston Post* reported:

> Marvelously realistic are the paintings of Mr. John Haberle now on exhibit at 48 School Street where they are inspected by a constant stream of interested lovers of the unique and

wonderful in art. Mr. Frederick McGrath's private collection of the work of Haberle is secured through the art expert Mr. C. E. W. Merrow and its principle feature is the distinct realism of each one of the canvases.

The spectator is very apt to doubt the assertion that the work has been accomplished with brush and oil colors alone until he has been permitted to gaze at the production through a magnifying glass which brings out in bold relief the fact that the statement is indisputable. One stands before a small frame, which encloses the representation of a $5 bank note, and is already to aver that it would be impossible for an artist to perform such a seeming miracle.

It would be so much easier to believe that a real bank note had been pasted upon that background, that it is hard to convince many of the skeptics who linger in front of copies of engraved work, and one man who is known beyond the limits of Boston as an art critic was heard to say "If I had not seen it through a very powerful microscope, I should have refused to believe it to be a genuine painting without witnessing the artist actually at work on the subject."[2]

The critic apparently knew Haberle and had perhaps seen him at work in his studio. The reference to the possibility of a "pasted" bank note echoes the accusation of the Chicago art critic of 1889 regarding *U.S.A.*

Two other important Haberle paintings from the 1890s include *The Editorial Board*, a rack-type composition similar to those of Harnett and Peto, and *Realistic* (both whereabouts unknown).

The Editorial Board was shown at the National Academy of Design in 1889.[3] *Realistic*, also known as *Japanese Screen with Spanish American War Heroes*, was a large painting that included a marble bust of Washington standing on a plinth set against a Japanese screen showing images of American war heroes, letters, and other printed scraps.

The Clay Pipe (fig. 18) is Haberle's most spare and elegant trompe l'oeil painting. It was owned by McGrath and included in his 1896 exhibition. *The Clay Pipe* contains only a long-stemmed churchwarden clay pipe, a sack of pipe tobacco, and four matches. A narrow silver-gray wood panel with graining and cracks serves as the background. A flat gray molding that acts as a frame encloses the panel. A round-headed nail, top left, holds the loop of string attached to the bowl of the pipe. At right is a white fabric bag of pipe tobacco suspended from a string attached to a small tack. The sack is open, as the official blue government seal is broken and the tobacco label torn. The remains of a red label and partial black lettering supply color and pattern to the largely monochromatic composition. The tobacco brand is Duke's Mixture, a variety so inexpensive that it was said to be made of factory-floor sweep-ups. "The simple arrangement of the objects creates an orderly system of repeating vertical lines, giving the painting a static, iconic character quite different from more crowded works by Haberle.... The traditional gift of a clay church-warden pipe and packet of tobacco to each Yale student upon graduation dates from the 1860's."[4] "Perhaps after prayers . . . or perhaps before . . . they formed a ring again and had another smoke, ending up with a rush or stag dance in which all the pipes were trampled and broken, as a sign that the pleasures of college life were ended; and then

each took the other by the hand and said goodbye."[5] Haberle was probably familiar with this tradition because of his close connections with Yale through his work with Professor Marsh at the Peabody Museum.

With its simple composition and subdued color scheme, *The Clay Pipe*, signed *J. Haberle* in block letters at lower right, emits an air of tranquility and nostalgia. It is among Haberle's contributions to the smoking theme. Harnett, Peto, and others included various kinds of pipes in their paintings of smoking paraphernalia, yet the fragile and simple clay pipe rarely appears in these popular compositions. As I observed in an earlier study:

> Haberle painted many of the same subjects popular with Harnett and Peto. In addition to currency, these consisted of letter racks, smoking materials, peanuts, guns, musical instruments, newspaper clippings, photographs, and such bits and pieces as receipts, scraps of paper, and tickets. Occasional Haberle paintings, such as *Clay Pipe*, are reminiscent of the severe, simple paintings of single objects executed by Harnett about 1886 to 1890. Two other works by Haberle which remain unlocated, a painting of a violin and *The Challenge*, which depicts a pistol nailed against a wall, probably also resemble these works by Harnett.[6]

Typically, Haberle painted objects that had been used; the pipe bowl is discolored from frequent smoking and tobacco still rests in its bowl. Some of the ashes have fallen from the

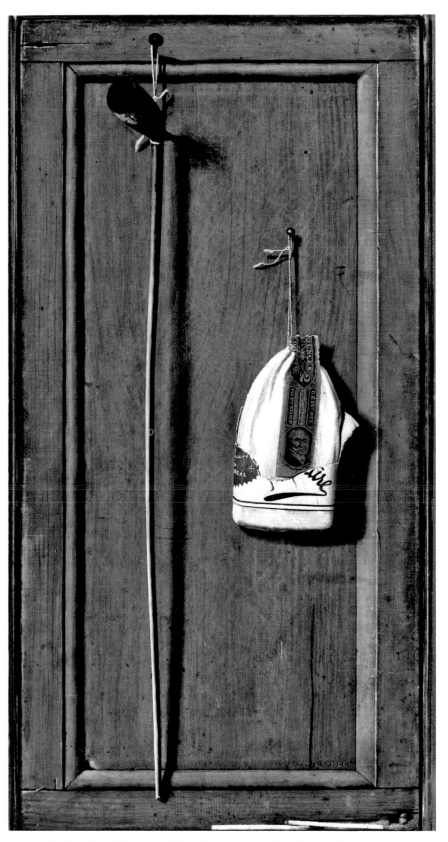

Figure 18. **The Clay Pipe,** ca. 1890. Oil on canvas, 18 x 8¾ in. Florence Griswold Museum, Old Lyme, Conn., Gift of The Hartford Steam Boiler Inspection and Insurance Company (2002.1.62)

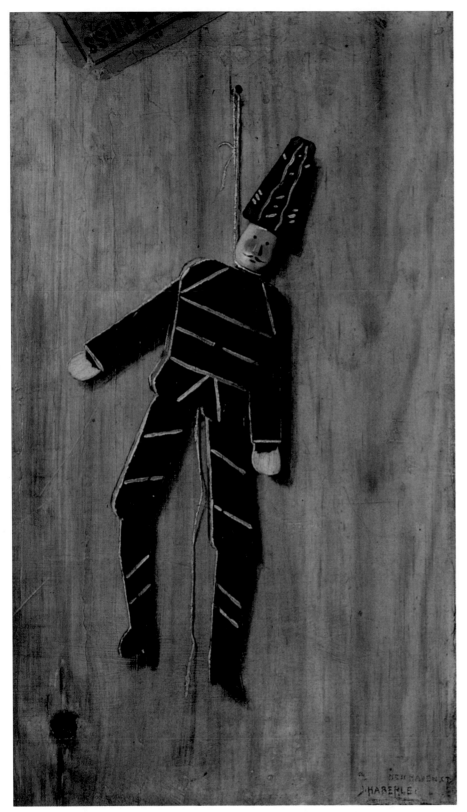

Figure 19. **Jumping Jack,** 1888. Oil on canvas, 14 x 8 in.
Private collection

broken head of one match has ceased to smolder. Light comes from the left and casts soft shadows since neither the pipe nor the tobacco pouch is flat.

Jumping Jack (fig. 19) is inscribed, dated, and signed *New Haven, CT. / J. Haberle / 1888*. It, too, was probably included in the McGrath collection exhibition. The composition is a simple one: a jumping jack, a popular toy of the period, perhaps imported from Nuremburg, Germany. The arms, legs, and body of the toy are flat, cut from tin, and painted a deep blue with white stripes. They are joined together and would "jump" when the connecting string was pulled. Here, that essential string hangs limply between the legs. A delicate shadow is cast on the right side of the toy. The head and tall hat are painted with more careful attention, as they were three-dimensional, of carved and painted wood.

The facial expression of the toy soldier, with his crisp mustache, rosy cheeks, and tiny black eyes, is amusing. He seems surprised and somewhat alarmed as he dangles uneasily from a string hung on a nail above him. The background surface is a plain pine board, its graining and knots painted in the trompe l'oeil style. Almost as if an afterthought, a fragment of a red express shipping label with frayed edges is attached at the upper left. A large version of this label appears in *Torn-In-Transit, Express Company, C.O.D.* In addition to the signature at the lower right, which has been deeply incised as if scratched with a sharp pin

pipe and rest in the lower left corner of the panel molding. The heat of the ashes has slightly discolored the gray paint surface. Below right, two matches and more ashes balance on the edge of the molding. The

when the paint was still wet, Haberle also incised the date *Dec. 1888* at the right center edge of the canvas as it folds over the stretcher, an unusual detail for him. The jumping jack projects an air of disjointed uncertainty.

The Thermometer (pl. 18) is painted in trompe l'oeil style to exact scale. The glass thermometer, filled with mercury, is mounted on a white enamel plaque marked from 10 to 130 degrees *FAHR.* The mercury in the tube registers a pleasant sixty-eight. The letters *T* and *F* are on the right.

The plaque is attached to a heavy wood mount surrounded by a carved border. At the top, a glowing sunburst representing summer radiates warming beams. The border incorporates chubby infants of the kind included in the "frame" of *The Palette.* At left, a naked infant, seen from behind, climbs spindly tree branches while a duck flies overhead. At right, an infant, seen from the front, rests precariously on similar branches with a large bird perched above. A strange, deep shadow runs through the center of the painting from top to bottom. At the base of the plaque is the profile of Old Man Winter, his hair, mustache, and beard blowing in the wind. This head is another odd touch, as it is out of scale with the other "carvings" incorporated in the border.

The wood mount has "aged," resulting in two painted cracks at top right and bottom left. *The Thermometer* is signed on the lower right border, as if carved, *HABERLE '88. The Thermometer* was owned by Marvin Preston of Detroit, who also owned *Grandma's Hearthstone* and *The Palette.*

In 1889 Haberle painted *Wife, Wine and Song* (Veuve Cliquot Champagne Company, Reims, France), a composition of luxurious high-style items of the kind often favored by Harnett. The complex, three-dimensional theatrical painting was a dramatic change for Haberle, who previously had concentrated on flat objects. The popular tune *Wine, Woman and Song* probably served as his inspiration.

Fancy bric-a-brac, musical instruments, gourmet food, and wine appealed to middle-class American Victorian taste. Here, Haberle placed a violin (missing one string) and a bow, sheet music, champagne, a full wineglass, and a wine list in a shallow carved wood niche. The niche and the elaborately patterned draped curtain are examples of high Victorian décor similar to those in *Night.*

The violin and bow fill the center of the canvas, providing an unusual diagonal projection into space. Haberle probably used his own violin as a model. The bow seems to prevent the glass of champagne and the open bottle from falling off the shelf, a precarious situation. All the letters on the champagne label, *Veuve Cliquot Ponsardin Reims,* the elaborate wine list, and the musical score are clearly legible. Judging from its torn blue cover and tattered pages, the score, composed by Lustig Weiber, has been well used.

The carved frame is decorated with grape vines, an allusion to the champagne and the painting's title. At the upper left is a carved roundel enclosing the profile of a beautiful young woman embracing an infant. She is in contrast to the photograph of a theatrically dressed buxom gal resting on the shelf below—the type of card included in cigarette packages of the period.

Haberle identified himself as the photographer with a flourishing *J. Haberle* beneath her image. His address is at right, *J. Haberle, New Haven, Ct. erle '89;* the rest of the signature is hidden behind the woman's photograph. An unlit cigar rests on the shelf beneath the photograph. As another

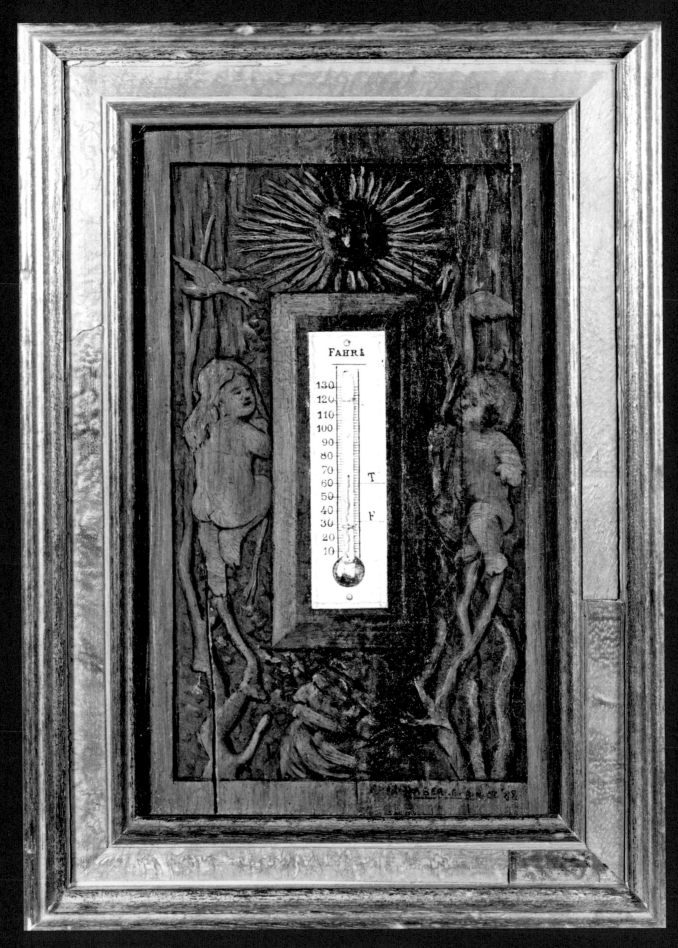

Plate 18. **The Thermometer,** 1888. Oil on canvas, 8 x 4⅞ in. Private collection

form of signature, Haberle inserted a tiny tintype photograph of himself on an angle at the lower left of the canvas. The painting is also signed on the side of the canvas *Haberle, Winthrop Ave, New Haven, Ct.*—probably so it could be identified while being stored in a rack.

The background of the niche is partially fitted with a loosely painted, puzzling white gauze curtain at left—atypical of the artist, whose images are always so specific. The right side is covered with a floral-print velvet drape suspended from a brass curtain rod.

Tinged with nostalgia like many Haberle works, *Wife, Wine and Song* may also be autobiographical. Haberle was married in 1887 or 1888—a year or so before he executed the painting. Do the female images evoke his wife? Does the hidden *g* in *Song* refer to a hoped-for son? Does *Wife, Wine and Song* suggest an interrupted romantic incident that took place in a fine, expensive restaurant? There is in *Wife, Wine and Song* a touch of male melancholy in the solitary glass, the unlit cigar, the silent violin—all remembrances of pleasures past.

The year 1888 was an important one for the artist, as he got much attention in the New Haven and Chicago press for *U.S.A.* It seems unlikely that he would have spent so much time on such a large work as *Wife, Wine and Song* without a specific buyer, as he needed to make a living from the sale of his paintings. Thus the painting was perhaps a commission for a Haberle client.

An unidentified clipping, probably from a New Haven paper, reads:

Wife, Wine and Song

This fine painting by John Haberle, instructor at the New Haven Sketch Club, may be seen at Cutler's during the remainder of the week, after which it will be exhibited in New York.[7]

There is, however, no current evidence that the painting was ever shown in New York.

Musical instruments have been a popular subject in European still-life paintings since the Renaissance. Artists in northern Italy especially favored the subject, particularly the violin, because the finest violinmakers—Amati, Guarneri, and Stradivari—lived and worked in that area. Violins and other musical instruments were also included in European vanitas still lifes for their symbolic meaning, since music is fleeting and ephemeral, suggesting the passage of time and the brevity of life.

Even if Haberle had not seen such paintings or reproductions of them, he was surely aware of the violin compositions of Harnett, Peto, Chalfant, and other American still-life painters of the period. Harnett's *The Old Violin* (1886; private collection) was popular with the American public from a widely distributed chromolithograph after the original. Haberle, who had studied music as a child, sang in quartets and played the piano and the violin, both of which he owned. He performed with amateur groups and friends in New Haven, including Professor Lonzelli from Yale University.

In 1896 Haberle decided to paint *Music* (pl. 19). Gemunder & Sons was a prominent manufacturer and importer of "Art Violins, Solo Guitars, and Genuine Old Violins" in New York City. Haberle borrowed one of their violins to use as a model.

An article in an unidentified New Haven newspaper of 1896 describes the circumstances relating to *Music:*

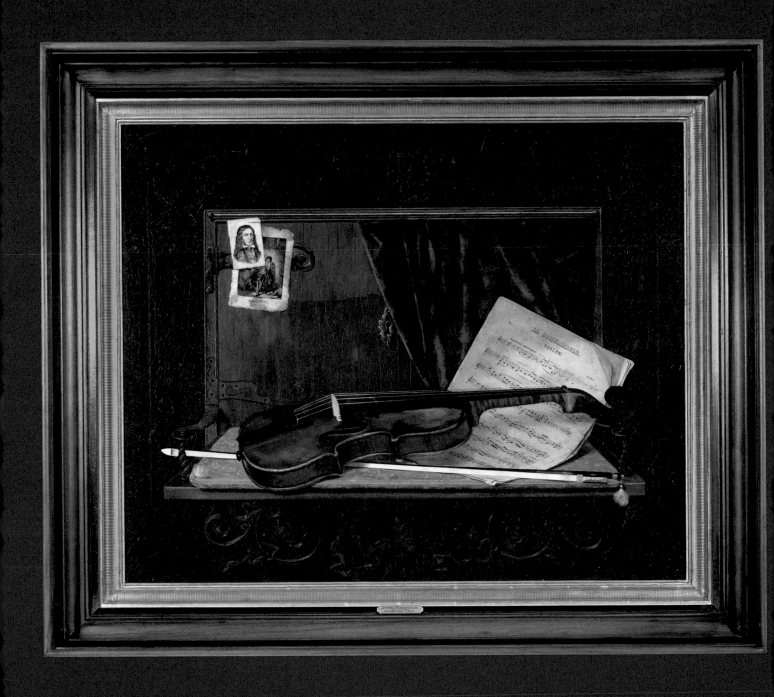

Plate 19. *Music,* 1896. Oil on canvas, 26 x 32 in.
Private collection

Mr. Haberle's Latest:
A Subject in Still Life of Remarkable Merit.
Painted for a New York Connoisseur in Art.
It gives a Startling Representation of Real
Objects That Deceive the Eye—Exquisite
Attention to the Detail

John Haberle, the well known artist of this city, has just completed a large musical still life subject, which he has painted for a prominent New York gentleman who is greatly interested in musical and art matters. The picture is done in the imitative style and is a marvel of careful and accurate work. It is now being framed at Cutler's Art Store in Chapel Street and will be placed on view a short time before it is sent to its owner.

Mr. Haberle has long since won a national reputation for his imitative work and this, his latest, is one of the best he has yet produced. The picture represents a wall cabinet of light wood, from which projects a shelf. On the shelf is a cushion covered with China silk and on this rests a violin. On the shelf also is some sheet music, "La Sonambula" by Bellini. In front of the doors of the cabinet is a blue plush curtain suspended from a brass rod. On the left door are two old prints of Paganini, the great violinist. The cabinet is hung against an old carved panel, around which are the portraits of the famous German composers in bas relief, surrounded by an oak leaf design. The violin represented is painted from one of Gemunder's celebrated art instruments and is worth many hundreds of dollars. It was loaned to Mr. Haberle by the gentleman referred to.

The painting is done with that wonderful fidelity of detail which makes the objects appear real to the point of deception. The old prints and the stained wood which show the marks of where the cabinet door once had a hinge are very faithfully reproduced. The brass curtain rod, with the slight tinge of green, showing that it had oxidized a little, is so true that it is difficult to realize that it is not metal.

This is the first of this style of work that Mr. Haberle has done in a year or two. He has been devoting his time to other styles of work, including modeling, and has achieved much success in this work also. He has not lost any of that cunning, however, which compelled him to scrape one of his pictures to the canvas to satisfy a *Chicago Herald* art critic that his work has not fraudulently done.[8]

Music is Haberle's only known "tabletop" composition. Instead of the more conventional tabletop as a support for the violin, bow, and sheet music, Haberle used an unusual wood wall cabinet with a hanging shelf for support. The violin, bow, and music lay on a blue China silk damask cushion with tasseled corners. At upper left, two engraved portraits of the virtuoso Italian violinist Niccolò Paganini are tacked to the panel. A close-up portrait partially covers a larger full-length view of the musician performing, surrounded by a nimbus of light. This larger engraving is stained and its edges are tattered.

The varnish on the back panel of the cabinet has been partially removed, and the elaborate metal hinge behind the Paganini engravings replaced. This subtle change in the color and texture of the wood panel gave Haberle a fine opportunity to display his impeccable

trompe l'oeil technique by contrasting the finished and unfinished portion of wood grain. The matching lower hinge, its outline intact, has been removed to facilitate the stripping of the lower portion.

The violin is rendered with careful attention not only to its edges and its strings but also to the subtle variations in the wood graining. The upper portion of its case has become lighter from wear. The white bow beneath it acts as a bright angular stroke, both supporting the violin and emphasizing the horizontality of the composition.

The sheet music is detailed with Haberle's professional precision; the notes growing dimmer as the page curls toward the bottom. Surrounding the composition is a deep brown, trompe l'oeil "carved" wood border filled with portrait roundels of important German musicians (clockwise from upper left): Beethoven, Gluck, Bach, Handel, Haydn, Schubert, Mendelssohn, Wagner, Meyerbeer, Schumann, and Weber. Their dates are included above their portraits.

At the top center of the border is the word *Musik* on a scroll placed above a lyre. A photograph of sculpted three-dimensional roundels of six of the composers prove that Haberle did indeed work in bas-relief and most likely used this relief work as a model for the painted border in *Music*.[9]

The identity of the original owner of *Music*, "a prominent New York gentleman who is greatly interested in musical and art matters," is unknown. Upon completion, however, the painting was loaned to August Gemunder. He wrote on his company letterhead to Haberle on April 20, 1896, "We shall be pleased to receive the painting *Music* for exhibition, and we are in a new place where we have a Parlor . . . we will exhibit your painting there. If it is sold, what is the cost?"[10]

A Gemunder catalogue of violins for sale lists item 390:

> August Gemunder, 1886, copy of Antonius Stradivarius, rich, reddish brown varnish finest selection of wood, tone absolutely perfect, full, carrying soft and responsive, this violin was used as a model by J. Haberle, the famous Painter for his latest work.[11]

Apparently *Music* did not sell and was returned to Haberle in New Haven. The painting was bought by a local family and remained in their collection for many years.

When Haberle set out to compose *Music*, he typically determined to produce a distinctive composition. The violin compositions of Harnett and Peto show the instruments hanging against a flat background, thereby diminishing their three-dimensionality. Haberle, on the other hand, by placing the violin on its side and setting the elaborately curved instrument on a shelf that itself projects into space made a convincing trompe l'oeil composition impossible. In *Music* the instrument is awkward, giving the entire composition an air of uncertainty even though most of the other objects are rendered with Haberle's most precise technique. The soft three-dimensionality of the blue velvet drape also contradicts the hard-edged, flat requirements of convincing trompe l'oeil compositions. It is ironic that this ambitious painting, the subject of which was personal and important to Haberle, should be one of his least convincing trompe l'oeil compositions. The painting is signed at lower right *Haberle,* in a kind of monogram, joining the *J* and the *H.*

6

Japonisme

In 1854, after two centuries of isolation, the island of Japan was opened to the world by the American admiral Matthew Perry and the Treaty of Kanagawa. Lavish gifts of the finest American and Japanese products were exchanged between Perry and the Japanese imperial commissioners, and thus began the craze for collecting objects of Japanese art and bric-a-brac in Europe and the United States. Exhibitions of Japanese products became part of European and American trade fairs, creating vigorous markets for Japanese goods. James Abbott McNeill Whistler, Louis Comfort Tiffany, and other American artists were strongly influenced by the style, which came to be known by the French term *japonisme*.

The Centennial Exhibition of 1876 in Philadelphia energized the taste for Japanese products in America. As William Hosley explained:

> Twenty years after Admiral Perry's historic encounter, however, most Americans knew little and cared less about the remote island nation. With few exceptions Japan remained a minor footnote in an American education in world history and art. This changed dramatically in 1876.

> The Centennial's role as a watershed in American life has not been overstated. A journalist for

The Philadelphia Inquirer noted that the Centennial exposition "had stirred up the sluggish blood of dwellers in the backwoods and great cities by introducing more cosmopolitan ideas. The pulse of this new life . . . can be felt in the nation's veins. . . . The millions who have visited Philadelphia this year, many of whom were never out of their native villages before, will not go home and sink into another twenty year's sleep. And awakened they were. Centennial fever induced a flurry of new enterprises, and more than any other event of the century was the impetus behind America's newfound competitiveness and the booming market for consumer goods and art products.[1]

The spectacular Japanese Pavilion at the Centennial Exhibition was enormously popular with the public. Japanese workers wearing Japanese clothes and using Japanese tools and materials constructed the pavilion while cooking their meals in the Japanese manner on the site. Eager American buyers purchased thousands of the Japanese objects on display. The last word in smart Victorian décor in the 1880s and 1890s was a corner of assorted Japanese objects set in the family parlor. Screens were particularly coveted. One home decorator advised, "Gather there easy chairs and

footstools, lounges strewn with pillows, stands, writing tables, jardinières, screens indispensably screens."[2]

Even if Haberle never went to the Centennial, he undoubtedly heard and read about it. He may have gone to Boston in 1883 to see the exhibition of Japanese art sponsored there by the Japanese government. While Boston collectors and the Museum of Fine Arts remained the center for collecting Japanese fine art, New York City became the center for imports and sales.

A. A. Vantine & Co. in New York dominated the Japanese market in the 1880s, the height of the Japan craze. Vantine stocked folding screens, decorative hanging scrolls, reed curtains for the porch, paper lanterns and umbrellas, toys, dolls, yard goods, piano scarves, kimonos, and gentlemen's smoking jackets. They offered these and many other Japanese products through their catalogue, which was distributed throughout the country.

Inspired by this exotic fad and the Japanese products available in New Haven shops, Haberle painted *Japanese Corner,* one of his largest, most ambitious trompe l'oeil works (pl. 20)—in spite of having declared more than once that he was giving up trompe l'oeil painting forever. He probably owned the Japanese objects that are included in the picture. To quote Hosley, "Although regarded as a minor tributary in the study of Japanese influence, the Japanese still life was present from the beginning to the end of the Japanese craze. As late as 1898 John Haberle, the noted master of American trompe l'oeil, painted what may be the greatest picture of the genre, an enormous six-foot high room view titled *Japanese Corner.*"[3]

The objects were probably arranged in Haberle's Morris Cove studio, where he meticulously painted one after the other. He always worked from the model

in order for his details to be precise. The dominant object in *Japanese Corner* is a two-panel screen with a black lacquer border surrounding painted panels of bright blue fabric. A flying white crane appears on each panel. The left panel is outlined with a gold border, arched at the top and accented with a white band. All the details on both panels are rendered with infinite patience and precision.

Draped over the upper part of the right panel are two fringed shawls, one red and the other peach (some details are missing due to paint loss). Decorating the latter are two white cranes. Below the red shawl is an image of a Japanese geisha in swirling flowered robes standing in a pavilion that is attached to a decorative scroll of pink flowered silk. The screen stands on a black and gold striped Japanese rug along with a bamboo tabouret, a popular Japanese table constructed of bamboo and panels of black-lacquer, here decorated with multicolored flowers, some made of mother-of-pearl. Standing on the tabouret is a large satsuma vase with a blue-and-white floral design that holds a casual arrangement of white and lavender Fuji chrysanthemums, a popular botanical import from Japan. One of the white flowers has fallen to the rug. The vase rests on a Japanese print projecting slightly over the top of the table. On the rug are two colorful Japanese paper fans—one round, one square—and a Japanese doll dressed in a pleated red dress, its head resting on the edge of the square fan.

At center top is a blue paper parasol hanging from a string attached to a bamboo rod balanced on the outer edges of the screen. Its delicate floral pattern and elaborate bamboo mechanism are represented in exact detail (the shadow of the parasol, if there was one, is gone due to paint loss). Hanging behind the right edge of the parasol is a red lacquer Japanese theatrical mask. A Japanese paper lantern decorated with white

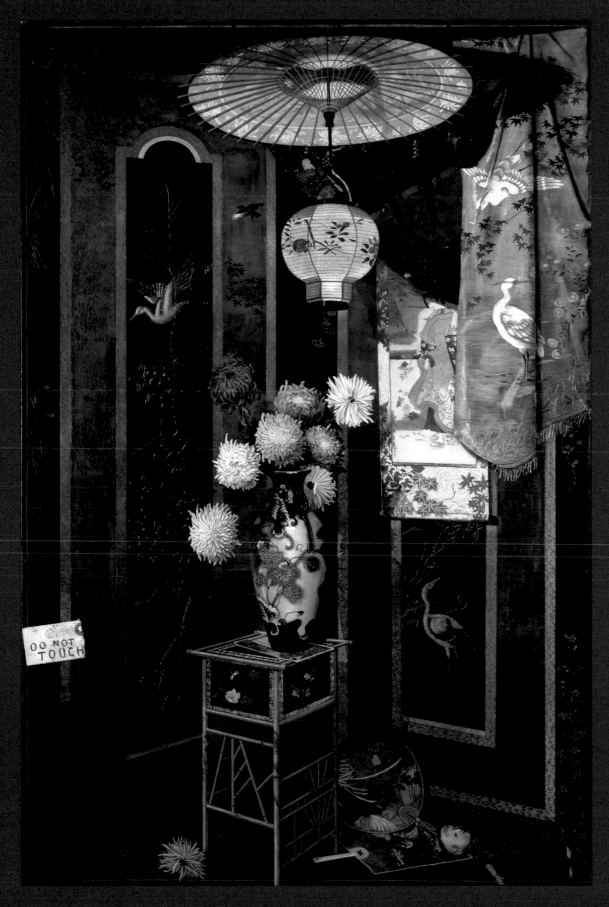

Plate 20. *Japanese Corner,* 1898. Oil on canvas, 6¾ x 4⅓ ft.
Michele and Donald D'Amour Museum of Fine Arts, Springfield, Mass.,
Gift of Mr. and Mrs. Chauncey Steiger

flowers is suspended from the parasol's handle. Gentle candlelight appears to glow from the base of the lantern, reflecting on its outer edges.

To sign his masterpiece dedicated to the *japonisme* craze, Haberle inserted two unusual items. The first, and most obvious, is a white envelope tucked into the outer black frame of the screen at lower left. The makeshift notice *DO NOT TOUCH* is hand-printed in black block letters on a two-cent-stamped envelope with the cancellation imprint *Apr. 12, 5:30 p.m. New Haven, Ct.* The right edge of the envelope has been torn open, implying that the recipient of the letter, Mr. Fred Hastings (a neighbor and friend of Haberle's), received it. His name and address are represented as if typed. Haberle, with a gleam in his eye and memories of the *U.S.A.* Chicago fraud accusation, no doubt decided to include this unconventional detail in his otherwise completely objective trompe l'oeil masterpiece.

Printed in the upper left corner is *please return to HABERLE.* Both Hasting's and Haberle's complete addresses probably were included but are gone due to paint loss. The tack that held the envelope is now also gone. The date is probably when *Japanese Corner* was finally finished after months of painstaking, eye-straining labor.

A second, subtler signature is arranged in a cartouche style on the lower right blue border: *HA* above *BE* then *RLE '98.* The letters are painted in a slightly Japanese manner and enclosed by a black outline. One can imagine Haberle's great sense of accomplishment and high hopes for the sale of his unique still life in the Japanese style.

The frame for *Japanese Corner*, now missing, was doubtless a handsome one with Japanese decorative elements. Haberle took great interest in the frames for his works, often designing and making them himself.

An extensive article in the New Haven *Morning News* described *Japanese Corner* and the public reaction to it in great detail:

A Japanese Corner:
Artist Haberle's New Painting Attracts Much Attention
Clever Work of Art that Deceives Everybody
The Painter's Latest Creation to Be Placed on View in a Leading Boston Gallery
Soon Is Pronounced by Many to Be His Masterpiece

The large painting by John Haberle of Morris Cove, which has been on view at Cutler's art store in Chapel Street for the past few days, is to be sent to Boston, where it will be exhibited by a leading picture dealer of that city. The painting is the artist's latest work, and is pronounced by many to be his best. Like many other pictures painted by Mr. Haberle which have attracted widespread attention, this one is handled with marvelous skill in the reproduction of detail, and will undoubtedly excite much favorable comment in Boston, where Mr. Haberle's work is already well-known and greatly appreciated.

The picture in question is called "A Japanese Corner" and some idea may perhaps be had from this brief description: A black Japanese screen with panels embroidered in gold form the background. The screen is folded so as to form a wide angle, and it rests on a Japanese rug. A bamboo rod rests across the top of the screen, and suspended from this are a Japanese umbrella,

lantern, an actor's mask and other Oriental articles. Resting on the rug, slightly to the left, in the angle formed by the sides of the screen, is a bamboo taborette. On the rug has also been placed carelessly, as if by chance, a small Japanese doll, a fan and other articles of Japanese manufacture. While this material has often been utilized in picture making, Mr. Haberle has displayed his usual degree of originality, and has produced a composition that is unique and interesting. It is the almost wonderful realism of the artist's technique which claims the most attention. An old envelope bearing a typewritten address has apparently been tacked to the screen. Across this is marked "Notice! Do Not Touch." So cleverly is this done that it will deceive the most observant. A lady while looking at the painting a few days since, did not realize that the picture was painted to deceive, remarked: "Well I think he might have placed a more presentable notice on the painting" supposing of course, that the envelope was real and not painted. The gold embroidery and other detail is indeed so realistic that one will hesitate, rub his eyes and wonder how plain paint can be used to make gold thread.

The painting, which is about 4 x 6 feet must have required an immeasurable amount of patience for in reproducing the embroidery on the screen many thousand lines, no wider than a thread were painted. Not withstanding the intricacies of all this detail, the painting is pleasing, both in composition and in its color effects. It was painted to be shown under a strong artificial light, consequently it has not been seen here under the most favorable circumstances.[4]

There are no reports on the Boston reaction to *Japanese Corner*, if it was in fact exhibited there. There is, however, a small clipping from an exhibition list similar in format to that of Gill's Art Gallery and Stationers in Springfield:

25. A Japanese Corner. By John Haberle

This large and important canvas is pronounced by many to be the masterpiece of this noted artist. This example of wonderful realism was only produced by an immeasurable amount of patience. The gold embroidery and other details requiring thousands of lines no wider than a thread. The Envelope, Satsuma Vase, Bamboo Tabourette, Japanese Doll, and in fact the entire picture is worthy of your careful study. Mr. John T. Abbe almost immediately bought the picture for two thousand dollars to replace Grandma's Hearthstone which he sold to Mr. Marvin Preston.[5]

Two thousand dollars was a princely sum in 1898— about ten thousand dollars today.

At first glance, *Japanese Corner* appears to be a detailed view of a cluttered corner of a room, a haphazard arrangement of Oriental bric-a-brac with a slightly old-fashioned Victorian air. It is only upon closer inspection that we begin to take in the trompe l'oeil precision of the individual objects. The white envelope may tip off the observant viewer to the artist's witty intentions. Observation of detail becomes compulsive; a magnifying glass is needed to prove the reality of every tiny detail in this delicate balancing act. Then stepping back, the whole composition comes into larger focus and creates a mood of disturbing imbalance, as if with the slightest breeze *Japanese Corner* would come tumbling down. The parasol string would

break; then it and the paper lanterns would fall on the vase with flowers, already dangerously close to the table edge, which would crash to the floor, breaking into many pieces, damaging the fans and doll below. The tabouret might also tip over, causing further damage. Chaos would replace order. There is also a sense of someone just having left the cozy nook, leaving the entire arrangement as a work in progress. It is as if Haberle had just stepped back to consider adjustments to his masterpiece. More than any other work, a sense of the artist's presence is here, strengthened by his personalized envelope impulsively tacked onto the canvas.

Frankenstein knew *Japanese Corner* only from an old sepia photograph, so his opinion was based on that imprecise image. In his chapter on Haberle in *After the Hunt*, Frankenstein wrote:

> In 1893, when *A Bachelor's Drawer* was first exhibited, Haberle was quoted in the press as saying that his eyes had gone bad from the strain he had placed on them and that he would do no more "imitative" painting. This statement is repeated in several paintings bearing later dates, yet in 1898 Haberle came out with *A Japanese Corner*, photographs of which survive, and which appears to be an ultra-ultra-ultra realistic tribute to the Nipponese craze satirized by Gilbert and Sullivan in *The Mikado*. A Japanese screen creates a cozy nook in which are displayed an open parasol, a lantern, a kakemono, a piece of embroidered silk, a cloisonné vase full of chrysanthemums, a small bamboo table, painted fans and a doll. The only visible touch of the endearing Haberle humor is the label reading "Do Not Touch" which appears at its left-hand edge. The work as a whole seems to modern

taste a depressing example of misapplied dexterity, and with it Haberle's "imitative" career seems actually to have closed. . . . He was more than a technical trickster. If he had done only works like *Japanese Corner*, he would have no place in this book. He was, rather, a prestidigitator of art, and in the enormous hyperbole of his best achievement there is something akin to the nineteenth century American spirit that found its most famous outlet in Mark Twain. Of all the American still life painters at work in his time, he is the most curious, the most piquant, and the one least likely to be confused with any other.[6]

If Frankenstein, who rediscovered Haberle and said the artist was his favorite American trompe l'oeil painter, could have seen *Japanese Corner* in the original, he most likely would have changed his mind.

The painting, which had disappeared, was found in 1986 by Richard Mühlberger, former director of the Museum of Fine Arts in Springfield. It had been in storage in the basement of the Steiger family home in Massachusetts for many years. Its elaborate frame in the Japanese style was gone. *Japanese Corner* had become unfashionable and been forgotten. Abbe likely sold the painting to the Steigers, who owned the major department store in Springfield. *Japanese Corner* may even have been on display in the store, featured with imported Oriental objects. Mr. and Mrs. Chauncey Steiger donated the picture to the Museum of Fine Arts in 1987. There it hangs, a strong, exotic presence next to Haberle's two smaller paintings *A Favorite* and *Twenty Dollar Bill*.

Haberle completed *Japanese Screen with American Historical Figures* or *American War Heroes* in 1900, two years after *Japanese Corner*. Now lost, the

picture is known only through an article in the *New Haven Palladium* of May 20, 1900:

Screen by John Haberle:
Striking Piece of Realism by Well Known
New Haven Artist
The Painter's Latest Work
Such Remarkable Fidelity in Execution that
One Is Deceived into Believing that
He Is Gazing on the Genuine—Painting Will
Be Sent to Boston

There has recently been placed on view in the gallery of Cutler's art store in Chapel Street, a large painting by John Haberle of this city. The picture is the painter's latest work and is attracting much attention. It is a decidedly unique canvas and has been executed with that rare skill which has won Mr. Haberle a national reputation as one of the cleverest of reproductive painters. The canvas represents a Japanese screen to which have been attached several flat objects, including photographs of Dewey, Schley, Sampson, Shafter and others who achieved fame during the recent war with Spain. Besides these there appears to have been fastened to the screen a leaf from an old history in which are lithograph portraits of heroes of the Civil War. The screen is partly folded and rests on the edge of an Oriental rug. In the angle formed by the sides of the screen stands a marble pedestal on which has been placed a reproduction of Houdon's bust of Washington.

Every detail of the painting has been worked out to a degree of realism that is indeed marvelous. The gilt embroidery of the screen, the photographs, the lithographic portraits, indeed each feature of the picture is so carefully done that even the most careful observer will be deceived at first glance into believing that it is a real screen and that all the objects are anything but oil color and canvas. The painting represents months of most patient study and of wearisome brush drawing. In many respects M. Haberle's latest work excels anything that he has yet produced in this particular style of work.[7]

The painting must have been approximately the same dimensions as *Japanese Corner* and marked Haberle's return to incorporating American historical events in his work, as he did in *The Changes of Time* and some of his currency pictures.

On March 7, 1905, an article appeared in the *New Haven Union:*

Unique Painting:
Artist Haberle Has Completed Another of His
Wonderful Illusions

Artist John Haberle, now residing at Morris Cove, and who is second to none in this country in the delineation of everyday articles in such a manner as to render it extremely difficult to tell whether they are real or not, has completed another painting. This work represents a bust of Washington in front of a Japanese screen, upon which are fastened photos and other articles, all being so skillfully done that it is only by closest scrutiny that the difficult work of the brush is detected. Mr. Haberle is the artist who paints bank bills so correctly that his work came to the attention of the United States Secret Service men some years ago. Several of his paintings are owned in the city and this latest one has been added to the collection of Charles Scholl and will be on exhibition for a short time.[8]

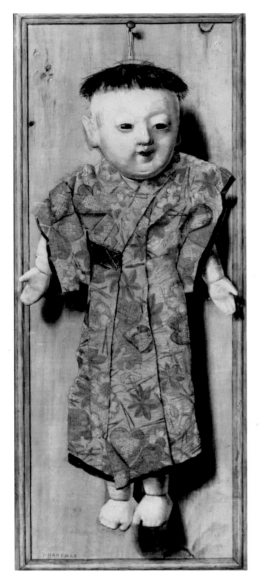

Figure 20. **Suspended: Japanese Doll,**
1898. Oil on canvas, 15⅛ x 6⅝ in.
Private collection

Before embarking on these two large paintings, Haberle painted two smaller works incorporating a Japanese doll, as if warming up for *Japanese Corner*. One of them was *Suspended: Japanese Doll* (fig. 20). As I observed in an earlier study:

Suspended represents a doll with Oriental features, dangling by a cord emanating from its skull. The cord is twisted around a tack driven into a pale wooden panel, carefully rendered with knots, graining, several dents, and a deep round hole at upper left. There is something primly comical about the doll. The head, with its Japanese features and drastically clipped tonsure, is painted with a surface as smooth as Oriental porcelain. The rest of the body beneath the pink, brightly patterned kimono seems limp, as do the stubby hands and feet. . . .

By choosing to paint a doll, an object which the viewer knows to be three dimensional, Haberle greatly challenged his trompe l'oeil technique. The illusion works primarily because the doll hangs against a flat surface and is encased in a deep frame.[9]

Haberle, always intent on engaging and entertaining the viewer, signed *Suspended* twice. The most obvious instance is his "carved"-type signature *J. HABERLE* at lower left in the wood background. The second signature, *J. Haberle 1889*, is hidden within the elaborate brocade of the doll's kimono, and above this *New Haven* is worked into a yellow blossom.

The deep wood frame, perhaps chosen by Haberle, is decorated with carved shell motifs. The careful staining, from pale yellowish brown to deep brown, contributes to the trompe l'oeil effect. An attached metal label in the bottom center reads: *HABERLE*. According to Jane Marlin, writing in 1898, the painting was "owned by a prominent art critic of Boston."[10] In *Suspended: Japanese Doll*, Haberle may have been making a sly reference to a painting of the same title (whereabouts unknown) by Harnett that was exhibited at the First Annual Exhibit of American Paintings at the Art Institute of Chicago, in 1888.

A Misunderstanding (fig. 21) also includes a Japanese doll, but in this case as an accessory, which marked a new direction for Haberle. Also new for the artist is the Impressionistic technique; the work is brightly colored, the paint applied with broad, clearly visible brushstrokes—a complete departure from his hyperrealistic trompe l'oeil work. This style was certainly less of a strain on the artist's eyes and much less time consuming. Haberle produced a number of these small animal paintings, all of which are lost. According to Marlin, "For some time past the artist has made a study of animals, just for relaxation, he says, and his studies of

cats are selling like the proverbial hot cakes."[11] A number of animal drawings by Haberle survive, including those of kittens, and as a boy he made such sketches in his school notebooks.

In *A Misunderstanding* the Japanese doll rests against a curtain at lower left, one foot casually propped on an overturned candy box. The brightly colored candies that have spilled out of the box surround a small black mouse. Confronting the mouse is a fuzzy black kitten, eyes blazing, ready to pounce on the startled visitor. Immediate action is implied. The viewer wonders what the outcome will be. *A Misunderstanding* is signed twice, at lower right. The first, in yellow script, reads: *HAB / Erle 1892*; over it *HABERLE* is painted in black block letters. Once again Haberle used the title of a painting to add a storytelling dimension to his work.

More original in many ways than the painting is the frame. Haberle was very handy and, according to Vera, able to make anything. He likely turned his hand to making the distinctive gold frame for *A Misunderstanding*, including the title at bottom center that serves as a label. The rest of the molding consists of a continuous relief of lively mice and kittens at play, alternating with little figures resembling Oriental figurines and an occasional small cube marked with an *H.* All the relief appears to be of gesso, applied to the wood frame and gilded.

A Misunderstanding with Cat and Canaries (fig. 22) is a similar composition in the artist's loose, Impressionist style but lacks a Japanese doll. Two animated yellow canaries are surprised to see a fluffy black and white kitten close by, about to drink from a saucer. The brown bird at right seems

Figure 21. **A Misunderstanding,** 1892. Oil on canvas, 12 x 18 in. Private collection

more composed and projects from the broken bars of its cage, which may have been made in Japan. Birdseed is scattered about the table surface and protective pad. At left, two small brown clay jugs, one overturned, act as solid anchors to the busy composition. The painting is signed in black block letters at lower right *HABERLE 1892.*

A plain gold molding separates the painting from the elaborate gold encrusted frame, which is a work of art in and of itself. The title of the picture begins at the upper left with the letters *A MISUNDER*—running from top to bottom—then on the lower frame *STANDING* completes it. The letters vary in design: some are small blocks containing one letter, others embellished with tiny kittens. The top and right moldings are free of lettering except for a gridlike design—perhaps a reference to the birdcage—decorating the top right corner.

Gill's Art Gallery offered a painting entitled *A Misunderstanding* by Haberle for sale for seventy-five dollars at their Seventeenth Annual Exhibition, 1893. Perhaps it was one of the two paintings mentioned above.

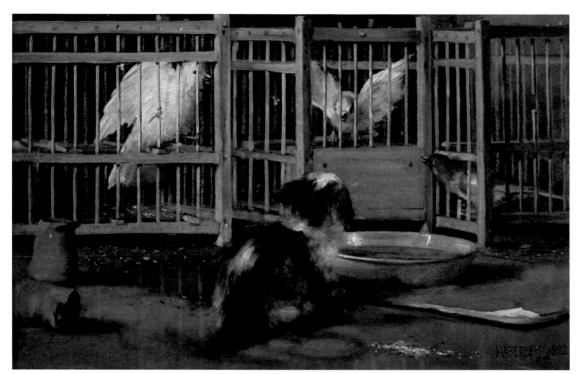

Figure 22. ***A Misunderstanding with Cat and Canaries,*** 1892.
Oil on canvas, 10½ x 16⅛ in. Private collection.
Photo courtesy Berry-Hill Galleries, Inc.

A Haberle painting (whereabouts unknown) combining *japonisme* with a currency theme is described in an article dated July 24, 1893, that appears to be from the *New Haven Register:*

Traeger's Purchase: Splendid Sample of the Artistic Skill of John Haberle
A Rare and Probably Unrivaled Specimen of the Great Artist's Handiwork which Is on Exhibition in Mr. Traeger's Café. Some Facts about Mr. Haberle

A. C. Traeger, the proprietor of Traeger's Hotel, has just purchased a cleverly executed "bill picture" by John Haberle, the well-known local artist. The painting is about 12 x 14 inches in size and represents an old and worn one dollar certificate pasted on a Japanese lacquered panel.

The panel is decorated with the conventional mother-of-pearl flowers embellished with gold. Besides the bill there are postage stamps and the photo of a well-known actress fastened to the panel. All the objects represented and painted with that consciousness and painstaking style which characterized Mr. Haberle's work. The bill is particularly well done, and is equal to that now famous picture, the bill of which had to be scraped down to the canvas in order to satisfy an incredulous Chicago critic, who would not believe but what the bill had actually been pasted on the canvas so exceedingly clever and deceiving was the execution.

Mr. Traeger paid about $350 for this chef d'oeuvre, and has hung it in his café. It is elaborately framed and is encased in a deep glass covered shadow box.

Some eight years ago Mr. Haberle executed a small picture consisting of an old one dollar bill pasted on a cigar box cover. This picture was shown in one of Evarts Cutler's local exhibitions and attracted much attention. Mr. Haberle had then just returned from New York where he had been studying at the National Academy.

Mr. Traeger had purchased the picture and it now hangs in Prokasky's café, so he had the distinction of having bought the first sold by a now prominent artist, for Mr. Haberle is generally accorded to be the most successful painter of deceptive subjects in the country.[12]

This painting, tentatively entitled *Japanese Panel with One Dollar Certificate* (ca. 1893), combines a postage stamp, a photograph of an actress, and a piece of paper currency—all objects previously used in Haberle trompe l'oeil compositions but with a new subject, a Japanese panel.

When Haberle read this article he must have been furious at the reporter's statement that he had pasted a one-dollar bill on a cigar box cover—precisely the accusation that caused so much trouble in Chicago in 1889. Traeger appears to have been Haberle's best New Haven patron and collector.

Haberle's work incorporating Japanese elements marks the end of his brilliant career as one of nineteenth-century America's painters in the "imitative" style. It also could be deemed his "international" style, as exemplified by these pictures with Japanese elements.

With *Chinese Firecrackers* (fig. 23) Haberle created another compositional type, one likely inspired by a sign hanging outside a New Haven Chinese laundry. Haberle's skill with precise lettering, which began with his early training as an engraver and lithographer, is clearly in evidence. In *Chinese Firecrackers*, dark gray lettering is the major subject in the trade sign. The gray background of the sign itself is somewhat washed out, revealing red underpaint that subtly varies the color of the background and makes it visually more interesting.

WONG SUNG / CHINESE LAUNDRY / Gurantee / all Clothes Washed / good as new, the sign proclaims. The establishment is located at street number 13, a number, with its traditions of both good and bad luck, that Haberle often chose to include. In the center of the composition, obscuring some of the lettering, is another Chinese specialty, firecrackers, dangling from a nail.

Figure 23. ***Chinese Firecrackers,*** ca. 1890. Oil on canvas, 22¹³⁄₁₆ x 26⅛ in. Wadsworth Atheneum Museum of Art, Hartford, The Ella Gallup Sumner and Mary Catlin Sumner Collection Fund (1964.156)

At the top of the cluster is a wrapper that reads: *BEST* [illegible] / *GOLDEN DRAGON / CANNON CRACKER / SUN SHING / CANTON CHINA.* A torn white tag hangs from the string connecting the individual firecrackers. The function of the tag is unclear; perhaps it is a laundry receipt and its numbers have worn off.

At the lower right Haberle playfully signed the painting *HAB-ER-LEE,* giving his name a Chinese twist. Below the signature, a single red Cannon Cracker rests precariously at the edge of the sign, casting a slight shadow at right. Haberle used this provocative device in several paintings: a peanut in *Fresh Roasted,* a smoldering cigarette in *A Bachelor's Drawer,* a blazing cigar in *Wife, Wine and Song,* and two matches in *The Clay Pipe.* It tempts the viewer into trying to touch and remove the firecracker. *Chinese Firecrackers* is more like folk art than the precise trompe l'oeil compositions Haberle usually painted. The frame, appropriately, is just a simple gray molding that blends with the background.

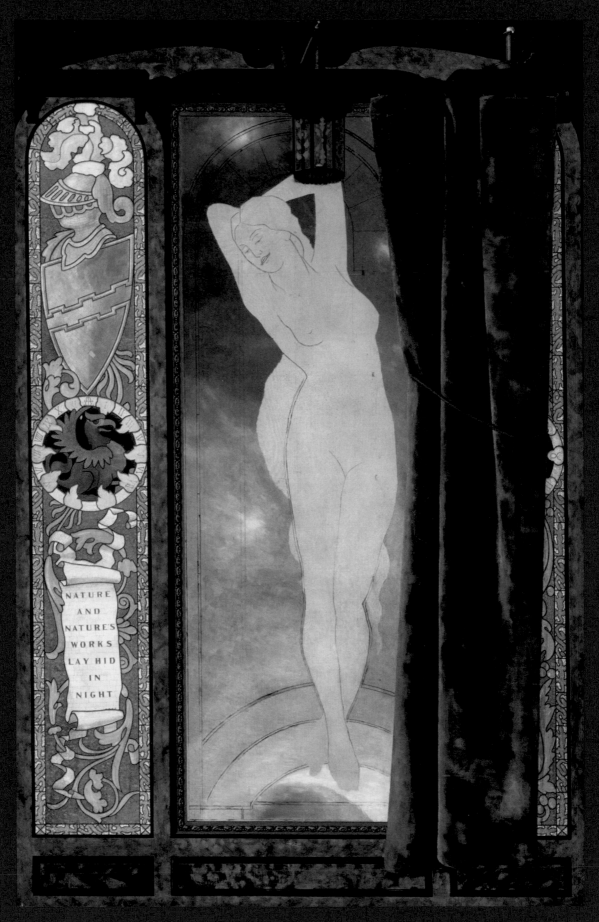

Plate 21. **_Night,_** ca. 1909. Oil on board, 6½ x 4⅓ ft. New Britain Museum of American Art, Gift of Mr. and Mrs. Victor Demmer (1966.66)

7

The Curtain Falls

A Life Long Day
by John Haberle

I'm glad to leave my restful bed
And set me at my humble spread.
That helps me in what e're is right
Until the coming of the night.
Then when the sun sets in the West.
I'll lay me down to eternal rest.[1]

*N*ight (pl. 21) is Haberle's most ambiguous painting and one of his largest (6½ by 4⅓ feet). Only *Grandma's Hearthstone* exceeds it in size. Unfinished, *Night* is the only painting by the artist that includes a full human figure; previously, his representations of people were limited to copies of a tintype or a photograph, both of which are flat.

Night represents an elaborate stained-glass window of the kind often found on staircase landings in Victorian houses. Two stained-glass panels frame the central section, which contains an unfinished female nude. The right panel is largely obscured by a brown velvet drape held back with a rope that Frankenstein described dramatically as "perhaps the most beautifully painted velvet drape in the entire history of the world."[2] The motif, which appears in seventeenth-century Dutch painting, evolved from the Dutch household tradition of drawing a piece of cloth across the surface of a painting to protect it from light.

The nude personification of Night, with long flowing hair and arms folded behind her head, resembles Renaissance images of Venus rising from the sea. The Haberle Venus, however, rests on a rainbow. The panels are enclosed by elaborately veneered and inlaid moldings and surmounted by a pedimental frame supported by brackets. The stained-glass panel at left contains a plumed medieval knight's helmet surmounting a bluish metal shield. Beneath it is a brown phoenix (a symbol of immortality and rebirth) surrounded by a sundial of yellow flames alternating with white squares. Below, on a long white scroll, is Haberle's twist on the English poet Alexander Pope's epitaph on Sir Isaac Newton's grave: *Nature and Nature's Works Lay Hid in Night.* (Pope's precise quote is: "Nature and nature's laws lay hid in night.")

Interlaced green vines and white scrolls connect these elements, which are contained within a border of green interlocking salamanders (a symbol of immortality). A portion of the salamander border and phoenix medallion appears in the small part of the right panel that is visible behind the drape. Hanging at top center is a black metal lantern with etched glass panels holding a burned-out candle, a suggestion of darkness and night.

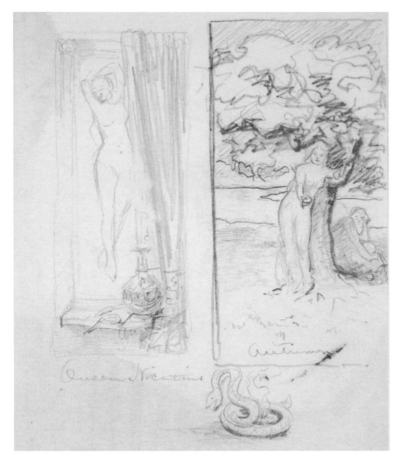

Figure 24. **Study for "Night,"** ca. 1909. Graphite on board, 4¾ x 4 in. New Britain Museum of American Art, Stephen B. Lawrence Fund (1969.1–.3)

The outlines of the nude, the rainbow, and the arch are in oil paint as is the grid guide across the upper section. The three patches of light (at upper left and right of the figure and at lower left, above the knee) may be reflections from electric studio lights, as Haberle mentioned them in his instructions for finishing *Night*: "Picture should be viewed and lighted from the left."³ The painting is signed in the lower right corner: *HABERLE 190[9]*.

A Haberle drawing of a female nude in a similar pose (fig. 24) is a study for *Night*.

An unidentified newspaper clipping, probably from the *New Haven Register*, announced the work:

John Haberle's Oil Painting *Night*

John Haberle of Morris Cove who is an Artist of Note, deserves mention of his wonderful art. One among them being a most unusual painting called *Night*. The canvas on which the picture is painted is 8 feet by 4 feet. It is realistic, imaginary, also poetic. The frame is handsomely inlaid, and in the center of the top, bottom, and side are the carvings appropriate to the subject. Mr. Haberle's health is such that he has been unable to display his skill of late but will probably finish his picture known as *Night* sometime this summer.⁴

The frame described by the newspaper may be the painted frame that is part of the composition. There is no evidence that *Night* was exhibited publicly, but the artist did sign and date the work, so perhaps it was shown locally or in his studio.

Night never sold and resurfaced about 1960 at the Haberle home in Morris Cove. Because of its size and precise, decorative subject matter, the painting was probably was a commission, perhaps from Haberle's patron James Abbe. With his continuing eye trouble, it is unlikely that Haberle would have embarked on such a large project if he did not have the hope of a buyer.

As I observed in an earlier study:

Haberle's subject is a painting within a painting. The body of Night is not on raw canvas but a thin layer of ivory paint suggesting underpainting, and the scaled squares in the central panel indicate enlarged transfer from a smaller drawing. Haberle probably intended the central panel to suggest not a painting of a nude in progress, but an unfinished painting of a stained glass panel incorporating a nude. . . . With his characteristic humor, Haberle interrupts himself in the act of painting what would have appeared to be stained glass when completed.⁵

On the other hand, perhaps Haberle did not intend the painting to be unfinished. He was a perfectionist and not one to exhibit a major work

in an unfinished condition, and his completion instructions are so precise that perhaps he had intended for another artist to complete the composition according to his wishes.

Frankenstein was convinced that *Night* was a finished painting. He included it in the first exhibition of Haberle's work at the New Britain Museum of American Art in 1962, which he organized, and wrote of it in *Reality of Appearance:*

> *Night* was apparently Haberle's last caper, and it may well be his greatest work. It came to light only recently. . . . One of Haberle's best inventions is the use of paintings which are not in *trompe l'oeil* style as *trompe l'oeil* objects in *trompe l'oeil* settings. Here he carries the diabolical paradox one step further, to its grand finale. The trick is to make you think, on encountering this picture for the first time, that it has not been completed. Then you suddenly realize that this is not the case at all: it is a completely finished picture of an unfinished picture.[6]

Sanford Low, former director of the New Britain Museum of American Art, which acquired the painting in 1960, agreed with Frankenstein's interpretation.

Haberle's written instructions regarding the picture surfaced in the family archives in an envelope marked *IMPORTANT.* The most surprising aspect of the directions, written about 1903, is that Haberle changed the title of the painting from *Night* to *The Earth and Reflection Moon:*

> *The Earth and Reflection Moon.* Begin around lantern to good relief with moonshine color, make them as light as possible through *Stained Glass* which keep free from ornamentation as is consistent. . . . The Bride (Pink) could be decorated with bride veil partly covering slippers and perhaps a rainbow sprinkling of pearls over drapery. The drapery can hide light colored part of circle of moon at bottom of canvas. Don't forget word Reflection at bottom of canvas and have iron rod or other parts joined at proper places where tile fell out darken. Palette knife good to use for flat surfaces. Wash with mild soap and paint when dry. A pane of glass might be partially cracked. Picture should be viewed and lighted from the left. Best place for working on painting is garage. Title: Earth and Reflection Moon[7]

Vera Haberle Demmer wrote the following letter regarding *Night* to Frankenstein about 1967:

> I have been looking for these directions for a long time. I am glad they were not lost. I found them five or six weeks ago. Please remember that Mr. Haberle was over 73 years of age when he wrote these directions, and that he had not seen the canvas for over twenty years. It was standing against the wall behind the organ all those years and he may not have remembered just what was done and what remained to be finished.

> When Mr. Haberle began work on this painting the newspapers announced that he was painting a picture to be called "Night." Just when he decided to change the title I do not know. At the time that we donated the painting to the New Britain Museum, I could not remember the new title, so we let it remain the old way, always hoping that some day I would find the scrap of paper that would set things straight.[8]

In 1971 Frankenstein received a letter from Victor Demmer (Vera married Victor Demmer, a vaudeville performer, in the 1960s):

> The now famous painting *Night* was taken by Mr. Low from 81 Cove Street, New Haven and on the advice of himself and Mrs. Demmer taken from the stretcher and rolled up and

stored (at the Museum). This rolling up never should have happened. . . .

The painting was in terrible shape when I saw it in 1966 when we divided all the drawings, paintings and memorabilia at New Haven between her niece and my wife. Her niece said it looked just too lousy for words. I kind of liked it, but it did look bad, and my wife and her niece decided to donate it to the New Britain Museum.[9]

So, finished or unfinished, titled *Night* or *The Earth and Reflection Moon*, the work remains a major nineteenth-century American trompe l'oeil painting. It would appear that *Night* was the artist's last painting, as no other works dated later have appeared.

Cove Street neighbor Mrs. Emily Jones married and moved to the neighborhood about 1924. She knew Haberle for the last six years of his life and had vivid memories of the artist. Her husband grew up across the street from the Haberle family and they both

> . . . thought the world of Mr. Haberle. Mrs. Haberle was a large woman, much younger than Mr. Haberle. She was not as educated as he was and quite humorless. She discouraged Haberle from painting because she thought the paint fumes were bad for his health. They were not of the same temperament, different as day and night. John Haberle was a grand little man, quite stooped, very frail with penetrating blue eyes. He was a lovely, very lively and informed gentleman. He could talk on any subject. His paintings were everywhere in the house. Some were even stored in the little Johnny house out back. They did not seem to have any relatives or visitors. They never went anywhere. The lovely garden was decorated with small cement sculptures—birds, little animals, a bird bath, all made by Mr. Haberle.[10]

Conglomeration [1889; whereabouts unknown] may have been painted for Emily Jones's father-in-law, as "commissioned by Walter D. Jones who designed same" is written on the back of the painting.

In 1932 Haberle and Vera went on a cruise on the R.M.S. *Aquitania*—Haberle's most extensive journey and very demanding for an elderly man in delicate health. The *Aquitania* stopped at several Mediterranean ports. A number of souvenirs from the trip remain, including the following poem:

> In Memory of the R.M.S. Aquitania
> 1932
> Aquitania, the gem of the oceans—
> I love thee for thy UPS and DOWNS;
> For thy various commotions.
> I love thy eats, thy breakfast ROLLS!
> I think thee SWELL and I'm feeling
> Well
> But x-cuse just now! I feel like—![11]

Upon his return from the Mediterranean cruise, Haberle continued to live with Vera in his cottage on Cove Street. His daughter Gloria had married a 1923 Yale graduate, Anthony Mamed Fresneda, the son of a wealthy Cuban sugar plantation owner, and moved to Cuba. The couple had one daughter, Gloria.

After many years of failing health, Haberle died of a heart attack at his home in Morris Cove on January 31, 1933. The obituary in the *New Haven Register* of February 3, 1933, was headlined: "Death Claims John Haberle Noted Artist, Famous for Works of Art":

> Heart attack proves fatal to Morris Cove Resident, famous for works of art. John Haberle, a resident of New Haven for 76 years and an artist of note, died of a heart attack at his home, 81 Cove Street, Morris Cove, Friday evening. Born in 1856 he lived all his life in New Haven with the exception of trips abroad

and trips about this country. During his youth he attended the National Academy of Design in New York City and later assisted a Professor Marsh in the Peabody Museum as a designer.

After achieving a national position in the field of imitative art, he was prevented from continuing his profession by ill health. Exhibitions of his work were held locally and throughout the country. The imitative paintings shown at the Chicago Art Institute were so well done that they were denounced as a fraud. Investigative commissions however, completely vindicated the painter and he was recognized as the foremost artist in this branch of painting.

Other Haberle masterpieces are "A Favorite," "A Frog and Some Others," "Suspended," "A Japanese Corner," and "The American." These canvases have been exhibited around the country. Mr. Haberle's forte was the reproduction of money, stamps and photos. "The Ten Dollar Bill" was one of the most deceptive examples of realistic painting ever exhibited.

Marvin Preston of Detroit, has the largest collection of Haberle masterpieces including "The Changes of Time," "Imitation," "The Palette" and "Grandma's Hearthstone."

Mr. Haberle leaves two daughters, Miss Vera M. and Mrs. Gladys Fresneda both residents of this city. Funeral services will be held from the funeral parlors of Bescher, Bennett and Lincoln, 100 Broadway, at 11 o'clock tomorrow.[12]

Dr. Paul Minear, who conducted the service on February 4, 1933, included the following comments:

We are met this morning in one common interest, drawn by one common love and admiration: "Love is the golden chain that binds our hearts together and unites us in sympathy." Our purpose is to pay fitting tribute to our loved one, Mr. Haberle.

He would not wish us to mourn overmuch for him. He himself conquered death and fear of death. He faced it bravely, he made plans to meet it. He thought of it with a touch of saving humor, a touch of simple curiosity concerning the future life and a deep feeling of peace and contentment. In all his thinking about it, he never feared it. He would not have us mourn overmuch for him.

Mr. Haberle was an artist, a true artist. As an artist he appreciated beauty, harmony, color and form. Both tragedy and happiness are essential to the greatest art, and he felt them both. His greatest work of art, however, was in the years after he had been forced to discontinue painting. His greatest masterpiece was painted on the canvas of life. It too, included tragedy and happiness, joy and sorrow, color, form and harmony. It was a work of beauty. In token of these memories, each of the friends here is invited to take home with him one of the roses from the casket.[13]

John Haberle, the greatest artist in the imitative style this country has ever seen, was buried beside his parents in the family plot in Evergreen Cemetery in New Haven. His obscurity would be complete for many years.

Haberle's role in American painting is unique. He took the traditionally objective still life, filled it with subtle private and historical references, and turned it into a personal vehicle. The ordered formality of his compositions is juxtaposed with his iconography of the ordinary and irreverent point of view. When Haberle laid down his brushes, a singular light in American painting went out.

Figure 25. *Photograph of John Haberle by Gladys Minear,* 1930.
Courtesy Gladys Minear

Postscript

On September 29, 1994, I gave a lecture at the Yale University Art Gallery on Haberle's painting "Fresh Roasted, Peanuts" (1887), a small trompe l'oeil in the museum's collection. After the lecture a couple introduced themselves to me as Dr. Paul Minear and his wife, Gladys. They explained that they had known Haberle in 1930 during Minear's student days at Yale and had briefly rented a cottage from him in Morris Cove. They became friends with Haberle and his devoted daughter Vera. Dr. Minear conducted Haberle's funeral service. Their vivid recollections of Haberle follow.

It was in September, 1930, that my wife and I first met John Haberle. We had arrived in New Haven to begin doctoral study at Yale and were in need of lodging and part-time work. The newspaper listed an ad for a furnished house at 300 Lighthouse Road, with instructions to inquire of the owner at his house on Morris Cove Road. Following instructions, we met John and his daughter Vera. The house for rent was on the same small lot as their own house; it was a two-room, two-story house that J.H. had used as a studio until bad health had forced him to give up his painting. We rented the house, although we did not stay beyond a few weeks because my wife received work at Sterling Library (on the first day the library was officially open) and soon thereafter the Graduate School employed us as host/hostess at its women's dormitory at 158 Whitney Avenue.

Even after we left Lighthouse Road, however, we continued to visit the Haberles.

I remember J.H. as a very short man, so stooped as to appear hunch-backed, very grey, shy and soft spoken. He spent much of his time sitting under a tree on their small lawn, or moving slowly and leaning on a cane. In a somewhat desultory conversation he showed a puckish sense of humor and a delight in "thinking otherwise." He seemed resigned to life as an old man and a recluse. Father and daughter were quite inseparable and it was clear that Vera had devoted herself wholly for many years to his care. They appeared to have very few contacts with their neighbors in Morris Cove and no involvement in community affairs. Earlier he had worked for the University but had no continuing ties there. Their income was obviously very limited, helped in part by occasional writing assignments for Vera in a New York magazine. Their house was small with simple furnishings. Its only distinction was that all available wall space was filled with his paintings.

It was obvious from the first that the life of both father and daughter centered in those paintings, for which Vera was the enthusiastic and articulate defender. She spoke with great pride of a museum or two that had exhibited examples. She recognized the fact, however, that there was at the time no market for them and that other artists

showed no interest. She resented this oblivion and was confident that the time would come when the same paintings would command high prices and museums would compete for them. Neither happened before his death or before her death some decades later. Having devoted herself to his care and career, her life was as deeply invested in his work as was his. Consequently, both of them lived with deep wounds and corrosive resentments.

We could sense those resentments, though at the time we could not share them. We had had no earlier contact with that school of painting and no basis for appraising his work. We were, of course, intrigued with the visual illusions involved in the precise detail but felt no aesthetic or emotional appeal. The idiosyncratic type of art seemed to correspond to their personal eccentricities. Thus, although we became friends almost immediately, we could not share their artistic obsessions or their resentments over the blindness of other artists. So it was not strange that when we noted the announcement of a lecture at the Yale Art Gallery on the work of John Haberle we were amazed at this long-deferred confirmation of the confidence of both John and Vera. In our day J.H. is an example of the artist who dies unheralded and unknown.

Paul S. Minear
October 10, 1994

We first knew the Haberles when we rented a small house on their property on Lighthouse Road in 1930, when my husband was beginning Ph.D. studies at Yale. Our relations were cordial, but not close. Vera was busy with her writing (usually under a pleasant arbor in the side yard) and her father was busy with his art. We were settling into new routines, one of which was coping with the hour-long trip to the Yale campus. My memory is that we were not at the cottage more than a month when the invitation came from Dean Wilbur Cross, via Margaret Corwin, his executive secretary, that we become host and hostess at the house for graduate women, just being opened at 158 Whitney Avenue. I don't recall that the Haberles protested, though they must not have enjoyed the bother of interviewing new tenants. Probably our lease was only a verbal understanding, and they understood how much it would mean to us to live on campus rent free.

I think of the Haberles as somewhat reclusive even then, a trait greatly magnified in Vera's later years. I suppose that the fact that their daily lives were absorbed in a realm so different from that of their shore-front neighbors made for a lack of communication. We had a pleasant Thanksgiving dinner with them once, but I had the feeling that guest occasions were not frequent for them. I don't recall that Mr. Haberle ever came to our apartment, though Vera came when she was overwhelmed with grief at her father's death, and she stayed with us for some days.

As I think of it, most of our contacts were through her, perhaps to protect her father's time and in consideration of his limited energy. He was a kindly person, with warm eyes and a gracious manner. We knew nothing of his life before 1930—whether his greatly bent posture was from birth, from pain or from an accident, what his earlier interests had been, or even that his art work on the first floor of the home was a major absorption. Our infrequent conversations did not cover national or regional concerns. In fact, it seems that he left conversation basically to the three of us.

I recall a trip Vera and her father made to Egypt—a major undertaking by sea in those days. I have the impression that they went as more than tourists, having some background in the art and archaeology of the region. The gifts they brought back to us interested us greatly.

Vera was sure that her father's artistic talents were sizeable and would some day be recognized. And indeed she was right. We had little understanding of work so strange, though we admired the meticulous detail. Perhaps if we had been more alert to investigate a discussion with him he would have told us a great deal. Obviously we wish now that we had had all this from his own lips, before art experts took an interest.

We had occasional correspondence with Vera after we left New Haven. She went to New York to pursue her interest in dance (ballet, I think) and she married. When my husband joined the Yale faculty in 1956 we drove out to Lighthouse Point to renew the Haberle connection. Vera was bedfast (a psychosomatic need as well as physical problems?). She and her husband were living on the second floor of the family home. We had the feeling that the main part of the house was totally unused. (One didn't ask about practical or personal matters in that situation.) Our conversation was pleasant, but with even more of a sense of detachment than earlier. That was our last contact with the Haberles. We were not notified of Vera's death, and we have no information about the sale of the house.

Gladys Minear
October 11, 1994

Notes

Chapter 1: The Early Years

1. Jane Marlin, "John Haberle: A Remarkable Contemporaneous Painter in Detail," *Illustrated American* 24 (December 30, 1898): 516–17.

2. *Benham's New Haven City Directory and Annual Advertiser*, 1875–76 (New Haven, 1875), p. 186.

3. "Haberle's Recollections to His Daughter Vera in 1925." Haberle Papers.

4. Theodore E. Stebbins, *American Master Drawings and Watercolors: A History of Works on Paper from Colonial Times to the Present* (New York: Harper & Row, 1996), pp. 170, 72.

5. Marlin, "John Haberle," p. 516.

6. John Wilmerding, "Notes of Change," in Doreen Bolger et al., *William M. Harnett* (New York: Metropolitan Museum of Art, 1992), p. 150.

7. Quoted in Nicolai Cikovsky Jr., "'Sordid Mechanics' and 'Monkey Talents,'" in ibid., p. 25.

8. *Autumn Exhibition Catalogue*, National Academy of Design, 1887.

9. *New York Evening Post*, November 19, 1887.

10. Thomas Clarke to W. M. R. French, 1888. Haberle Papers.

11. Richard Mühlberger, quoted in Gertrude Grace Sill, *John Haberle: Master of Illusion* (Springfield: Museum of Fine Arts, 1985), p. 4.

12. Private Sale of Collection of Thomas B. Clarke, American Art Galleries, Chickering Hall, Madison Square South, New York, February 14, 15, 16, 1899.

13. New Haven Sketch Club, Archives, New Haven Colony Historical Society, New Haven.

14. *New York Evening Post*, November 19, 1887.

15. "Haberle's Recollections."

Chapter 2: Fame and National Attention

1. "Haberle's Recollections to His Daughter Vera in 1925." Haberle Papers.

2. Clipping from unidentified newspaper.

3. "Art Institute Pictures," *Chicago Tribune*, July 1888.

4. Thomas B. Clarke to W. M. R. French, July 12, 1888. Haberle Papers.

5. Haberle to French, July 13, 1888. Ibid.

6. Alfred Frankenstein, *After the Hunt: William Harnett and Other American Still-Life Painters, 1870–1900* (Berkeley and Los Angeles: University of California Press, 1953; rev. ed. 1969), p. 117.

7. Clarke to Haberle, June 18, 1889. Haberle Papers.

8. French to Haberle, June 21, 1889. Ibid.

9. "Critics Called to Decide," *Chicago Daily News*, July 3, 1889.

10. Jane Marlin, "John Haberle: A Remarkable Contemporaneous Painter in Detail," *Illustrated American* 24 (December 30, 1898): 516–17.

11. Clipping from unidentified Chicago newspaper, July 3, 1889.

12. Mr. Bartlett, *Chicago Inter-Ocean*, July 7, 1889.

13. "Remarkably True to Nature," *New Haven Palladium*, July 2, 1889.

14. Bruce W. Chambers, *Old Money: American Trompe l'Oeil Images of Currency* (New York: Berry-Hill Galleries, 1988), p. 33.

15. Gertrude Grace Sill, *John Haberle: Master of Illusion* (Springfield: Museum of Fine Arts, 1985), p. 13.

16. *New Haven Register*, July 24, 1893.

17. Pennsylvania Academy of the Fine Arts, Philadelphia, 59th Annual Exhibition, January 24–March 7, 1889, p. 15.

18. Sill, *John Haberle*, p. 13.

19. Nicolai Cikovsky, Jr., "'Sordid Mechanics' and 'Monkey Talents,'" in Doreen Bolger et al., *William M. Harnett* (New York: Metropolitan Museum of Art, 1992), p. 25.

20. Frankenstein also found Haberle's painting *A Favorite* at the Museum of Fine Arts in Springfield about 1948. It had been donated to the museum in 1939 by Charles and Emilie Shean, owners of the Hotel Charles, the finest hotel in Springfield at the time. It was purchased from Gill's. The Hotel Charles was noted for its collection of American trompe l'oeil paintings that decorated the bar.

21. K. R. Hammond to Haberle, April 11, 1915. Haberle Papers.

22. "Haberle's Recollections."

23. Clipping from unidentified Boston newspaper, ca. 1896.

24. Stuart Feld et al., *American Paintings and Historical Prints from the Middendorf Collection* (New York: Metropolitan Museum of Art, 1967), p. 70.

25. Frankenstein, *After the Hunt*, p. 117.

26. Doreen Bolger Burke, *American Paintings in the Metropolitan Museum of Art*. Vol. 3, *A Catalogue of Works by Artists Born between 1846 and 1864* (New York: Metropolitan Museum of Art, 1980), p. 280.

27. *Evening Leader*, May 15, 1894.

28. Ibid.

29. James Gill to Haberle, February 19, 1894. Haberle Papers.

30. Gill to Haberle, May 21, 1894. Ibid.

31. Haberle's Masterpiece: Fine Work of Art on Exhibition at Traeger's," *Evening Leader*, May 15, 1894.

32. Gill to Haberle, June 20, 1894. Haberle Papers.

33. William Bradish to Haberle, July 1898. Ibid.

34. A. H. Griffiths to Haberle, October 18, 1898. Ibid.

35. James T. Abbe to Haberle, June 21, 1899. Ibid.

36. Griffiths to Haberle, January 31, 1900. Ibid.

37. Griffiths to Haberle, March 1, 1900. Ibid.

Chapter 3: History Paintings

1. Victor Demmer to Alfred Frankenstein. August 28, 1970. Haberle Papers.

2. Linda Ayers, *American Paintings from the Manoogian Collection* (Washington, D.C.: National Gallery of Art, 1980), p. 110.

3. Ibid., pp. 110–11.

4. William H. Gerdts, *Painters of the Humble Truth: Masterpieces of American Still-Life, 1801–1939* (Columbia, Mo., and London: University of Missouri Press, 1981), p. 196.

5. Alfred Frankenstein, *After the Hunt: William Harnett and Other American Still-Life Painters, 1870–1900* (Berkeley and Los Angeles: University of California Press, 1953; rev. ed. 1969), p. 118.

6. Ibid.

7. Ayers, *American Paintings*, p. 110.

8. Frankenstein, *After the Hunt*, p. 118.

9. *Detroit Evening News*, June 8, 1893.

10. "Haberle's Grandma's Hearthstone," *Springfield Republican*, November 22, 1890.

11. James T. Abbe to Haberle, October 4, 1888. Haberle Papers.

12. Ibid., November 1888.

13. Ibid., November 9, 1888.

14. Ibid., March 8, 1889.

15. "Search for a Fireplace: How Mr. Haberle Secured His Subject for a Picture," *New Haven Register*, December 19, 1889.

16. Clipping from unidentified Springfield newspaper, ca. 1887.

17. "Haberle's Grandma's Hearthstone."

18. Abbe to Haberle, September 19, 1891. Haberle Papers.

19. W. H. Griffith to Haberle, 1891. Haberle Papers.

20. Frankenstein, *After the Hunt*, p. 118.

21. "The Picture Fooled the Cat," *Detroit Evening News*, June 4, 1891.

22. Haberle to "Friend Sadie," ca. 1892. Haberle Papers.

23. "A Work of Art Is Marvin Preston's Latest Acquisition," *Detroit Evening News*, 1894.

24. Gertrude Grace Sill, *John Haberle: Master of Illusion* (Springfield: Springfield Museum of Fine Arts, 1985), p. 45.

25. William H. Gerdts and Russell Burke, *American Still-Life Paintings* (New York: Praeger, 1971), p. 157.

26. William W. Fuller, Fraternal Column, *Detroit Evening News*, February 24, 1952.

27. "Mr. Haberle's Paintings," *Boston Transcript*, May 28, 1896.

28. "Realistic Paintings: Work of John Haberle Attracting Exclamations of Surprise," *Boston Daily Globe*, June 30, 1896.

29. William Reese to the author, February 3, 2009.

Chapter 4: A Remarkable Variety

1. "Realistic Paintings," *Boston Gazette*, June 28, 1895.

2. Alfred Frankenstein, *The Reality of Appearance: The Trompe l'Oeil Tradition in American Painting* (Greenwich, Conn.: New York Graphic Society, 1969), p. 120.

3. Clipping from unidentified Boston newspaper, June 1895(?).

4. John Wilmerding, *Important Information Inside: The Art of John F. Peto and the Idea of Still-Life Painting in Nineteenth Century America* (Washington, D.C.: National Gallery of Art, 1983), p. 214.

5. Cited in Karyn Esielonis, *Still-Life Painting in the Museum of Fine Arts, Boston* (Boston: Museum of Fine Arts, 1994), p. 109.

6. "By Local Artists—Cutler's Second Exhibit—The Labors of New Haven Professionals . . . in Oil and Watercolor Crayon and Poker Work, Pencil and Etching—First Exhibit of Its Kind Here," *New Haven Register*, ca. 1895.

7. Alfred Frankenstein, "Haberle: or the Illusion of the Real," *Magazine of Art* 41 (1948): 226.

8. Wendy Bellion, "The Painting as Object," in Sybille Ebert-Schifferer, *Deceptions and Illusions: Five Centuries of Trompe l'Oeil Painting* (Washington, D.C.: National Gallery of Art, 2002), p. 322.

9. Frankenstein, *After the Hunt: William Harnett and Other American Still-Life Painters, 1870–1900* (Berkeley and Los Angeles: University of California Press, 1953; rev. ed. 1969), p. 121.

10. "Thirteenth Annual Exhibition of American Paintings." Museum of Fine Arts, Springfield, archives.

11. *Detroit Evening News*, June 8, 1893.

12. On Ingersoll, see Gitt Cramer, *Royal Bob: The Life of Robert Green Ingersoll* (New York: Bobbs Merrill, 1952).

13. Both the watch and the rosary, gifts from the Haberle family, are in the archives of the New Britain Museum of American Art.

14. "Haberle's Autobiography." Haberle Papers.

15. Elizabeth Champney to Haberle, November 7, 1891. Haberle Papers.

16. Quoted in Frankenstein, *After the Hunt*, p. 121.

17. Franklin Kelly, "The Painting as Object," p. 320.

18. Alfred Frankenstein, *Reality of Appearance*, p. 120.

19. Frankenstein, *After the Hunt*, p. 115.

20. Wolfgang Born, *Still-Life Painting in America* (New York: Oxford University Press, 1947), p. 35.

21. Jane Marlin, "John Haberle: A Remarkable Contemporaneous Painter in Detail," *Illustrated American* 24 (December 30, 1898): 517.

22. William H. Gerdts and Russell Burke, *American Still-Life Painting* (New York, Washington, and London: Praeger Publishers, 1971), p. 158.

23. Vera Haberle, unpublished note, 1965. Haberle Papers.

Chapter 5: Boston Triumph: New Directions

1. "A Great Curiosity," *Boston Times*, June 28, 1896; "Realistic Paintings," *Boston Gazette*, June 28, 1896.

2. "Wonders in Art," *Boston Post*, July 3, 1896.

3. Alfred Frankenstein, *After the Hunt: William Harnett and Other American Still-Life Painters, 1870–1900* (Berkeley and Los Angeles: University of California Press, 1953; rev. ed. 1969), p. 120.

4. Gertrude Grace Sill, *John Haberle: Master of Illusion* (Springfield: Museum of Fine Arts, 1985), p. 43.

5. Lyman Hotchkiss Bagg, *Four Years at Yale* (New York: Henry Holt & Co., 1871).

6. Sill, *John Haberle*, p. 12.

7. "Wife, Wine and Song," clipping from unidentified newspaper, probably New Haven.

8. "Mr. Haberle's Latest," clipping from unidentified New Haven newspaper, 1896. Alfred Frankenstein Papers, Smithsonian Institution, Washington, D.C.

9. Photograph of bas-relief roundels. Haberle Papers.

10. August Gemunder to Haberle, April 20, 1896. Ibid.

11. Cited in Gertrude Grace Sill, "Found: A Missing Masterpiece by New Haven Painter John Haberle," unpublished ms.

Chapter 6: *Japonisme*

1. William Hosley, *The Japan Idea* (Hartford: Wadsworth Atheneum, 1990), p. 32.

2. Mme de Girardin, "A Chapter on Screens," *Art Interchange* (November 27, 1878): p. 41. Quoted in Marylinn Johnson, "The Artful Interior," in Doreen Bolger Burke et al., *In Pursuit of Beauty: Americans and the Aesthetic Movement* (New York: Metropolitan Museum of Art, 1986), p. 137.

3. Hosley, *Japan Idea*, p. 92.

4. "A Japanese Corner," *Morning News*, July 16, 1898.

5. Unidentified clipping, probably from Gill's Art Gallery. Haberle Papers.

6. Alfred Frankenstein, *After the Hunt: William Harnett and Other American Still-Life Painters, 1870–1900* (Berkeley and Los Angeles: University of California Press, 1953; rev. ed. 1969), p. 122. The sepia photograph is now part of the Frankenstein Papers, Archives of American Art, Smithsonian Institution, Washington, D.C.

7. "Screen by John Haberle," *New Haven Palladium*, May 20, 1900.

8. "Unique Painting," *New Haven Union*, March 7, 1905.

9. Gertrude Grace Sill, *John Haberle: Master of Illusion* (Springfield: Museum of Fine Arts, 1985), p. 46.

10. Jane Marlin, "John Haberle: A Remarkable Contemporaneous Painter in Detail," *Illustrated American* 24 (December 30, 1898): 516.

11. Ibid., p. 517.

12. "Traeger's Purchase," probably *New Haven Register*, July 24, 1893.

Chapter 7: The Curtain Falls

1. Haberle, "A Life Long Day." Haberle Papers.

2. Alfred Frankenstein, *The Reality of Appearance: The Trompe l'Oeil Tradition in American Painting* (Greenwich, Conn.: New York Graphic Society, 1970), p. 126.

3. Haberle, "Important," ca. 1903. Haberle Papers.

4. "John Haberle's Oil Painting *Night*," clipping, probably *New Haven Register*.

5. Gertrude Grace Sill, *John Haberle: Master of Illusion* (Springfield: Museum of Fine Arts, 1985), p. 47.

6. Alfred Frankenstein, *The Reality of Appearance: The Trompe l'Oeil Tradition in American Painting* (Greenwich, Conn.: New York Graphic Society, 1969), p. 126.

7. Haberle, "Important."

8. Vera Haberle Demmer to Frankenstein, ca. 1967. Haberle Papers.

9. Victor Demmer to Frankenstein, August 27, 1971. Ibid.

10. Emily Jones, interview with the author, August 1982.

11. Haberle, "In Memory of the R.M.S. *Aquitania*," 1932. Haberle Papers.

12. "Death Claims John Haberle," *New Haven Register*, February 3, 1933.

13. Dr. Paul Minear, Funeral Service, February 4, 1933. Private collection.